Page, Barbara
AUTHOR

BOOK MARKS:
TITLE
An Artist's Card Catalog

DATE DUE	BORROWER'S NAME
2021	

Book Marks

F Murakami, Haruki,
Murakami 1949-

 Kafka on the
 shore.

"But inside our heads... there's a little room where we store those memories... you'll live forever in your own private library."

BOOK MARKS

An Artist's Card Catalog

BARBARA PAGE

Notes from the
Library of My Mind

BAUER AND DEAN PUBLISHERS ‖ NEW YORK

To my beloved sons, George and Paul, and my pal Amy

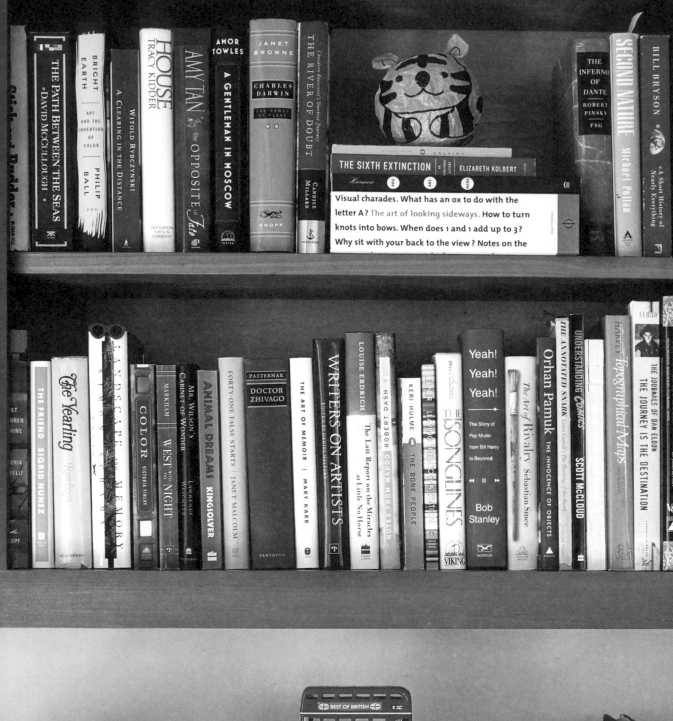

Contents

Writing a book, just like building a library,
is an act of sheer defiance. It is a declaration that
you believe in the persistence of memory.

—— Susan Orlean, *The Library Book*

AUTHOR LEHRER, JONAH

TITLE PROUST WAS A NEUROSCIENTIST

DATE DUE	BORROWER'S NAME
2007	

"Our memories obsess us precisely because they disobey every logic, because we never know what we will retain and what we will forget."

v1-v5

Imagine a library holding all the books you have ever read, books that helped shape who you are today. Imagine the catalog for that library. It exists in your mind, much as the catalogs for many public libraries around the world now float in cyberspace. As an avid reader and visual artist, I wanted to give the library in my mind a physical dimension and make it vibrant with colorful imagery. The result is *Book Marks*, an ongoing art project consisting of hundreds of three-by-five-inch cards illustrated with my impressions of memorable books I have read over seven decades.

Long ago, as I became aware of the whims of memory, I began to paste ephemera in scrapbooks and jot down random observations in flimsy spiral notebooks. At first I was so self-conscious about disclosing anything personal, I mainly scribbled the number of hours I had worked in the studio that day, along with remarkable passages from whatever book I was reading at the time. Eventually I began to make more thorough notes in Italian hardbound journals that had lined pages to keep my thoughts straight. At the back of each I kept a list of books I wanted to read and carried that list forward from journal to journal, leaving off the titles I had read. As a result, each book removed from the list receded into the past, and it was frustrating to search through my numerous journals for a reference to a title or author that had slipped my mind.

That changed one day in 2008 when I found an obsolete checkout card still tucked into the pocket of a library book, with its author, title, and call number—often referred to as a book's "address"—typed at the top. This remnant of a largely outmoded system that allowed libraries to keep track of their holdings on loan struck my artistic fancy. It seemed the perfect medium to help me remember a particular book, especially if I added some visual elements to reflect its content. So before returning the novel to the library, I removed the card and kept it. Once back in my studio, I "summarized" the plot with a pictogram in the space below the labels for "Date Due" and "Borrower's Name," and my first *Book Marks* card was created. In time this impulsive act turned into a systematic process for chronicling my reading history.

ILLUSTRATION 1

Opposite, *Book Marks* card for *Proust Was a Neuroscientist*.

Like many, I can remember the procedure for borrowing a book from the library using these checkout cards. I would take the card from its pocket, fill in the blank under "Borrower's Name," and hand it to the clerk behind the desk, who then stamped the due date on the card before filing it in a long, narrow box. In exchange, the clerk handed me a slip, reminding me to return the book by the indicated date or incur a fine. When libraries began to digitize their systems, as my local public library did, the checkout cards were discarded or left unused in the books.

A frequent user of my public library, I began to collect these old cards whenever I came across one still in its pocket—with permission from the librarian, of course. Unfortunately, not many books retained their checkout cards; furthermore, I wasn't exclusively reading library books. In order to move my budding art project forward, I purchased a box of two thousand new checkout cards from a library supply store. As I turned these pristine cards into memory prompts, I deliberately left any accidental smudges or errant ink stampings I'd made to echo the used cards that displayed years of borrowing history. I have also cut, burned, or creased certain cards when the books' contents moved me to do so.

Usually when I convert a card—new or used—into a small artwork for *Book Marks*, I utilize drawing, rubber-stamping, and collage elements to encode my sometimes-peculiar recollections of each book on the lined spaces reserved for borrowers' names and due dates. The media and imagery I choose are intentionally eclectic, to reflect the unique content of each book. My childhood postage stamp collection has proven invaluable for adding compact historical and geographic references. I also use a date stamp to indicate the year of publication—either of the edition of the book I own or borrowed from the library, the edition I assume I read based on my age at the time, or, when I couldn't make an educated guess, the first American edition.

As my cards began to pile up, I faced the age-old dilemma that collectors of all sorts confront—how should their possessions be organized? Historically, methods of cataloging books and arranging them on the shelves presented a challenge for anyone with an extensive library. Volumes were sometimes shelved chronologically by date of acquisition or alphabetically by title or author or simply grouped by their size. In the eighteenth century, Thomas Jefferson divided his extensive library into forty-four "chapters," or subjects, a flexible model comprising general knowledge as well as highlighting his own particular interests, such as agriculture. Later, in the middle of the nineteenth century, librarian "Melvil" Dewey developed a standardized system for cataloging bibliographic items, similarly using subject matter as the criterion. His system became known as the Dewey decimal classification (DDC) and is still used in most public libraries. While other cataloging systems were developed and still exist, such as the Library of Congress Classification (LCC), used by most academic and research libraries, all of the discarded checkout cards in *Book Marks* have Dewey call numbers.

The Dewey decimal system, as it is colloquially known, distributes reading material among ten main categories, including Philosophy, Religion, Science, Arts and Recreation, Literature, and History, each designated by a three-digit number. These are then divided into progressively more specialized subsections. Under "Science" (500) we find "Animals" (590), and under "Animals," the subset "Birds" (598). Over time categories have been added or revised in keeping with the expansion of knowledge and literary genres. For example, "Data Processing and Computer Science" (004)—which

did not exist in 1876, when Dewey's first library classification pamphlet was published—is now a dominating presence among general works on information, surpassing encyclopedias. And today, graphic novels have a huge presence in the category of "Drawing" (741), particularly "Manga" (741.5), the popular Japanese comics that now swamp shelves in the young-adult section of many public libraries. Adding numbers after the decimal point easily allows for additional subdivisions of categories. Considering the constant introduction of new topics, whether "Black Holes" (523.8) or "Garage Sales (management)" (658.87), this system is handy as the options become almost infinite.

A few large subcategories are designated with a letter instead of a number: Fiction, under "F," is shelved together in alphabetical order by the author's last name, and biographies, autobiographies, and memoirs are designated with a "B" and arranged alphabetically by the last name of the subject of the book. By mostly using numbers, Dewey's system avoids any controversy caused by letter designations such as the Library of Congress Classification use of "BS" for anything relating to the Bible. Regardless, there has long been criticism of the Dewey decimal system's undeniable cultural bias; for example, Dewey set aside extensive numerical space for "Christianity" (230 through 289) but very little for all other religions (290 through 299).

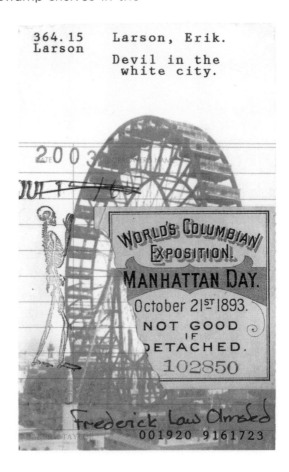

For my purposes, arranging the *Book Marks* cards according to subject matter seemed far too complicated. I would ultimately choose a time-based structure, as I had in earlier art projects. First, however, my growing collection of tiny artworks required an appropriate repository. As luck would have it, I found a wooden two-drawer library case at the first antique shop I visited, and I labeled one drawer "BOOK" and the other "MARKS." Though "bookmark" is one word, the two drawers prompted me to break the project name into two words, thereby putting emphasis on the "marking" of the cards as well as on their role as "markers" of my past reading. I arranged the cards chronologically, by the year I read the books, not according to subject matter, author, or title. By using these checkout cards and filing them in a library case, I am creating an oblique but tangible connection between the library in my mind and those library card catalogs housed in the shallow drawers of heavy wooden cabinets, now sometimes found in antique shops. Their ranks of drawers gave substance and heft to the vast and complex history of human endeavor, represented by the contents within, in a way that the invisible storage of information in the "cloud" today cannot. The tactile experience of

riffling through the well-thumbed index cards arranged by subject, title, and author—our original "search engines"—was akin to browsing the bookshelves themselves. Similarly, flipping through my *Book Marks* file drawers connects me to memories stored in the library of my mind.

Shortly after I started creating cards for the books I'd recently read, I was inspired to document my entire reading history. I knew that recalling all the significant books I had ever read would be impossible, but that didn't stop me from trying. While my early journals certainly helped me in this effort, another rich source for reconstructing my bibliographic time line was the list of titles my book club has chosen over the past thirty years—a sometimes-contentious process in and of itself! When it came time to dig down into my childhood and remember those first books that were read to me, this exercise in memory retrieval reached a whole new level.

While the crannies and chasms of my cerebrum are filled with heaps of trivia—the weight of the obelisk in front of the Vatican, three stanzas of "Good King Wenceslas," and the NATO phonetic alphabet from "Alfa" to "Zulu"—I can never predict what facts and impressions are going to stick with me. Why do I remember my grandmother's telephone number, MI 2-6653, with "MI" standing for "Midway," or the name of Miss Seagraves, the nurse at my pediatrician's office, more than sixty years later? Why do I wake up with the lyrics of "Itsy Bitsy Teenie Weenie Yellow Polka-Dot Bikini" coursing through my head, when I have forgotten almost all the math I studied beyond fractions? I can reel off the order of the geological periods by heart (Cambrian, Ordovician, Silurian, Devonian, etc.), but I can seldom recall the mnemonic device some science teachers use to help students remember the order: "Charlie Oliver Still Drives My Purple Plymouth To Jersey City Through Quicksand." If breathing were not an autonomic process, it would surely get lost in the chaos.

Sometimes this random assortment of mental odds and ends produces background noise for whatever I'm doing at a given moment. For example, as I carry a basket of laundry to the clothesline, the French word for "windshield wipers" might echo rhythmically in my mind, or the libretto of the musical *Hamilton* will merge with that of *Hair* like Jupiter aligning with Mars. Yet when I want—or need—to retrieve specific information, my mind will often trip along a poorly paved highway before trotting up a side road, only to be waylaid by a large pothole. How long it might take to arrive at the sought-after detail is unpredictable, ranging from a split second to forever.

Fortunately, the striking illustrations and vivid narratives of picture books read to me when I was little remain etched in my memory all these years later. As a child, I found the antics of talking animals dressed in pants or pinafores particularly intriguing and often instructive. I adored storybooks embellished with maps of their imaginary settings, such as *The Wind in the Willows* and *Winnie-the-Pooh*. I fondly recall those special occasions when

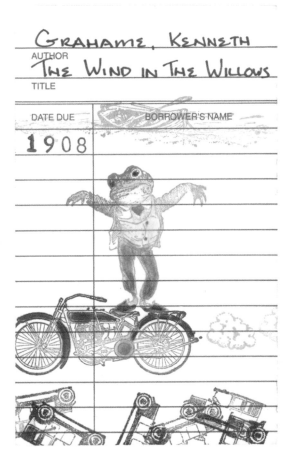

my father would read me a chapter from *The Jungle Books* at bedtime. He would mix those fictive tales with true stories about his own experiences as a radar officer on a submarine in the Pacific during World War II. Instead of putting me to sleep, all this excitement made me want to jump on a boat and go find Mowgli!

My early memories also include leafing through Classics Illustrated comics at the dentist's office as well as studying the illustrated cardboard dividers in the Nabisco Shredded Wheat boxes at breakfast time. These cards featured Straight Arrow's "Injunuity Manual." At that age I was fully engaged in the directions on how to make moccasins, identify poisonous snakes, or handle a horse. While the cereal box inserts were not bound books, they served a similar function: they entertained and informed, opening my innocent young eyes to a wide world of possible adventures. The offensive play on the word "ingenuity" was something I realized only in hindsight. Likewise, while the story of *Little Black Sambo*—and its tigers that turned into butter—taught me about bullies, it never occurred to me as a child that Sambo's name and the caricatures, especially of his parents, were insulting to both African Americans and people who live in southern India. This popular children's book was eventually banned in the 1970s for its objectionable illustrations and naming of characters, but it has since been republished with significant revisions to both its words and pictures.

During my middle school years, books provided companionship when I was bored or lonely. I remember spending hours with the March sisters in *Little Women*; their loyal support for one another still moves me. A true story—whether a biography or history—also had the power to alter my mood; when a heroine such as Anne Frank made me aware of the unimaginable hardships suffered by her family during the Nazi occupation of Amsterdam, how could I possibly feel sorry for myself? (Since her diary ends three days before the family was arrested, Anne did not record the horrors to come.)

Plate 20

ILLUSTRATION 3
Book Marks card for *The Wind in the Willows.* The endpapers in my copy show a map of Toad Hall and its surroundings.

Plate 6

Plate 49

Plate 55

Plates 125, 57

In high school my assigned reading revolved mainly around the plays of Shakespeare and novels by nineteenth-century white males (with the exception of George Eliot), as well as a long slog through Virgil's *Aeneid* in its original Latin. One June we were handed a summer reading list of one hundred titles that offered a broader scope, from which we were required to read at least three thousand pages. We were free to select whichever books we wanted, and I remember choosing, among others, *To Kill a Mockingbird*, *Brave New World*, and *The Nun's Story*. It was perhaps that summer when my eclectic reading habit began to take shape.

Plate 53

Plates 48, 63

Later, as a young wife, I moved across the country, from an East Coast bastion of white Anglo-Saxon Protestantism to Berkeley, California, a community imbued with activist energy. I delved into books written by Black Americans, including *The Autobiography of Malcolm X*, a firsthand perspective of the inequalities that African Americans continue to endure today in a society rife with racist policies. A few years later, Betty Friedan's *The Feminine Mystique* introduced me to the Women's Liberation Movement and made me question the role that had been defined for me well before I was born.

Plate 119

Plate 134

Over years of reading, I've become better informed about cultural stereotyping and the many histories we were not taught in school, not least of which are those of native peoples in America. Recently, one of these long-suppressed histories of racism was effectively recounted by journalist David Grann in his book *Killers of the Flower Moon.* He details

Plate 391

the 1920s murders of dozens of wealthy Osage people of Oklahoma in a pernicious quest to deprive them of their rights to the oil beneath their land. Another is Tommy Orange's novel *There There,* which poignantly portrays how the genocide and displacement of tribal communities still affect urban Native Americans today.

Plate 392

In recent years I have been grateful that the American publishing industry is putting out so many books by foreign authors—one notable benefit of globalization. Often these writers introduce me to the culture of a nation I have not yet visited or vastly amplify my appreciation of a country where I have already traveled. Among them are Nigerian-born Chimamanda Ngozi Adichie, Pakistani activist Malala Yousafzai, and Turkish journalist and novelist Ayşegül Savaş. (I have yet to create a card for Savaş's quietly reflective novel *Walking on the Ceiling,* but I can already envision the images I'll use for Paris and Istanbul.)

Plate 357
Plate 364

Today, my nearly seven hundred *Book Marks* cards, neatly filed in their drawers, reflect my intellectual and emotional development over seventy-odd years, roughly paralleling American history since World War II. Divider cards mark the passage of time, with each year handwritten on their tabs, starting with 1950. Whenever I prepare to insert a newly created card for a book I read some time ago, I revisit my past while searching for its proper spot in the drawers. It can feel as if I am traveling through the decades of my life, unearthing memories of people and places, book characters and locales. For this book, I wanted, if possible, to illuminate the connection between

ILLUSTRATION 4

Book Marks, **front view of library case, 2008 to present, multimedia. Solid oak case, 13 x 5 x 14 inches, made by Library Bureau Sole Makers, a company founded by "Melvil" Dewey.**

my life and this art project by recounting some of the stories these cards and the books they represent elicit for me. I did not write a straightforward memoir; instead, I pasted together a collage of remembrances of times past. Therefore, my recollections may seem as eclectic as the small art-works themselves, perhaps even as random.

The resulting autobiog-raphical chapters serve as dividers between the groups of plates, whose chronological arrange-ment corresponds with the stages of my life touched upon in the text—as a child, wife, mother, pilot, widow, or artist. By interweaving the artworks with events from my life, I hope to underscore the interplay between our experiences and our reading, and how memory shapes or reshapes each, reflecting both our lived and imagined lives.

Plate 1

Reproduced here are about half of the cards currently housed in the two wooden file drawers (mainly in an attempt to keep the size of this book manageable). These illustrated "book marks" are not simply part of an art project or a visual survey of my reading history; to me they are artifacts, tokens, and souvenirs of my lifetime, beginning with *Three Little Pigs* and moving beyond *The Sixth Extinction*. To you, these artworks may be small puzzles, providing an incentive to read or reread books in order to decipher my pictorial references. Perhaps they will also evoke memories of your favorite books and elicit your own personal stories to share with others.

PLATE 1

BANTA, M & DEMPSTER, A
AUTHOR
THE THREE LITTLE PIGS
TITLE

DATE DUE	BORROWER'S NAME
1840	

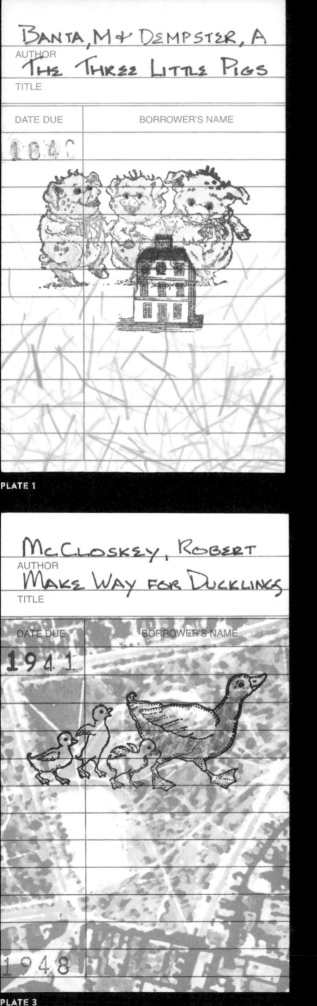

PLATE 2

POTTER, BEATRIX
AUTHOR
THE TALE OF PETER
RABBIT
TITLE

DATE DUE	BORROWER'S NAME
1904	Flopsy
	Mopsy
	Cottontail
	Peter
1904	Mr. McGregor

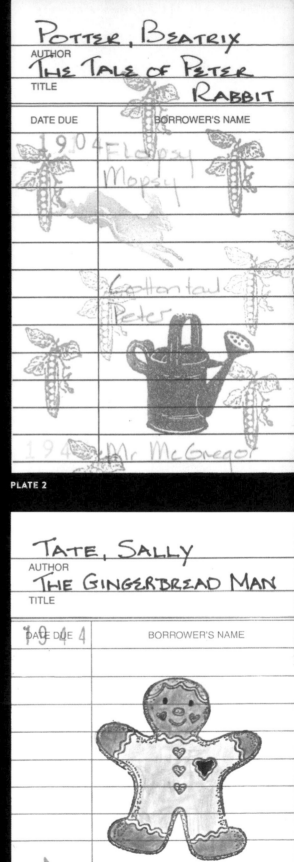

PLATE 3

McCLOSKEY, ROBERT
AUTHOR
MAKE WAY FOR DUCKLINGS
TITLE

DATE DUE	BORROWER'S NAME
1941	
1948	

PLATE 4

TATE, SALLY
AUTHOR
THE GINGERBREAD MAN
TITLE

DATE DUE	BORROWER'S NAME
1944	

Run, Run as fast as
you can. You can't
catch me. I'm the
gingerbread man.

PLATE 5

GRUELLE, JOHNNY
AUTHOR
RAGGEDY ANN STORIES
TITLE

DATE DUE	BORROWER'S NAME
1918	I LOVE YOU

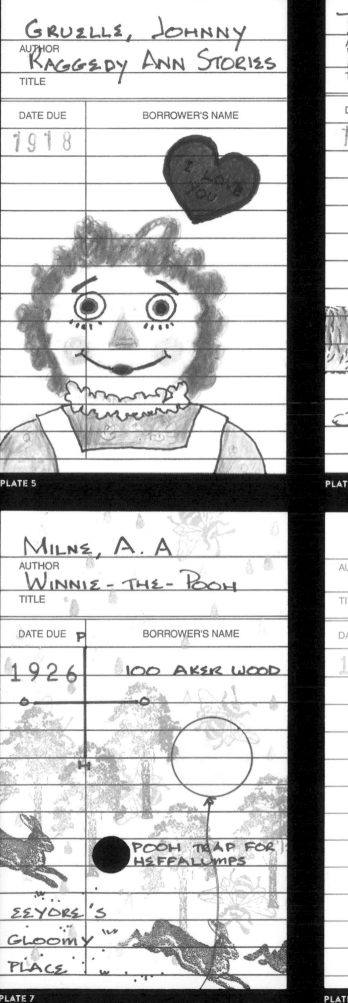

PLATE 5

PLATE 6

BANNERMAN, HELEN
AUTHOR
LITTLE BLACK SAMBO
TITLE

DATE DUE	BORROWER'S NAME
1889	

PLATE 6

PLATE 7

MILNE, A. A
AUTHOR
WINNIE-THE-POOH
TITLE

DATE DUE	BORROWER'S NAME
1926	100 AKER WOOD
	POOH TRAP FOR HEFFALUMPS

EEYORE'S GLOOMY PLACE

PLATE 7

PLATE 8

BEMELMANS, LUDWIG
AUTHOR
MADELINE
TITLE

DATE DUE	BORROWER'S NAME
1939	Miss Clavel

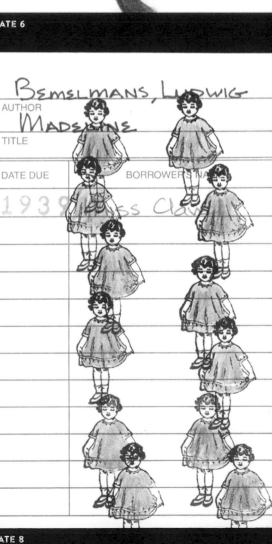

PLATE 8

GANNETT, RUTH STILES
AUTHOR
My Father's Dragon
TITLE

DATE DUE	BORROWER'S NAME
1948	

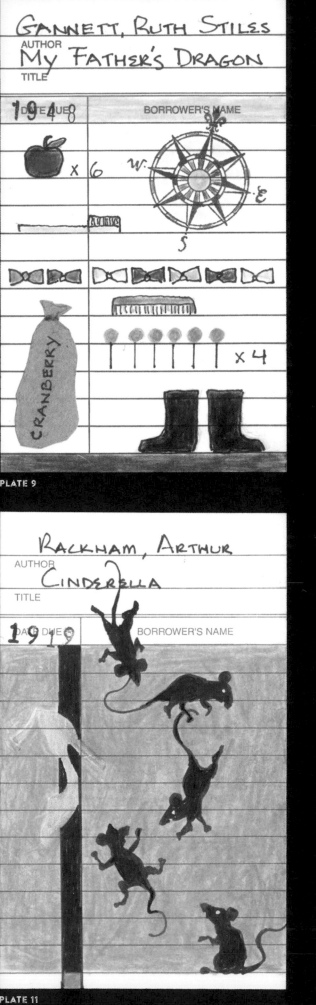

PLATE 9

WALLACE, IVY
AUTHOR
POOKIE
TITLE

DATE DUE	BORROWER'S NAME
1948	

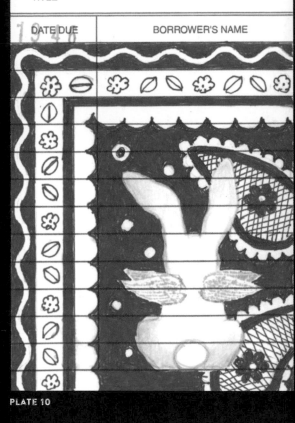

PLATE 10

RACKHAM, ARTHUR
AUTHOR
CINDERELLA
TITLE

DATE DUE	BORROWER'S NAME
1919	

PLATE 11

HOFFMANN, HEINRICH
AUTHOR
STRUWWELPETER ∼
SLOVENLY PETER
TITLE

DATE DUE	BORROWER'S NAME
1918	

PLATE 12

TRAVERS, P.L.
AUTHOR
MARY POPPINS
TITLE

DATE DUE — BORROWER'S NAME
1934

PLATE 13

GRAY, W. AND SHARP, Z.
AUTHOR
DICK AND JANE
TITLE

DATE DUE — BORROWER'S NAME
1950

SEE
SPOT
RUN

PLATE 15

BARRIE, JAMES M
AUTHOR
PETER PAN AND WENDY
TITLE

DATE DUE — BORROWER'S NAME
1911

PLATE 14

LOFTING, HUGH
AUTHOR
THE STORY OF
TITLE
DOCTOR DOOLITTLE

DATE DUE — BORROWER'S NAME
1920 Pushmi-pullyu
 Polynesia

PLATE 16

MacDonald, Betty
AUTHOR
Mrs. Piggle-Wiggle
TITLE

DATE DUE	BORROWER'S NAME
1947	
1950	

PLATE 17

Duvoisin, Roger
AUTHOR
Petunia
TITLE
The Silly Goose

DATE DUE	BORROWER'S NAME

DANGER

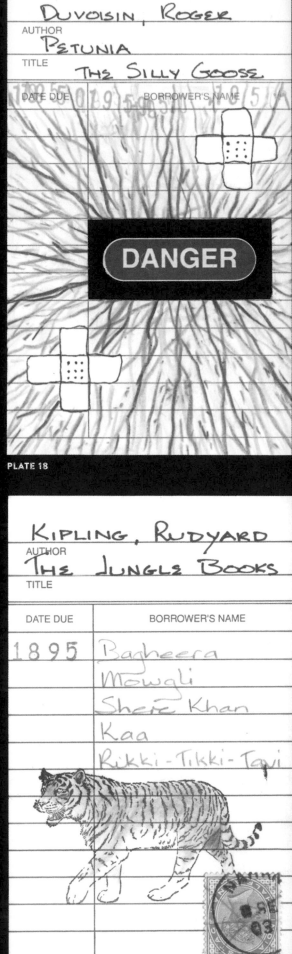

PLATE 18

Baum, Frank
AUTHOR
The Wizard of Oz
TITLE

DATE DUE	BORROWER'S NAME
1900	
1954	

PLATE 19

Kipling, Rudyard
AUTHOR
The Jungle Books
TITLE

DATE DUE	BORROWER'S NAME
1895	Bagheera
	Mowgli
	Shere Khan
	Kaa
	Rikki-Tikki-Tavi

PLATE 20

HOLLING CLANCY HOLLING

AUTHOR

MINN OF THE MISSISSIPPI

TITLE

1951

DATE DUE BORROWER'S NAME

PLATE 21

COLLODI, CARLO

AUTHOR

PINOCCHIO

TITLE

DATE DUE BORROWER'S NAME

PLATE 22

DE SAINT-EXUPÉRY, ANTOINE

AUTHOR

THE LITTLE PRINCE

TITLE

DATE DUE BORROWER'S NAME

1943

PLATE 23

J
White

White, E. B.
(Elwyn Brooks),
1899-

Stuart Little.

1945 DATE BO

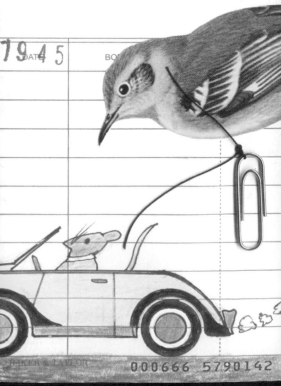

BAKER & TAYLOR 000666 5790142

PLATE 24

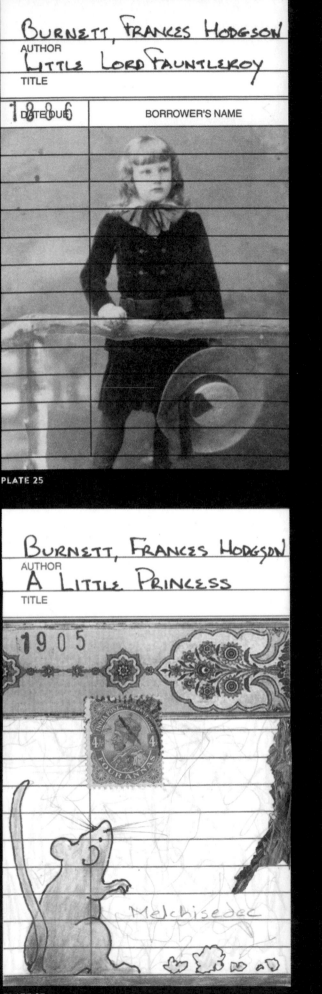

Plate 25

BURNETT, FRANCES HODGSON
AUTHOR
LITTLE LORD FAUNTLEROY
TITLE

DATE DUE	BORROWER'S NAME
1886	

PLATE 25

Plate 26

J
Burnett, Frances
The secret garden

DATE	ISSUED TO
FEB	Henderson 1
APR 5	Kenton Burr
APR 19	Winston Hopper
AUG 2	Della Shaw
MAR 2	Remi Poronz
AUG 22	Marc
APR 09	M. S
APR 23	renewed
AUG 20	Beth Wickham
SEP 09	renew
DEC 10	Taken
JUN 17	Jan Steel
JUL 01	renewed

GAYLORD 40

PLATE 26

Plate 27

BURNETT, FRANCES HODGSON
AUTHOR
A LITTLE PRINCESS
TITLE

1905

Melchisedec

PLATE 27

Plate 28

TWAIN, MARK
AUTHOR
THE ADVENTURES OF
Tom SAWYER
TITLE

DATE DUE	BORROWER'S NAME
1876	

5¢

PLATE 28

KNIGHT, ERIC
AUTHOR
LASSIE COME-HOME
TITLE

DATE DUE	BORROWER'S NAME
1940	

HENRY, MARGUERITE
AUTHOR
KING OF THE WIND
TITLE

DATE DUE	BORROWER'S NAME
1948	Earl of Godolphin

حَضَان
Sham

PLATE 29

PLATE 30

SLAUGHTER, JEAN
AUTHOR
HORSEMANSHIP FOR BEGINNERS
TITLE

DATE DUE	BORROWER'S NAME
1952	

ANDERSON, C.W.
AUTHOR
A PONY FOR LINDA
TITLE

DATE DUE	BORROWER'S NAME
1954	

PLATE 31

PLATE 32

When do childhood memories begin? I know it's well before we learn to read. Shapes and colors of beloved items are still vivid in my mind's eye: animal crackers, a cardboard kaleidoscope, and the black leather nose on the stuffed koala bear my father brought back from Australia. My favorite possession was an assortment of crayons I kept in a cookie tin. Every hue was so bright: pink, yellow, and indelibly blue. I remember once coloring in the black-and-white illustrations in my copy of the children's classic *The Story of Ferdinand*, for which I was scolded. At that time, my tin held about thirty Crayola colors. It would be several years before the box with sixty-four hues hit the market. By the time my grandchildren arrived, Crayola was manufacturing one hundred and twenty standard colors. As we age, we similarly drift toward ever more complexity as we continually sort ourselves into more specific tints and shades.

I know I was born with a "twisted" left foot, but I don't remember this. I only learned about it later from my mother while we were looking at a professional portrait taken of me seated, with my left foot oddly out of sight, beyond the photograph's border. She also mentioned that my pediatrician had told her to put a right shoe on my left foot when I wasn't wearing a brace. She was embarrassed to do so in public, since an infant with mismatched shoes might reflect badly on her parental capabilities. The anatomical defect was soon corrected, though it is hard to tell in the black-and-white photograph of my squinty-eyed, sixteen-month-old self standing on the beach, as I am wearing socks. According to family lore, I hated walking on sand in my bare feet. I don't remember this either.

ILLUSTRATION 7

Book Marks card for *The Story of Ferdinand*, banned by Franco in Spain as pacifist propaganda when it was first published in 1936.

For the first year and a half of my life, while my father was overseas serving in World War II, my mother and I lived on Faulcon Farm, a large property outside of Philadelphia belonging to my mother's parents. It was a working farm that employed several people without whom it would have been impossible to handle the day-to-day chores, especially since my grandfather had died two years before I was born and my father was away. Living in the house was Uncle Robin, a teenager then, and the three Barbaras—me, my mother, and her mother. My grandmother had been named as a whimsical allusion to Bar Harbor, Maine, where she was born.

She was Bobbie to her friends and Gammy to her grandchildren. My mother was called Babsie for short, and I was dubbed Penny. Nobody remembers the origin of my nickname, but because of it, I've always had an affinity for the shiny copper coins.

My father returned from his tour of duty after witnessing the surrender of Japan aboard the USS *Missouri* in Tokyo Bay. He joined us at Faulcon Farm, where we all lived together for three months while he coordinated the decommissioning of his submarine at the Philadelphia Naval Shipyard. With his degree in chemical engineering, he was soon hired by DuPont and posted to its plant in Western New York. Aside from peering at my sister, Carol, in her crib, I remember little of living in Buffalo. But I do clearly recall one event that, all these decades later, remains available for Technicolor replay. I was out for a walk with my babysitter, when she bought me a helium-filled balloon that, to my mind, was as big and brightly striped as Jupiter. She carefully tied the tugging string around my wrist in case I accidentally let go of my new treasure. When we returned home, I was so excited to show it off to my mother, I ran through the dining room and into the kitchen, and *BANG!!!???***!!!* The universe exploded. I burst into tears as the fat balloon collapsed into a damp rag caught between the swinging kitchen door and the doorjamb.

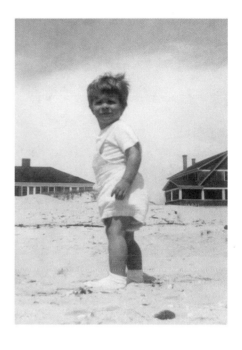

My distress brought out a rare instance of tender parenting on my mother's part. I was especially fond of A. A. Milne's stories about Winnie-the-Pooh, Eeyore, and Tigger, as were my parents. (My father's letters from "somewhere" in the Pacific to his bride always began with "Dear Piglet.") So my mother pulled from our beloved Piglet's experiences to help me overcome the trauma. In an act of sympathy, which was not a hug, she reminded me of when Piglet fell and broke the balloon that he had intended to give to Eeyore for his birthday. She then gave me an empty mug in which to put the shreds of my burst balloon, just as Eeyore had put Piglet's deflated gift in the empty honey pot Pooh had given him moments before.

After two years in Buffalo, my father was transferred to DuPont's head-quarters in Delaware. I never knew why, but my mother refused to move to Wilmington, the company town. She and my father compromised and bought a cottage surrounded by fields in the Philadelphia outskirts, midway between Wilmington and Gammy's farm. While we were settling into our new house, and for several years afterward, I was frequently deposited at Faulcon Farm to stay with Gammy for a few days or even a week. Like my mother, my grandmother was not physically demonstrative, but she was attentive and consistent, and I always knew she loved me.

Each morning Gammy retrieved her upper and lower sets of false teeth from a glass of water, fizzy with Polident, on her bedside table. She would then go down to the kitchen to arrange a breakfast tray, placing on it a cup of coffee and a bowl of cornflakes doused with heavy cream, before taking it back to bed along with that day's copy of *The Philadelphia Inquirer*. When she was eventually ready to start the day, Gammy would first define her eyebrows with a black pencil before pulling on her sickly pink girdle. (She once informed me that after I had children, I would need to wear one, too.) She would then have a smoke, choosing a Pall Mall, a Lucky Strike, an Old Gold, or a Camel. I was intrigued with the silver-lined packs, especially the one with the dromedary in front of pyramids and palm trees. This exotic image planted in me the seed of a dream, finally fulfilled a few years ago when I rode a camel in India. One day Gammy dramatically declared that smoking was a disgusting habit and abruptly quit, never to start again. I suspect she had noted my budding interest in her cigarette packs, not understanding that my fascination was only with the colorful branding.

Every evening Gammy exchanged her capris for a long brocade dressing gown and took off the wedge heels she wore even while mowing grass, replacing them with satin mules just in case some of Uncle Robin's former schoolmates showed up to visit her. After dinner she settled down in front of the television in her den, surrounded by leather-bound editions of Dickens, Trollope, Ibsen, and the Brontë sisters, many of which her father had collected. I don't remember ever seeing my grandmother read a book, but she once mentioned that Trollope was her favorite author. I can still clearly picture her knitting while watching the NBC nightly news—*The Huntley-Brinkley Report*—followed by the Philadelphia Phillies during baseball season or an episode of *Gunsmoke*, and then whatever late-night movies were playing. Gammy once told me that she maintained this nocturnal lifestyle to discourage burglars. Not that they would have escaped alive if they had broken in, as my grandmother was a former Pennsylvania skeet shooting champion with a custom double-barreled shotgun locked in a closet near the front door.

I remember many treats at my grandmother's house, including her stash of chocolate-covered peppermint wafers that she doled out, one by one, after dinner. But not everything at Faulcon Farm was as delicious as those peppermints. Occasionally Gammy would paint my fingernails with a bitter concoction to discourage me from biting them. Worse was the mandatory afternoon nap. I would stare at the blue ceiling of my small bedroom, on which Uncle Robin had glued the upper half of a model cruise ship steaming toward the northwest corner. He had painted its trailing wake in the form of

ILLUSTRATION 9

Gammy holding her shotgun at a skeet shooting competition in 1939.

progressively larger white teardrops. Eyes wide open, looking up, I wished I were traveling with Elmer Elevator and his baby dragon to Tangerina or Blueland, those magical places invented by author Ruth Stiles Gannett, who would become my friend and neighbor many years later. One afternoon, nap time involved more than daydreaming. Bored with my confinement and unable to sleep, I opened a jar of Pond's Cold Cream left sitting on the dresser in my room and finger painted the mirror, the windows, the maple bureau, and the bedstead, using up the entire contents. After that day Gammy made sure to supply dot-to-dot activity books and *The Travels of Babar* to keep me occupied while she rested. Gammy was the one who needed the nap.

Plate 9

I loved Babar's adventures, but *Make Way for Ducklings* was perhaps my favorite picture book. I was mesmerized not only by the urban exploits of Mr. and Mrs. Mallard and their eight ducklings but also by the illustrations from the point of view of a bird in flight over Boston Common. Bringing the story to life was our own pet mallard, named Honeybun, who lived with us at Faulcon Farm. Uncle Robin had found an abandoned egg one day near the barnyard and kept it warm until it hatched. The duckling quickly imprinted on Uncle Robin, following him around for the fourteen years of its notably long life.

Plate 3

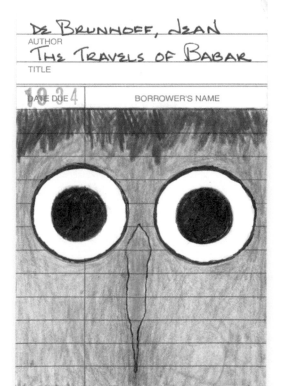

Occasionally Uncle Robin took me for a joyride in his MG T convertible. I would sit small in the passenger seat, transfixed by the red dashboard directly in front of me. My uncle would always keep our destination a secret. On one excursion we pulled into Wings Field, the local airstrip. He parked, and we walked over to the fixed-base operator to rent a Piper Cub, a small plane equivalent to the Model T in its popularity and simple, straightforward design. Uncle Robin, now about twenty years old, had been flying since he was sixteen. Back when he took his private pilot's test, the written portion of the current exam was not yet required—fortunate for someone who had undiagnosed dyslexia and couldn't read. At that time, a flight examiner probably granted certification to anyone who could fly by the seat of their pants. But my uncle's qualifications were of no concern to a five-year-old.

ILLUSTRATION 10

Book Marks card for *The Travels of Babar*, showing eyes painted on an elephant's rump.

I had never imagined myself inside an airplane, and I was now on the verge of takeoff. My body was prickling with trepidation and excitement. Uncle Robin checked the gas, buckled me into the copilot's seat beside him, and started the engine. The propeller rolled over, swiftly gained momentum, and then seemed to dissolve into thin air. We taxied to the end of the well-mown runway. He checked for traffic, swung the

plane around, and pushed in the throttle. The grass turned from blades to a blur as the seat pressed hard into my back. Suddenly we were airborne. As we gained altitude, the world below decelerated into slow motion, and the landscape settled into a giant crossword puzzle, where hedgerows divided fields into green squares and separated them from wooded lots. I had learned that Earth was round, but it now lay below me as flat as the proverbial pancake, extending in all directions before fading into a blue haze at the margins.

Uncle Robin cut the throttle, and we descended, flying low over Faulcon Farm. I could easily identify the large barn decorated with white Pennsylvania Dutch hex signs and the muddy pigsty, whose occupants appeared to be ants. Gammy's fieldstone house was smaller than a matchbox, and Lilliputian people emerged and waved their arms. Uncle Robin made a second pass and waved back with our wings. I felt slightly nauseated as the horizon tilted to the left and then back to the right. My familiar world shrank to even smaller dimensions as we climbed a mile high. (Mr. Mallard never flew at this altitude!) By the time Uncle Robin drove us back to the farm, everything had regained its former stature. My mother, who never had the courage to fly with her brother, stood in the driveway as we approached, furious that he had taken me aloft without her permission.

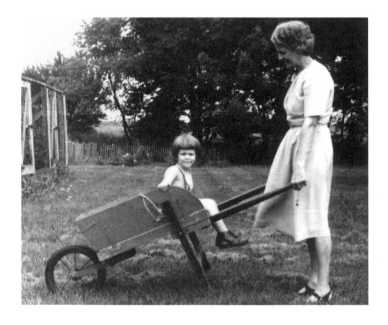

ILLUSTRATION 11

Gammy pushing me in a wheelbarrow at Faulcon Farm.

That flight was the highlight of my childhood, but almost as exciting were the hours I spent with Uncle Robin on the lawn out back, building cities out of newspaper, then undermining them with firecrackers, lighting the fuses, and running away as fast as possible. (Gammy did not approve.) Most days lacked that level of excitement and advanced at my grandmother's pace, revolving around farm chores and errands. A few of these, however, while likely mundane to adults, to me were either magical, mysterious, or menacing. Once Gammy took me to buy Buster Brown sandals. I stood on the fluoroscope, an apparatus used at the time to determine one's shoe size, and I saw the bones of my feet glowing pale green. I instantly became fascinated by the invisible made visible. What else was inside me? I vaguely remembered a picture book featuring trees and their underground systems. Maybe I had roots, too?

Farm chores were more routine and often involved preparation of the next meal. The tenant farmer—Whitey to the adults and Mr. Vincent to me—plowed, planted, and harvested acres of vegetables surrounding the farmhouse and barnyards. Gammy and I would sit on the back porch steps shelling peas and lima beans with Honeybun beside us, quacking for a handout. However minimally, I was a participant in bringing the food from field to Gammy's dining room table.

At Faulcon Farm, Julia ruled the kitchen, pantry, and adjoining sitting room, while her husband, Louis, roamed the rest of the house, vacuuming the rugs or polishing brass doorknobs and silver candlesticks. I can't be certain if I called them by their first names, which is how I remember them, but certainly the adults did. They were immigrants who had sought refuge in the United States after the Hungarian government formed a political alliance with the Germans in 1938. She was ample, and he was as lean as Jack Sprat. Julia had perfected her culinary artistry working at a restaurant in Budapest, so we were frequently treated to goulash and chicken paprikash. She constructed seven-layer chocolate cakes and conjured up apple strudel as if by sleight of hand, stretching the pastry dough over the tabletop like a sheet draped on a bed. Julia taught me how to attach a decorative nozzle to a cookie press in order to squeeze sugar-cookie dough into eight-pointed stars. I don't remember Julia using cookbooks, but she certainly initiated my lifelong interest in reading about food and eating it. (With my hearty appetite, I was never a candidate for Mrs. Piggle-Wiggle's "Slow-Eater-Tiny-Bite-Taker Cure.")

Plate 17

When I was little, Gammy would often push me around in her wheelbarrow to visit the farm animals, stopping to pry up dandelions with an asparagus "fork," cut flowers, or rake leaves, depending on the season. We would roll past the huge red barn, carrying slops to the pigs in their stinky mud wallow, before feeding the guinea fowl, chickens, and turkeys housed in their separate pens. One day I happened upon Mr. Vincent's wife wringing the neck of one of the chickens. The dots connected, and I now understood the fate of these animals: they ended up in Julia's kitchen. I knew some stories vividly portrayed animals conniving to eat up little children, but on that day, I learned it went both ways.

At some point stories describing the antics of animals that conversed in English no longer reminded me of the farmyard creatures I knew, but the tales delighted me nonetheless. I am not sure how children first learn to distinguish fantasy from reality, but in due course I came to understand that these storybook animals were human beings in disguise with lessons to teach. I still have my tiny tattered Beatrix Potter books with their charming pastel illustrations that belie the serious nature of these tales. My parents read them to me, along with other childhood classics, but I don't recall anyone reading me *Little Red Riding Hood*—maybe because I was already terrified of the wolves that lived in the woods behind my grandmother's house, not to mention the alligators under my bed.

Plate 2

Fables may blur the line between truth and falsehood, but adults are often no better. I was so gullible that grown-ups easily fooled me with old wives' tales. I believed Uncle Robin when he said that a tree would grow inside me after I swallowed a grapefruit seed. I burst into tears as I visualized leafy branches sprouting out of my ears, laden with heavy yellow fruit dangling like preposterously huge earrings. Gammy, on the other hand, firmly maintained that eating bread crusts would make my straight hair curly. Alas, I ate a lot of them, but to no avail.

Living with my parents and Carol in our cottage in the countryside was not as engaging as staying at Gammy's farm with all of her books and animals. Imagination was required to enliven the summer months, whose days drifted from fresh-hay-scented mornings to hot, humid afternoons. Time often ground to a halt, unmoved by the incessant and monotonous droning of cicadas. If it was a weekend, my sister and I might play Chinese checkers with our father, or the three of us would practice handstands in front of the house. Deft with a pencil, our father would also draw pictures of invented animals, inspired by a more or less random string of letters my sister and I eagerly recited, like O-Y-L-Y-P-I-B-B-L-E. On weekdays, my sister and I were routinely sent outside to play. If we objected, my mother would announce that she didn't want to hear any more of our guff, and out the door we would go. Keeping the house in order seemed to be her main concern and engaging with her children somewhat beside the point, though I do remember her helping me make my costume for an elementary school play. On a sheet of poster board she drew the outline of a huge conch shell, and, with our heads together, we spent hours filling in the contours with colored pencils.

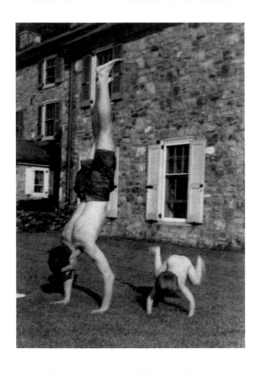

ILLUSTRATION 12

My father and I practicing handstands in the yard at Faulcon Farm, before we moved to Buffalo.

Learning to read in "Teacher Bea's" first-grade class became my ticket to a more fascinating world whenever I was bored or sent to my room. One rainy day when I was about nine years old, I retreated to a comfy armchair in the den to finish reading *Charlotte's Web*. By the last chapter I was sobbing so loudly that my mother asked what was wrong. Charlotte's death, following her valiant crusade to save Wilbur the pig from slaughter, had devastated me. But the story also brought back memories of a tragic incident that had occurred some years earlier at Faulcon Farm.

Gammy's big black slobbery Newfoundland named Tar, who outweighed me by eighty or ninety pounds, had followed me one afternoon as I set off down the very long driveway that ran between fields of corn stubble. I saw a car stopped on the road in front of us, and Tar lumbered ahead

to investigate. Without warning, the driver jumped out and shot him, and within minutes, Gammy, my mother, Uncle Robin, Julia, and Louis were running down the lane, visibly relieved to find me alive. But Tar was dead. The man mumbled his excuse: "I thought he was a bear." Gammy gathered me up in her arms and tried to console me with the concept of heaven. It was a brave gesture, considering the horrible memories the shooting must have triggered for her; six years earlier her husband had intentionally shot himself while out hunting with his springer spaniels. Adding to that tragedy, one of the dogs had licked my grandfather's wounds after he fell to the ground and, poisoned by the lead pellets, died shortly afterward. My mother once told me that she never forgave her father for the death of the dog.

Perhaps because of this, she and my father always had numerous dogs during the seven-odd years we lived in the country. The dogs often served as playmates for Carol and me, as no kids lived nearby. I remember the names of our two wire-haired dachshunds—Thistlebritches and Schatzie—and of our three poodles—Frank, Teddy, and (regrettably) Sambo—but I can't remember the name of our Irish setter. Unlike faithful Lassie, the canine heroine of *Lassie Come-Home*, he wasn't loyal and frequently ran away before he disappeared altogether. I would periodically run away from home, too, usually during a fit of temper or stubbornness. While I never got much farther than the end of our gravel driveway, I always prepared for a longer journey. My guidebook was *Pookie*, a tale about a rabbit born with useless little wings. Only published in England, the book was very popular with British children. I don't know how a copy ended up in our house, but I regarded Pookie as my role model for the carefree life of a hobo. He taught me how to pack a peanut butter sandwich in a bandana and tie the bundle to the end of a stick, hobo-style. My mother always provided the bandana.

After school, I often went to play with my classmate Alice, who lived two miles away with her parents in a house on her grandmother's farm. Alice had a piebald pony named Indian. I was jealous, as I desperately wanted a pony, too. Alice also had a lot of books passed down from her mother and grandmother. I don't remember how many books we had in our house, but I always wanted more to read, and no one ever took me to the public library. At least I didn't have to be jealous of Alice's collection, since she allowed me to use it as a lending library—without stamping any checkout cards. I still remember borrowing her copies of *Otto of the Silver Hand*, *The Story of Doctor Doolittle*, and *Hans Brinker; or, The Silver*

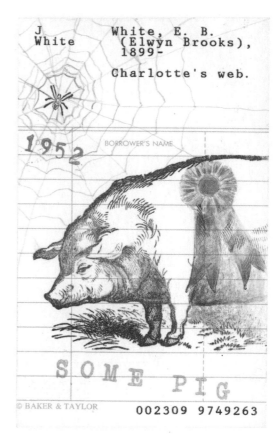

ILLUSTRATION 13
Book Marks card for *Charlotte's Web*.

Plate 10

Plate 34

Plates 16, 33

Skates. Afterward, I was terrified of the Middle Ages and happy I lived in the twentieth century, but I wanted to be able to talk with animals and hoped that one day I might win that pair of silver blades.

Mrs. D, Alice's mother, was a graceful skater whom I idolized. Watching her made me wish I, too, could dance on ice. I still remember her sitting at her sewing machine making scarlet vests and trimming black sombreros with fuzzy red balls for a Mexican hat dance number she performed at the annual carnival on ice. Likely at our urging, Mrs. D began taking Alice and me to the Ardmore skating rink for group lessons, where we earned yellow, red, and blue ribbons for our achievements. Unlike Hans Brinker and his sister, who raced long distances on frozen canals, we went around and around in circles.

Alice eventually quit skating, preferring to read, and I moved on to private lessons with Mr. Thale, a bear of a man who dressed in a full-length fur coat. His critical comments easily reduced me to tears, but in hindsight I am grateful. Learning to lay down precise figure eights and serpentines, one tracing on top of another, backward and forward, taught me body awareness and balance, both of which proved invaluable for my athletic pursuits later in life. I also believe that Mr. Thale's unrelenting emphasis on precision taught me the value of repetitive hard work in achieving one's goals—a lesson that, no doubt, aided in my artistic endeavors. While I enjoyed skating, eventually I had to decide how much time I wanted to spend on the ice. Even in the era before triple axels and product endorsements, a commitment to the sport still meant arriving at the rink at the crack of dawn. I decided to quit. Besides, I had fallen in love with horses.

In my imagination, I could transmogrify into a horse, albeit with two legs and a wilting bunch of field grass stuck into the back of my pants for a tail. I often spent all weekend cantering through the fields and jumping over fences. This "horseplay" developed into a few years of riding lessons, and, after much nagging, my parents bought me a Thoroughbred of my own. She was 16.2 hands and named Trouble. We spent a year riding cross-country together, and I never felt so big.

Plate 32

Plate 30

I also passed many hours copying C. W. Anderson's exceptional drawings in *A Pony for Linda*, a book about another girl who was crazy about horses. I read *King of the Wind* and brooded over the mistreatment of Sham, an Arabian stallion who, in his old age, finally reaps the respect and recognition due him when his offspring prove to be exceptionally fast. That book made me yearn to be a racehorse sprinting down the backstretch to the finish line. Thirty years later my mother pointed out that she had raised me to be a Thoroughbred, but I turned out to be a workhorse.

ILLUSTRATION 14

Opposite, jumping in a competition at age 9.

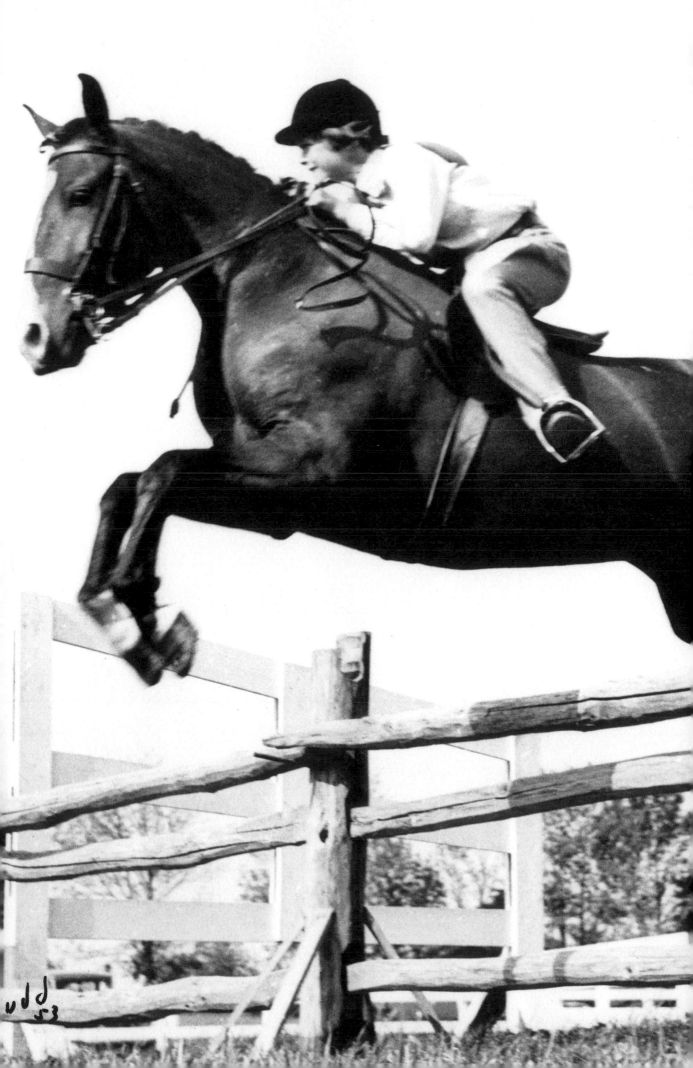

DODGE, MARY MAPES
AUTHOR
HANS BRINKER:
TITLE
OR, THE SILVER SKATES

DATE DUE	BORROWER'S NAME
1865	

PLATE 33

PYLE, HOWARD
AUTHOR
OTTO OF THE SILVER
TITLE
HAND

DATE DUE	BORROWER'S NAME
1888	
1956	

PLATE 34

KIERAN, JOHN
AUTHOR
AN INTRODUCTION TO
TITLE
NATURE

DATE DUE	BORROWER'S NAME
195	

PLATE 35

COLUM, PADRAIC
AUTHOR
THE CHILDREN OF ODIN
TITLE

DATE DUE	BORROWER'S NAME
1920	

PLATE 36

NORDHOFF, C. AND HALL, J
AUTHOR
MUTINY ON THE BOUNTY
TITLE

DATE DUE	BORROWER'S NAME
1932	
1958	Fletcher Christian
	Captain Bligh

PLATE 37

NORDHOFF, C AND HALL, J
AUTHOR
MEN AGAINST THE SEA
TITLE

DATE DUE	BORROWER'S NAME
1933	

PLATE 38

GILBRETH, F & CAREY, E.
AUTHOR
CHEAPER BY THE DOZEN
TITLE

DATE DUE	BORROWER'S NAME
1948	

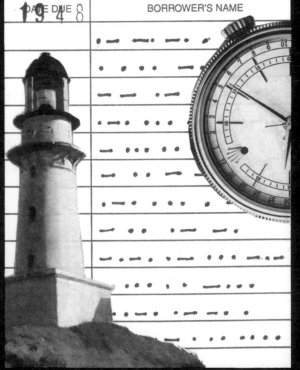

PLATE 39

STEVENSON, ROBERT LOUIS
AUTHOR
TREASURE ISLAND
TITLE

DATE DUE	BORROWER'S NAME
1883	Long John Silver

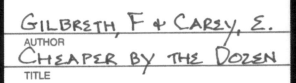

PLATE 40

LORD, WALTER
AUTHOR
A NIGHT TO REMEMBER
TITLE

DATE DUE	BORROWER'S NAME

1955

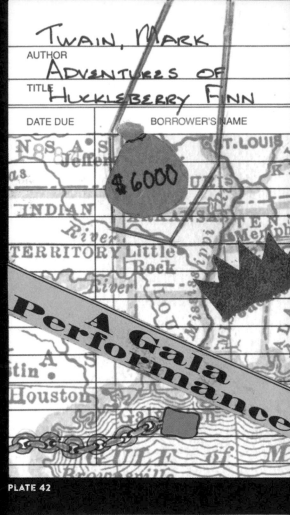

APR 14 P.M. 1912

FINEST & FASTES

PLATE 41

TWAIN, MARK
AUTHOR
ADVENTURES OF
TITLE **HUCKLEBERRY FINN**

DATE DUE	BORROWER'S NAME

$6000

A Gala Performance

PLATE 42

VERNE, JULES
AUTHOR
AROUND THE WORLD
TITLE **IN EIGHTY DAYS**

DATE DUE	BORROWER'S NAME

1873

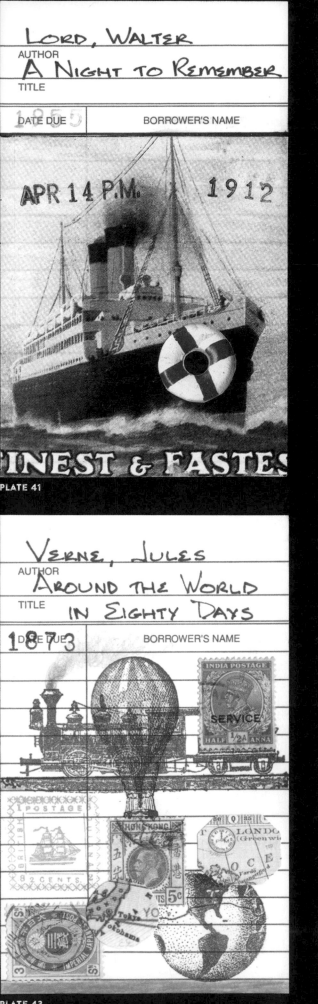

PLATE 43

F
Dumas

Dumas, Alexandre,
1802-1870.

The three
musketeers.

1884

BORROWER'S N

© BAKER & TAYLOR

000957 6379285

PLATE 44

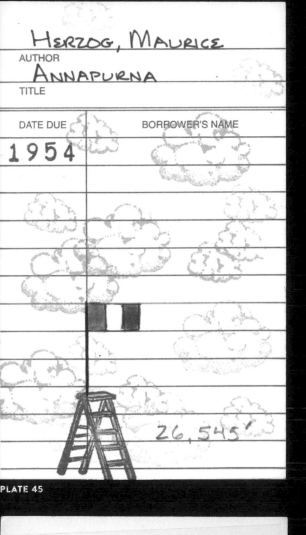

HERZOG, MAURICE
AUTHOR
ANNAPURNA
TITLE

DATE DUE	BORROWER'S NAME
1954	

26,545'

PLATE 45

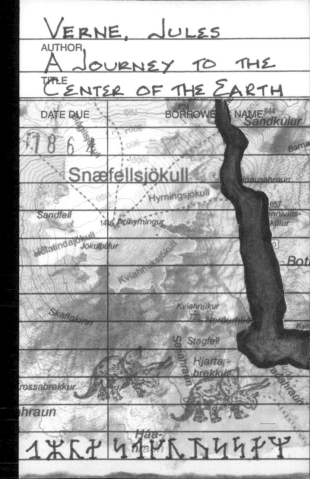

VERNE, JULES
AUTHOR
A JOURNEY TO THE
TITLE
CENTER OF THE EARTH

DATE DUE	BORROWER'S NAME
1864	Sandkúlur

Snæfellsjökull

PLATE 46

910.4
Heyerdahl, Thor
Kon-Tiki

ISSUED TO

F Huxley
Huxley, Aldous, 1894-1963
Brave new world /
Harper & Row,
c1946.

1932

ISSUED TO

THE YEAR OF OUR FORD

682

ALCOTT, Louisa May
AUTHOR
LITTLE WOMEN
TITLE

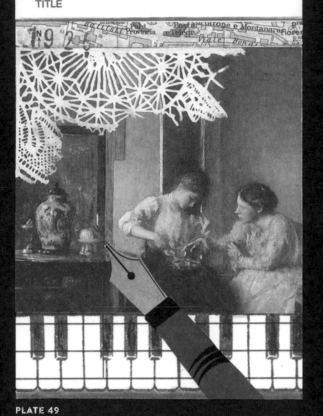

PLATE 49

F
Crane Crane, Stephen,
 1871-1900.

 The red badge of
 courage.

DATE BORROWER'S NAME

1895

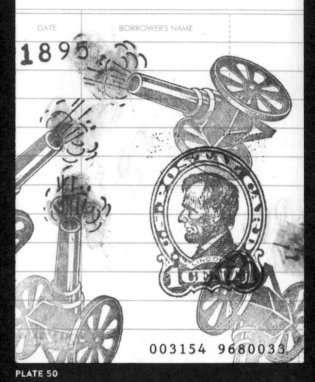

003154 9680033

PLATE 50

F
Orwell Orwell, George,
 1903-1950.

 1984.

DATE BORROWER'S NAME

1949 BIG BROTHER

WAR IS PEACE
© BAKER & TAYLOR 001313 9663775

PLATE 51

ORWELL, GEORGE
AUTHOR
ANIMAL FARM
TITLE

DATE DUE BORROWER'S NAME

1945

PLATE 52

PLATE 53

F
Lee

Lee, Harper.

To kill a
mockingbird.

PLATE 53

PLATE 54

F
Mitchell

Mitchell,
Margaret, 1900-
1949.

Gone with the
wind.

20 inch waist

PLATE 54

PLATE 55

940.54
Frank, Anne, 1929-1945.
The diary of a young girl;
(Doubleday)

DATE	ISSUED TO
DEC 13 '80	
DEC 27 '80	
JUN 8 '81	
AUG 8 '81	
AUG 22 '81	
APR 24 '8?	

PLATE 55

PLATE 56

940.54
Hersey, John
Hiroshima.

DATE	ISSUED TO
MAR 1 78	O 1157?
2 79	O 12422
APR 28 79	OJ 51
FEB 29 80	
APR 28 80	
JUL 20 96	

1946

PLATE 56

PLATE 57

873
Virgil

Virgil.

The Aeneid.

1900 BORROWER'S NAME

ILLE ego, qui quondam gracili mo
carmen, et egressus silvis vicina coeg
at quamvis avido parerent arva colon
gratum opus agricolis, at nunc horre
arma virumque cano, Troiae qui prim
Italiam fato profugus Lavinaque veni
litora—multum ille et terris iactatus
vi superum, saevae unonis
multa quoque et bell m co
inferretque deos La nde
Albanique patres at oenia
Musa, mihi causas memora, quo n
quidve dolens regina deum tot volve
insignem pietate virum, tot adire lab
impulerit tantaene animis

DIDO

003418.9715414

PLATE 58

WILDE, OSCAR
AUTHOR
THE PICTURE OF DORIAN GRAY
TITLE
1930 DATE DUE BORROWER'S NAME

PLATE 59

BRONTË, CHARLOTTE
AUTHOR
JANE EYRE
TITLE
1847 DATE DUE BORROWER'S NAME

PLATE 60

SWIFT, JONATHAN
AUTHOR
GULLIVER'S TRAVELS
TITLE
1735 DATE DUE BORROWER'S NAME

Lilliputs
Brobdingnags

Yahoos
Houyhnhnms

MASTERS, EDGAR LEE

AUTHOR

SPOON RIVER ANTHOLOGY

TITLE

DATE DUE	BORROWER'S NAME
1916	

PLATE 61

DATE BORROWERS

1946

002925 7211473

PLATE 62

HULME, KATHRYN

AUTHOR

THE NUN'S STORY

TITLE

DATE DUE	BORROWER'S NAME
1956	

PLATE 63

WHARTON, EDITH

AUTHOR

ETHAN FROME

TITLE

DATE DUE	BORROWER'S NAME
1911	

PLATE 64

PLATE 65

FITZGERALD, F. SCOTT
AUTHOR

THE BEAUTIFUL AND
THE DAMNED
TITLE

DATE DUE	BORROWER'S NAME
1922	

PLATE 66

SPARK, MURIEL
AUTHOR

THE PRIME OF MISS
JEAN BRODIE
TITLE

DATE DUE	BORROWER'S NAME
1962	

PLATE 67

SHAKESPEARE, WILLIAM
AUTHOR

MACBETH
TITLE

DATE DUE	BORROWER'S NAME
1603	

PLATE 68

MAUGHAM, SOMERSET
AUTHOR

OF HUMAN BONDAGE
TITLE

DATE DUE	BORROWER'S NAME
1915	

HAWTHORNE, NATHANIEL
AUTHOR
THE SCARLET LETTER
TITLE

1850 DATE DUE | BORROWER'S NAME

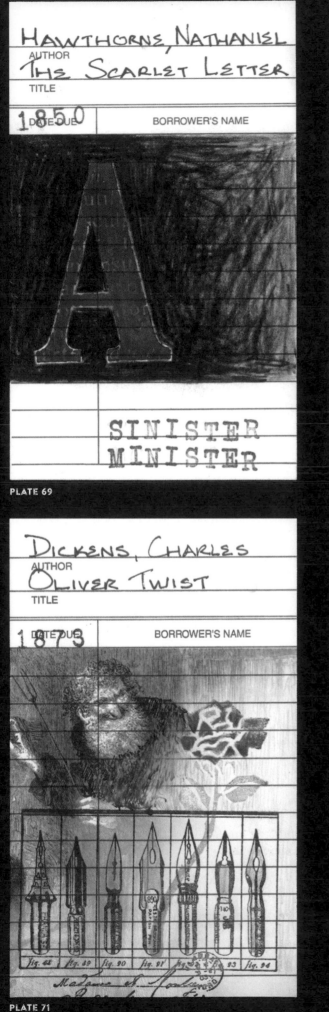

SINISTER
MINISTER

PLATE 69

STEINBECK, JOHN
AUTHOR
OF MICE AND MEN
TITLE

DATE DUE | BORROWER'S NAME

1937

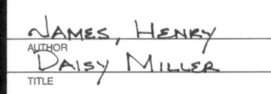

PLATE 70

DICKENS, CHARLES
AUTHOR
OLIVER TWIST
TITLE

1873 DATE DUE | BORROWER'S NAME

PLATE 71

JAMES, HENRY
AUTHOR
DAISY MILLER
TITLE

1879 DATE DUE | BORROWER'S NAME

PLATE 72

PLATE 73

F
Salinger

Salinger, J. D.
(Jerome David),
1919-2010.

Franny and
Zooey.

1955 BORROWER'S NAME

© BAKER & TAYLOR

004802 9572719

PLATE 74

LAWRENCE, D.H.
AUTHOR
LADY CHATTERLY'S LOVER
TITLE

DATE DUE	BORROWER'S NAME
1960	
	ARSE

PLATE 75

Metalious, Grace
AUTHOR

Peyton Place
TITLE

DATE DUE	BORROWER'S NAME
1956	Selena Cross
	Allison MacKenzie

p. 91

p. 365

PLATE 76

F
Dreiser

Dreiser,
Theodore, 1871-
1945.

An American
tragedy.

DATE BORROWER'S NAME

ADIRONDACK 005910 9558252

PLATE 77

ΟΜΗΡΟΥ
AUTHOR
ΟΔΥΣΣΕΙΑ
TITLE

DATE DUE BORROWER'S NAME
1964

PLATE 78

MOORE, J.A
AUTHOR
GREEK LYRIC POETS
TITLE

DATE DUE BORROWER'S NAME
1965

PLATE 79

ΕΥΡΙΠΙΔΟΥ
AUTHOR
ΜΗΔΕΙΑ
TITLE

DATE DUE BORROWER'S NAME

PLATE 80

RENAULT, MARY
AUTHOR
THE KING MUST DIE
TITLE

DATE DUE BORROWER'S NAME
1958

PLATE 81

SKINNER, B.F.
AUTHOR
WALDEN TWO
TITLE

DATE DUE	BORROWER'S NAME
1948	

PLATE 82

GRIFFIN, JOHN HOWARD
AUTHOR
BLACK LIKE ME
TITLE

DATE DUE	BORROWER'S NAME
1961	

PLATE 83

PASTERNAK, BORIS
AUTHOR
DR. ZHIVAGO
TITLE

PLATE 84

RAND, AYN
AUTHOR
ANTHEM
TITLE

DATE DUE	BORROWER'S NAME
1938	Ego 5-3992
	Equality 7-2521
	Fraternity 2-3503
	Solidarity 9-6347
	Collective 0-0009
	Alliance 6-7349
	International 4-8818
	Harmony 5-3000
	Liberty 5-3000

GALSWORTHY, JOHN
AUTHOR
THE FORSYTE SAGA
TITLE

DATE DUE	BORROWER'S NAME
1906	

PLATE 85

SHUTE, NEVIL
AUTHOR
A TOWN LIKE ALICE
TITLE

DATE DUE	BORROWER'S NAME
1950	

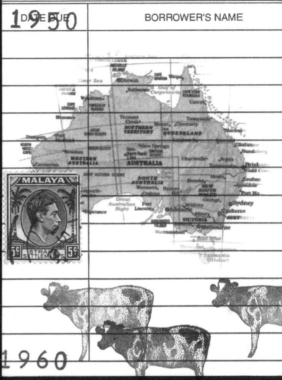

1960

PLATE 86

HEMINGWAY, ERNEST
AUTHOR
A FAREWELL TO ARMS
TITLE

DATE DUE	BORROWER'S NAME
1929	

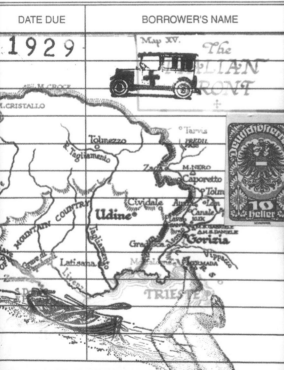

PLATE 87

AMIS, KINGSLEY
AUTHOR
LUCKY JIM
TITLE

DATE DUE	BORROWER'S NAME
1953	

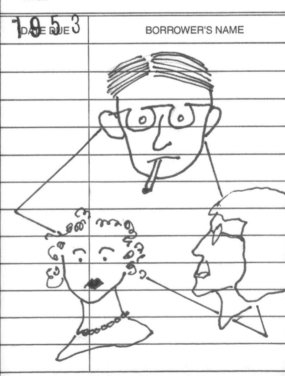

PLATE 88

I was nine when my brother, Cro, was born. While still in the maternity ward, my mother was told by the doctor that her swollen thyroid gland indicated a serious cancer threat and needed to be removed. She had been one of many infants in America to receive radiation to shrink an enlarged thymus gland, under the misguided belief that they might otherwise suffocate. This treatment was standard policy throughout the first half of the last century, before the medical establishment concluded that the procedure was entirely unnecessary and increased the likelihood of thyroid cancer later in life. A mere few days after childbirth, my mother underwent surgery, marking the first of her periodic hospital stays.

After the operation, my mother was left listless, prone to tears, and even delusional, and thus incapable of caring for an infant, let alone coping with the rest of us. She was sent away to recuperate at a psychiatric hospital, and my baby brother was entrusted to Gammy's care. By that time Gammy was living in a new house only a few miles from my paternal grandparents, Muzzy and Pop-Pop, where Carol and I were deposited. No doubt my sister and I would rather have stayed with Gammy, who, despite the move, had retained her familiar habits, furniture, books, and our individual toy chests. But, with our baby brother, Gammy had her hands full of diapers and bottles, and so we began a prolonged stay in a house where we had rarely even spent the night.

My father probably slept at our home by himself during the workweek, but I don't remember. Nor do I remember exactly how long my mother was in the hospital. Over a year, by my present calculations. My father eventually sold our house and my horse. I don't remember my exact reaction to the displacement, but I remember feeling ambivalent toward Muzzy, since my mother was openly critical of her mother-in-law. My brittle yet beautiful mother was a crystal with many facets, both light and dark, and I had never been able to predict which face she would turn to me or others. She could be beastly behind people's backs, cranky with her family, and then perfectly charming in the company of her friends. Once, to win my mother's approval, before our family was torn apart, I had formulated a complaint about Muzzy, but that strategy backfired and ended with a dressing down for my bad manners and ingratitude.

Muzzy was a socialite who played bridge, belonged to a golf club, couldn't boil an egg (according to my mother), and hosted cocktail parties that exacerbated her husband's predilection for alcohol. Pop-Pop, who had recently retired, was taking painting lessons and had set up an easel in their ill-lit basement. For my tenth birthday, while my sister and I were still living with them, Pop-Pop gave me a paint-by-numbers kit with the outline

of a horse's head printed on canvas board. I would sometimes paint in the basement with him, at least when he wasn't staying at Connecticut's Silver Hill Hospital for a couple of weeks to "dry out." No one ever fully explained the reason why Pop-Pop periodically disappeared, nor why my mother was absent for so long.

During this period of upheaval, Muzzy didn't curtail her social activities to look after Carol and me. Just as she had entrusted her own children to servants, so she did with us. She hired a driver to take us to school, and after school was dismissed, we happily joined Muzzy's two sprightly maids—spinster sisters Mary and Lizzy—for tea and shortbread. Mary prepared the meals, and Lizzy served them and did the housework. (I didn't understand why we were allowed to call them by their first names, since we were required to address most adults as "Mr." or "Mrs.") They both swallowed the letter "r," an effect of their lilting accent. I once asked them if they were Scotch. Mary replied that Scotch was a drink and that she was Scottish. During Sunday lunches with our grandparents, Lizzy magically appeared at the end of each course with more platters of food. I eventually discovered a buzzer hidden under the dining room rug that Muzzy pressed with her toe, summoning Lizzy when our plates were empty.

Muzzy saw our temporary stay in her home as an opportunity to turn my sister and me into proper young ladies, though I wouldn't appreciate her fancy tea parties and gracious conversational skills for years. She emphasized manners at the dinner table, including tipping the shallow soup bowl away while spooning up the last drops. I was required to curtsy when introduced to grown-ups and had to attend dancing class on Tuesday afternoons to learn the waltz and fox-trot. Church was mandatory, as were the white gloves and hats we wore there. (Muzzy had promised God that she would attend services every Sunday if my father survived the war.) When I later read *Little Women*, I would think about the sermons on good behavior that salted the narrative and decide to emulate the domestic tendencies of Meg if I ever got married, but at this stage in my life Jo's feisty independence would have been much more compelling.

My tomboy tendencies were somewhat stifled living with Muzzy and Pop-Pop in their suburban neighborhood, though I still spent hours constructing a makeshift dam at a nearby stream. No longer free to roam beyond property lines, I largely resigned myself to homework and reading books borrowed from Gammy's library whenever we paid her and Cro a visit. I loved browsing

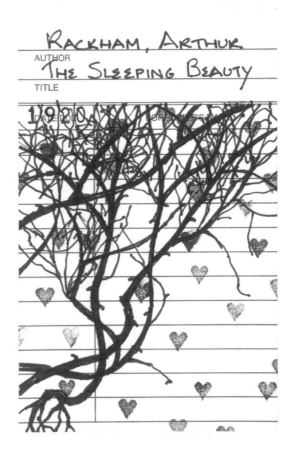

ILLUSTRATION 15

Book Marks card for *The Sleeping Beauty*, one of the books I have from Gammy's library (a treasured 1920 edition).

Plate 49

Illustration 15

Plate 40

Plates 37, 38

Plate 41

among her children's books and finding such treasures as *The Sleeping Beauty* with the lively black-and-white silhouettes by Arthur Rackham. I raced through the tales of mutineers and buccaneers in *Treasure Island* and *The Bounty Trilogy* and was awed by the characters' survival tactics and feats of endurance. My favorite novel was *The Yearling*, the poignant story of a young boy named Jody, his pet deer, and the complicated resolution of his conflict with his father (named Penny, like me). In my imagination, I transformed my grandparents' backyard into the Florida scrub described in the novel while I attempted to reconstruct Jody's fluttermill—a small waterwheel—down by the stream near the dam. I also spent time in the school library, where I discovered popular histories, such as *A Night to Remember* about the sinking of the RMS *Titanic* in 1912. I found these accounts of events that had actually happened especially engaging; they made me wonder how I would act in similar circumstances.

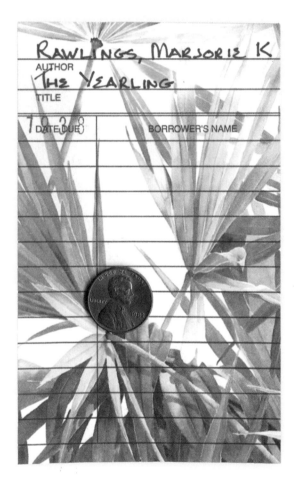

ILLUSTRATION 16

Book Marks card for *The Yearling*.

After nearly a year of conforming to Muzzy's regimen, my sister and I were enrolled in a summer camp for two months. We were sent by train three hundred miles north to New Hampshire, with Lizzy as chaperone. After our arrival at the camp, I was so upset at having yet another environment, as well as a bevy of strangers, to adapt to that I wanted my usually irksome sister to stay with me in my cabin. (So much for Jo's feisty independence!) However, since we were assigned to different quarters based on age, that was not a possibility. To assuage my general anxiety, I was encouraged to ride the white pony housed in the camp's stable, a weak antidote for the recent sale of my own horse. Our father and Muzzy drove up to see us just once, and for weeks I wrote pathetic letters to my mother, whom I had rarely visited in that grim institution where she was staying, with its locked doors, comatose inmates, and pallid green walls. I was homesick for a home that no longer existed.

By the time I learned to dog paddle, maneuver a canoe, and make a hula skirt out of reeds, summer was over. My father had bought a house around the corner from Muzzy and Pop-Pop, and we were all reconstituted as a family, but the secrets and innuendos about my mother's recent absence left me groping in the dark. While I had the impression that my friends' families were "normal," I had no idea what epithet could describe mine. It appeared that a prim facade was to be maintained no matter what, and troubling issues were swept under the rug. I doubt my parents ever would have considered them the business of a family therapist.

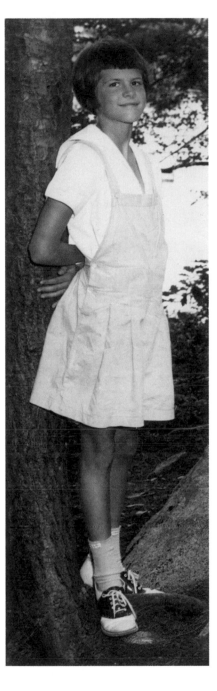

Communication with my parents seldom went beyond reprimands. They didn't particularly encourage us to discuss our school days, let alone the facts of life, race, or religion. A friend once noted the lack of conversation at our dinner table, aside from my little brother babbling about his favorite literary character, the Gingerbread Man. What she didn't witness was the frequent bickering between my parents, likely due to differences not only of opinion but also of temperament. Though prone to angry outbursts, my father operated under the laws of logic and scientific rigor. In contrast, reasoning was not my mother's strong suit. Aside from her erratic behavior, she drifted off topic, interrupted conversations, and stuck to her convictions no matter how much evidence was presented to the contrary. Interchanges between my parents further deteriorated after my father contracted multiple staph infections that left him practically deaf. "Speak up, Babsie" became their marriage refrain. Despite this impairment, my mother never broke her lifelong habit of mumbling background commentary while my father was on the telephone, making it impossible for him to hear the person on the other end of the line, let alone what my mother was saying.

Plate 4

ILLUSTRATION 17

At summer camp, age 10, during my mother's first hospitalization.

My father asked me once, when I was a teenager, if he should get a divorce. I was stunned. Despite my burgeoning rebellious attitude toward the stodgy and insular community we lived in, I still couldn't fathom the disgrace divorce would bring to our family, not to mention eviction from the *Social Register*, the hallowed directory that sorted Main Line society into an exclusive pecking order. If I said yes, would it make us outcasts? I can't remember how I replied, but my parents remained together until my father's death, their marriage lasting sixty years, excluding a two-year separation prompted by an ugly episode during one of my mother's breakdowns after we three kids had left home.

The interactions between my parents were not the only source of stress in the household. My sister and I also had a good many arguments, particularly over whose turn it was to feed the dogs. In addition, when Carol was mad at me, she shut me out by refusing to speak to me. Once, in retaliation, I poked her leg with a pencil, hard enough to leave a tiny piece of its tip under her skin. It did nothing to change her behavior. The silent treatment continued. To compensate, I found plenty of interesting conversations in novels. In particular I recall the cruel exchanges among the boys in *Lord of the Flies* as their attempts at self-governance deteriorate into sadistic warfare, again making my problems seem slight by comparison.

Plate 62

Over the years, school, with its set curriculum and specific homework assignments, gave me much-needed structure, countering my mother's lack of direction and unpredictable outbursts. I was comfortable following rules. Logical systems appealed to me. I dutifully studied Latin conjugations and declensions before plowing through the *Aeneid*. Geometry attracted me, not only for its postulates, theorems, and proofs, but also for its visual component, though I was put off by Mr. Tom, our math teacher, who had lips the color of Silly Putty and leered at his audience of adolescent females.

From second grade through high school, I attended Agnes Irwin, a private school for girls, where I was called Barbara, not Penny. In the elementary grades, I welcomed breaks for kickball and Simon Says, and the cafeteria food was delicious, except for boiled cabbage, which I have always hated. Segregation by gender made no immediate impression on me, but I soon recognized that a major benefit of attending an all-girls school was active and full participation in sports: field hockey, basketball, and lacrosse. It would be almost ten years after I graduated from high school before Title IX mandated equal athletic opportunities for boys and girls in all schools, public and private, that received federal funds.

SPORTS LIBRARY FOR GIRLS AND WOMEN

Field Hockey-Lacrosse
GUIDE

SEPTEMBER 1964 – SEPTEMBER 1966

THE DIVISION FOR GIRLS AND WOMEN'S SPORTS
American Association for Health, Physical Education, and Recreation

ILLUSTRATION 18

The cover of a book on regulations I still have from college—a very dry read about my two favorite sports.

Among the detractions of some girls' schools in the 1960s were subpar science classes, with physics totally absent from the curriculum. The launch of Sputnik in 1957, which inspired an intense emphasis on technology and engineering in schools across the country, had not yet made an impact on our faculty. In the eleventh grade, our incompetent chemistry teacher, who had just been hired, was fired. When the headmistress stepped in to teach the class, she dismissed the periodic

Plate 64

table and substituted *Ethan Frome*, Edith Wharton's tale of a twisted love affair, for the basic elements. Miss Lent, our English teacher, assigned novels and poetry written exclusively by British authors: Shakespeare, Sir Walter Scott, William Makepeace Thackeray, and George Eliot, the pseudonym of Mary Ann Evans. We endured Miss Lent's lengthy, short-answer quizzes that required us to remember obscure place-names in England and the definitions of such antiquated terms as "eleemosynary." Based on our assigned reading, the geography of literature appeared to center around Europe, and most of the selections were written before nineteen hundred. We began by reading Julius Caesar's "Gaul is a whole divided into three parts" but never seemed to arrive at a world I recognized. Most memorable of the books we read was *A Tale of Two Cities*. Just like Gammy, Madame Defarge was adept with knitting needles; however, Defarge was not knitting baby blankets. She was stitching the names of aristocrats to be beheaded in the course of the French Revolution.

During my last two years of high school, my sister and I lived with Gammy. The summer before eleventh grade, my father had started a job at a chemical plant in New Jersey and moved nearby with my mother and brother. He gave me his old Hillman Minx for transportation to and from school and to drive Carol and me to our parents' house for weekend visits. Living with my grandmother and attending a private school for girls had many advantages, but both also contributed to my naive notions and largely unexamined life. There was never any discussion of careers. Both Carol and I were expected to put in a few years at a women's college, get married, and have kids. As a fourteen-year-old who was petrified by the permutations of the dating game, I found any sort of romance unlikely. On the rare occasion when a boy called me on the weekend and my mother answered the phone, she didn't summon me with her usual "Penny," but instead shouted, "Barbara," as if to give fair warning of a foreign invasion. I had developed a few casual friendships with boys, but as far as I was concerned, they were a different species. The boys I met appeared to be either complete jerks outfitted with white socks, pimples, and stupid jokes, or they were attractive, suave, and out of my reach. There was nothing to do about it but hug my pillow and listen to the forty-fives in my record case—recordings by crooners Elvis Presley, Pat Boone, Bobby Vinton, the Fleetwoods, and the Everly Brothers—and "dream, dream, dream."

While pretending not to care about boys, we girls, wearing saddle shoes and shapeless blue-and-yellow school uniforms, were curious about the opposite sex and sex itself. At school, we had no formal instruction on

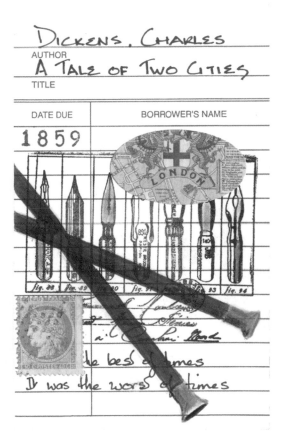

ILLUSTRATION 19

Book Marks card for *A Tale of Two Cities*.

what was sometimes referred to as "funny business" and were completely ignorant of prophylactic devices. In fact, we were ignorant about very many things. I avoided wearing green and yellow together because they were considered "fairy" colors by my cohort in high school, but I had no idea what that implied. Our extracurricular, and surreptitious, reading would eventually open our eyes to adultery and other taboos, preparing some of us for dubious duets and obtuse triangles later in life. When a copy of Grace Metalious's *Peyton Place*, a high-class potboiler, somehow fell into our hot little hands, we noticed that the upper corners of pages 91 and 365 had been dog-eared to indicate the steamiest sections. I read only those pages in the short time that the book remained in my possession. Later, a classmate passed me a copy of *Lady Chatterley's Lover*, just released after having been banned for obscenity. I hid it under my pillow at Gammy's house and read it at night, contemplating its use of "arse." What, exactly, was Lady Chatterley doing with her lover? The ins and outs of the racy fiction we read certainly augmented the various fabrications passed around among my classmates, but lack of guidance from my parents left me confused and bewildered. And then I hit sweet sixteen.

Plate 75

Plate 74

In the spring of my junior year, one of my schoolmates invited me to spend the night. She lived in a dilapidated Victorian house resembling the haunted mansion in The Addams Family cartoons. I was cautioned to walk lightly on the creaking floorboards in my friend's third-floor room lest we wake her mother napping in the bedroom below. Besides her three siblings living at home, my friend had an older brother, George, who was away at boarding school. After playing Parcheesi, we sat down to a dinner of chipped beef on toast, with milk poured into blood-red glasses. During the meal my friend's mother referred adoringly to George, calling him a mathematical and musical genius. He seemed like a ghost, absent but present at the same time.

Soon after that sleepover, I met George himself at a party. He wore glasses, was a good dancer, and played the piano proficiently. He idolized Beethoven, whose sonatas he practiced and later performed in recitals, including the "Appassionata" and the "Waldstein." I didn't immediately capture his undivided attention, but at some point he asked me out for what would be my first slice of pizza. On one of our early dates, George and I sat side by side on a piano bench as he patiently coached me through some Bach fugues transcribed for piano with four hands. At least I could read sheet music, thanks to Tune Up, a remedial class for students like me who couldn't carry a tune. George was a good catch, and I eventually caught him.

Since George was now away at college and I was still in high school, we didn't see each other often. Nevertheless, I floated around in a romantic fog perpetuated by his lengthy, amorous letters, occasional phone calls, and a trip by train to visit him at Dartmouth for Winter Carnival. That frigid weekend George introduced me to his friends, one of whom crowned

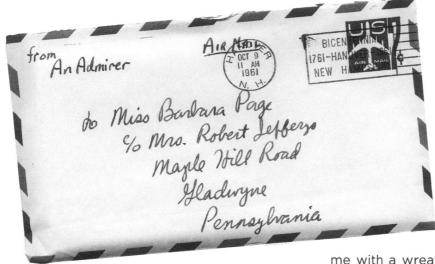

me with a wreath he had made out of evergreen boughs. My astonishment reached its pinnacle when George presented me with an intricate wooden necklace whose smooth oval links he had carved, unbroken, out of a single block of black cherry. Both gifts made me feel like a wood nymph resurrected from Greek mythology. Late that night, after the festivities, George escorted me back to the home of his piano teacher, where I was staying that weekend. He came inside, and we spent a few hours together in the spare bedroom—our first opportunity to experiment a bit with our bodies and yet a far cry from the fast-paced hookup culture of today. His teacher noticed George slipping out of her house before dawn and, I would later learn, was furious. The next morning, she didn't say anything to me when I thanked her for her hospitality.

Shortly after I went off to college, George and I broke up for several months. I was feeling overwhelmed by calculus and Aristotle, and George was putting pressure on our relationship with ever-increasing demands for going beyond "third base." I empathized with Roberta, the heroine in Theodore Dreiser's *An American Tragedy*, who wrestled with being typecast as a "bad girl" if she yielded to her lover. Guilt, remorse, and fear of getting pregnant sometimes overshadowed the thrill of making out with George, but I dreaded losing a relationship that might lead to marriage. After all, wasn't that the goal to strive for? And so I caved.

Plate 76

The summer after my freshman year of college I was working as a counselor at a camp in New Hampshire when I phoned George and anxiously described my suspicious morning sickness. To his credit, and my relief, he took on the responsibility of telling my parents that I might be pregnant, at the same time requesting that we get married as soon as possible. My mother arranged for me to come down to Philadelphia to see the doctor who had delivered me nineteen years earlier. Until that appointment I had never heard the expression "one-night stand." The general disapproving atmosphere in the room lessened a bit when the doctor learned I was in a committed relationship. Faced with an unmarried woman from a family with a reputation to preserve, he provided me with information about having an abortion. No doubt it was illegal at the time, but that didn't seem to matter.

When the doctor confirmed what we all knew, I remember my father smiling as he said, "So, I am going to be a grandfather." Gammy, on the other hand, greeted the news of my unanticipated pregnancy with a stern rebuke, then forgiveness, followed by an offer to host a small family reception after a swiftly arranged wedding ceremony. I launched into three weeks of chaotic planning for the marriage I had long foreseen— though only *after* college. I withdrew from the summer camp, selected a wedding dress, chose a bridesmaid, and found a china pattern. All the while, I was wavering between exhilaration and profound agitation. Having finished only my freshman year, I dropped out of college and, two months pregnant, was wedded for better or for worse.

ILLUSTRATION 22

Opposite, George and I as we leave
the church after getting married.

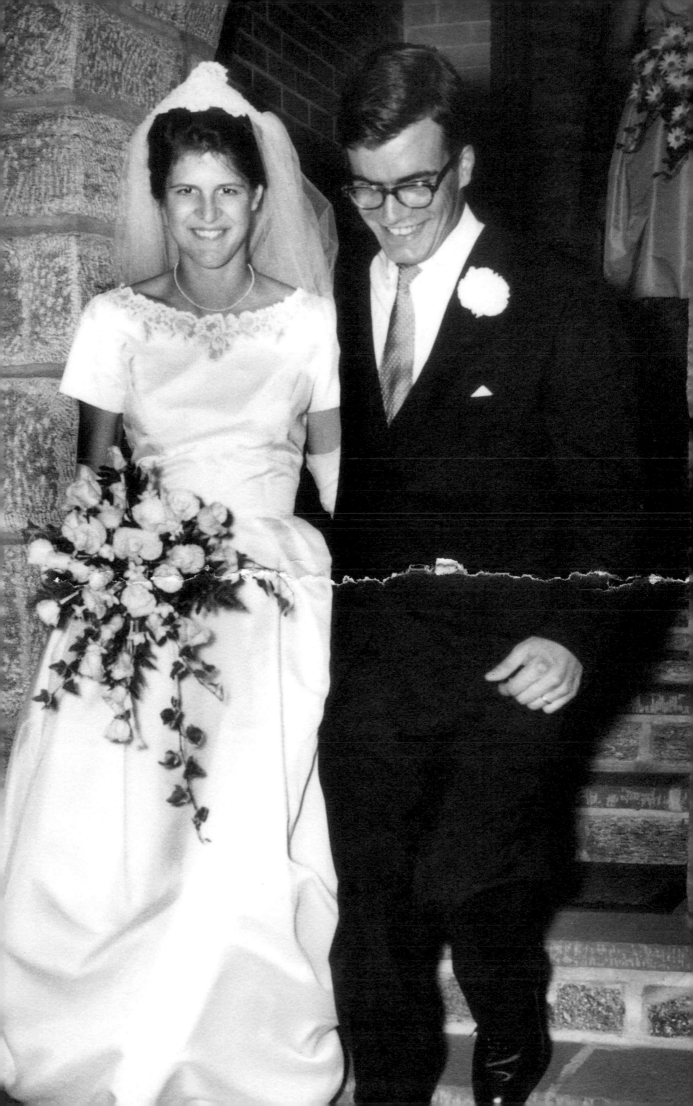

PLATE 89

WEBSTER'S SEVENTH
AUTHOR
NEW COLLEGIATE DICTIONARY
TITLE

DATE DUE	BORROWER'S NAME
1963	

trans·mog·ri·fy \
vt. [origin unknown]
to change or alter
often with grotesque
or humorous effect
syn see TRANSFORM

A
B
C
D
E
F

PLATE 89

PLATE 90

Updike, John ✓
Rabbit, run.
23933

096	MAR 31	A 3961
	APR 16	A 3175
	MAY 4	A 3190
	MAY 29	A 4135
	JUL	A 3159
	AUG 6	A 4379
	DEC 13	A 3159
	DEC 27	A 3159
	NOV 30	A 10030

PLATE 90

PLATE 91

641.5973 Rombauer, Irma
Rombauer von Starkloff,
1877-1962.

Joy of cooking.

DATE	BORROWER'S NAME

© BAKER & TAYLOR 002085 9691154

PLATE 91

PLATE 92

F McCullers,
Mcculler Carson, 1917-
 1967.

The heart is a
lonely hunter.

DATE	BORROWER'S NAME
1940	Motsart

© BAKER & TAYLOR 004898 9968184

PLATE 92

LINDBERGH, ANNE MORROW
AUTHOR
GIFT FROM THE SEA
TITLE

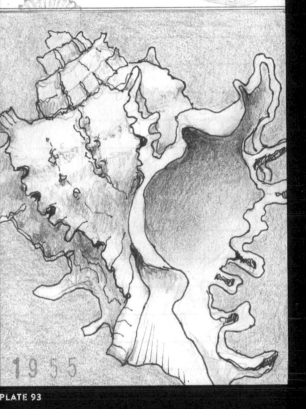

1955

PLATE 93

SPOCK, BENJAMIN MD
AUTHOR
BABY AND CHILD CARE
TITLE

DATE DUE	BORROWER'S NAME
1946	

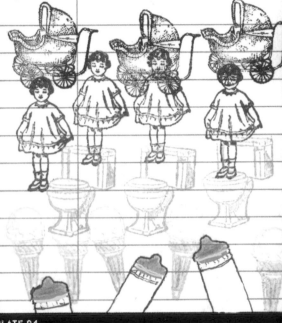

PLATE 94

SMITH, BETTY
AUTHOR
A TREE GROWS IN BROOKLYN
TITLE

DATE DUE	BORROWER'S NAME
1943	

PLATE 95

GESELL, A AND ILG, F.
AUTHOR
INFANT AND CHILD IN
TITLE THE CULTURE OF TODAY

DATE DUE	BORROWER'S NAME
1943	

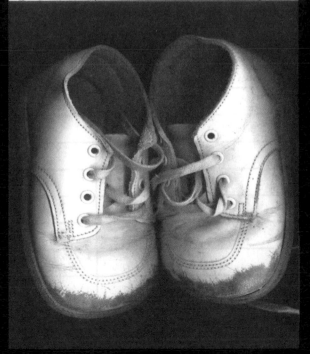

PLATE 96

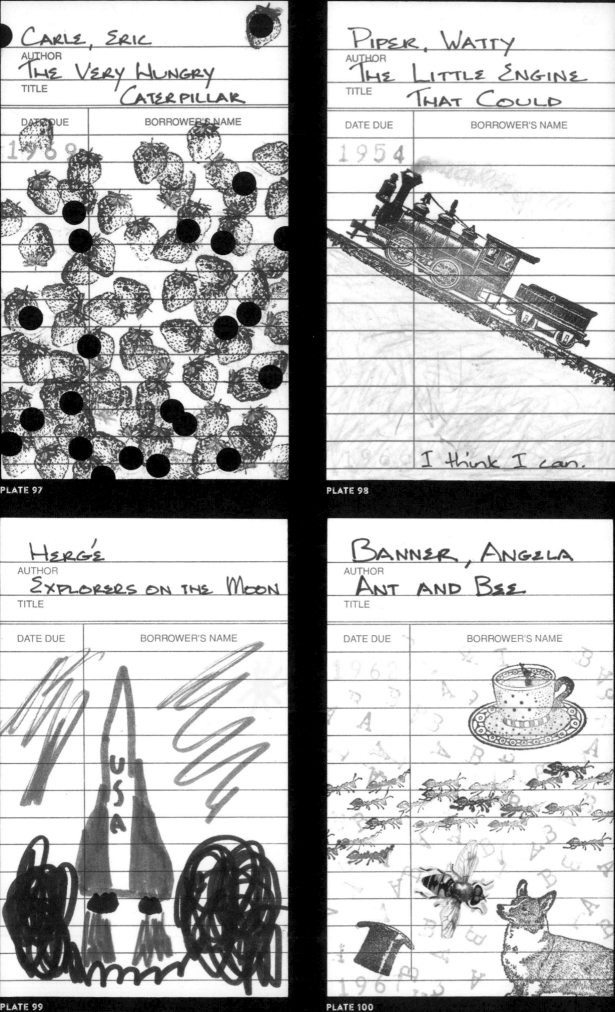

AUTHOR CARLE, ERIC
TITLE THE VERY HUNGRY CATERPILLAR
DATE DUE / BORROWER'S NAME
1989

PLATE 97

AUTHOR PIPER, WATTY
TITLE THE LITTLE ENGINE THAT COULD
DATE DUE / BORROWER'S NAME
1954
I think I can.

PLATE 98

AUTHOR HERGÉ
TITLE EXPLORERS ON THE MOON
DATE DUE / BORROWER'S NAME
USA

PLATE 99

AUTHOR BANNER, ANGELA
TITLE ANT AND BEE
DATE DUE / BORROWER'S NAME

PLATE 100

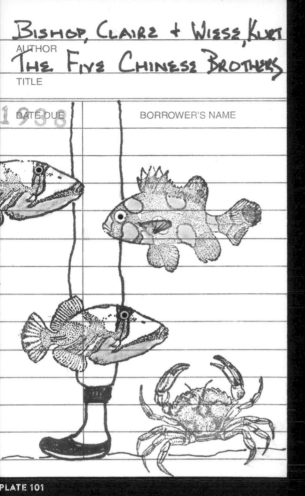

Abbey, Edward
AUTHOR
Desert Solitairs.
TITLE

DATE DUE 1968	BORROWER'S NAME

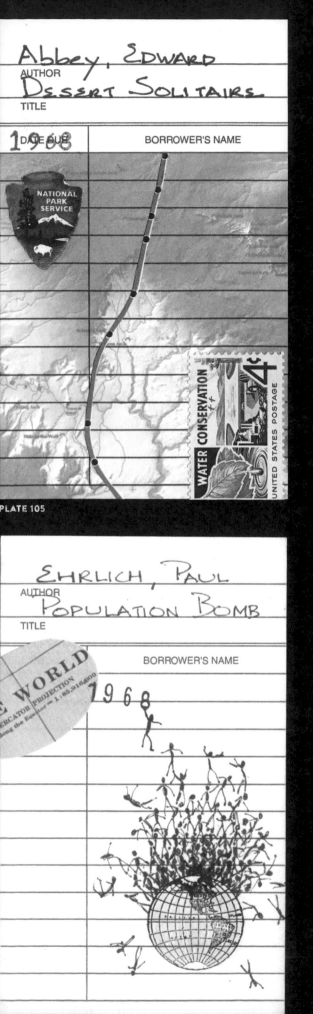

PLATE 105

Carson, Rachel
AUTHOR
Silent Spring
TITLE

DATE DUE 1962	BORROWER'S NAME

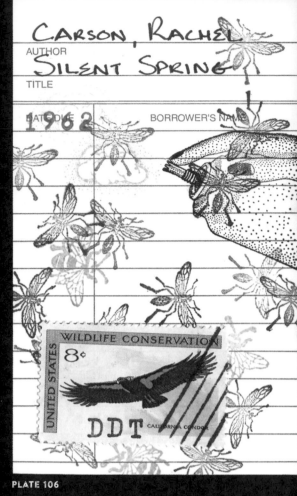

PLATE 106

Ehrlich, Paul
AUTHOR
Population Bomb
TITLE

DATE DUE	BORROWER'S NAME 1968

PLATE 107

Reich, Charles A.
AUTHOR
The Greening of America
TITLE

PLATE 108

SOUTHERN, T & HOFFENBERG, M
AUTHOR
CANDY
TITLE

DATE DUE	BORROWER'S NAME
1958	

PLATE 109

HESSE, HERMANN
AUTHOR
SIDDHARTHA
TITLE

DATE DUE	BORROWER'S NAME
1922	

EGO
M

PLATE 110

JUSTER, NORTON
AUTHOR
THE DOT AND THE LINE
TITLE

DATE DUE	BORROWER'S NAME
1963	

PLATE 111

WOLFE, TOM
AUTHOR
THE ELECTRIC KOOL-AID
TITLE
ACID TEST

DATE DUE	BORROWER'S NAME
1968	

 OREGON
FURTHR

LSD

PLATE 112

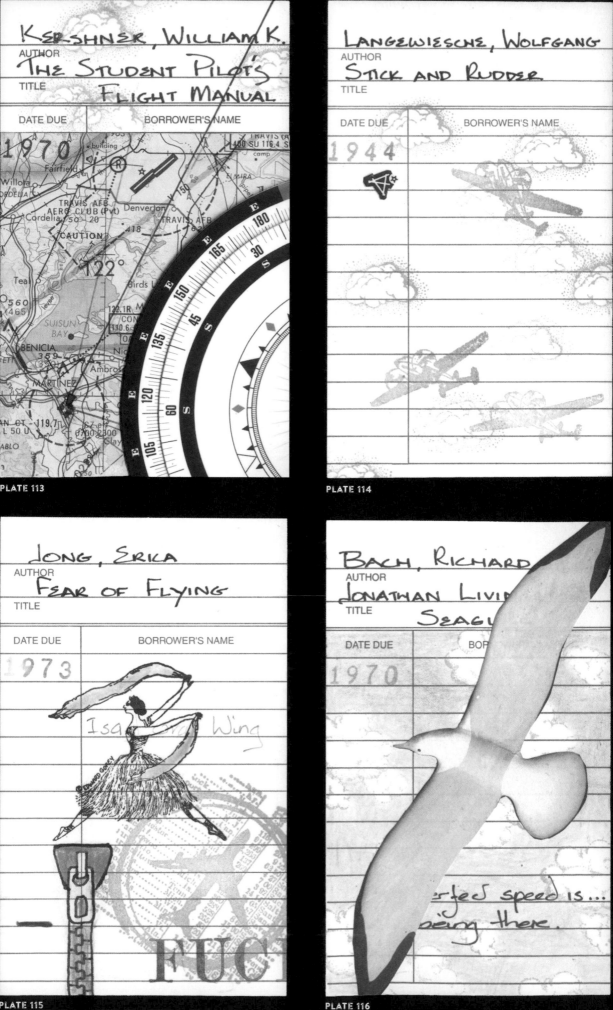

KERSHNER, WILLIAM K.
AUTHOR
THE STUDENT PILOT'S
TITLE
FLIGHT MANUAL

DATE DUE · BORROWER'S NAME

1970

PLATE 113

LANGEWIESCHE, WOLFGANG
AUTHOR
STICK AND RUDDER
TITLE

DATE DUE · BORROWER'S NAME

1944

PLATE 114

JONG, ERICA
AUTHOR
FEAR OF FLYING
TITLE

DATE DUE · BORROWER'S NAME

1973

Isadora Wing

FUC

PLATE 115

BACH, RICHARD
AUTHOR
JONATHAN LIVING
TITLE
SEAGU

DATE DUE · BOR

1970

rfect speed is...
being there.

PLATE 116

BRAND, STEWART ED
AUTHOR
THE WHOLE EARTH
TITLE
CATALOG
DATE DUE BORROWER'S NAME
1968

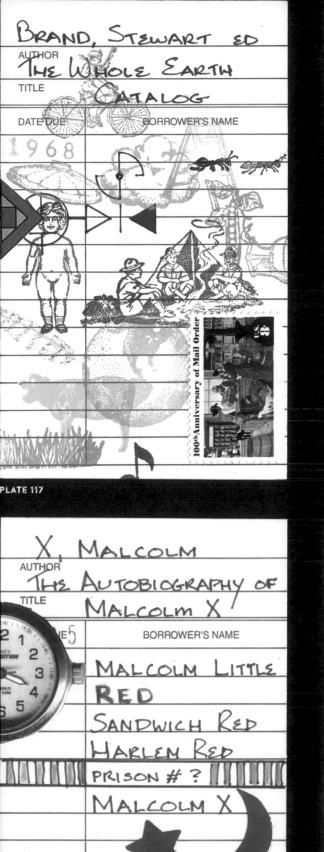

PLATE 117

FITZGERALD, FRANCES
AUTHOR
FIRE IN THE LAKE
TITLE
1972 DATE DUE BORROWER'S NAME

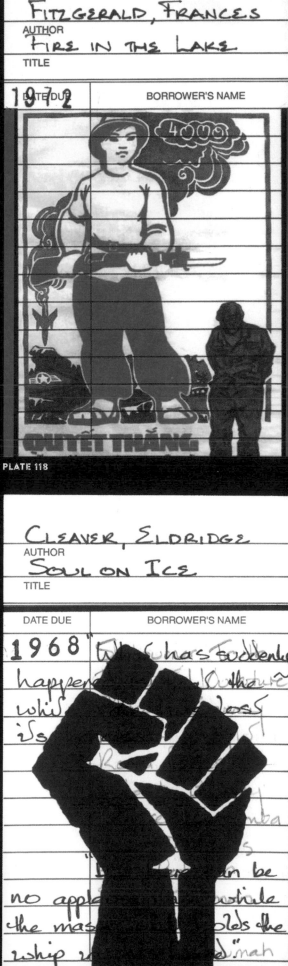

QUYẾT THẮNG

PLATE 118

X, MALCOLM
AUTHOR
THE AUTOBIOGRAPHY OF
TITLE
MALCOLM X
DATE DUE BORROWER'S NAME
MALCOLM LITTLE
RED
SANDWICH RED
HARLEM RED
PRISON # ?
MALCOLM X
REP. # M-138
OMOWALE
EL-HAJJ MALIK
SHABAZZ

PLATE 119

CLEAVER, ELDRIDGE
AUTHOR
SOUL ON ICE
TITLE
DATE DUE BORROWER'S NAME
1968

PLATE 120

Plate 121

AUTHOR: Dr. Seuss
TITLE: The Cat in the Hat

DATE DUE	BORROWER'S NAME
1957	

PLATE 121

Plate 122

AUTHOR: Holling, Holling Clancy
TITLE: Tree in the Trail

DATE DUE	BORROWER'S NAME
1942	

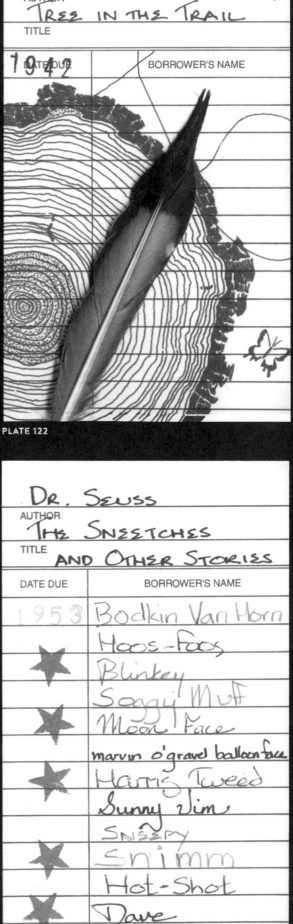

PLATE 122

Plate 123

AUTHOR: Holt, John
TITLE: What Do I Do Monday?

DATE DUE	BORROWER'S NAME
1970	

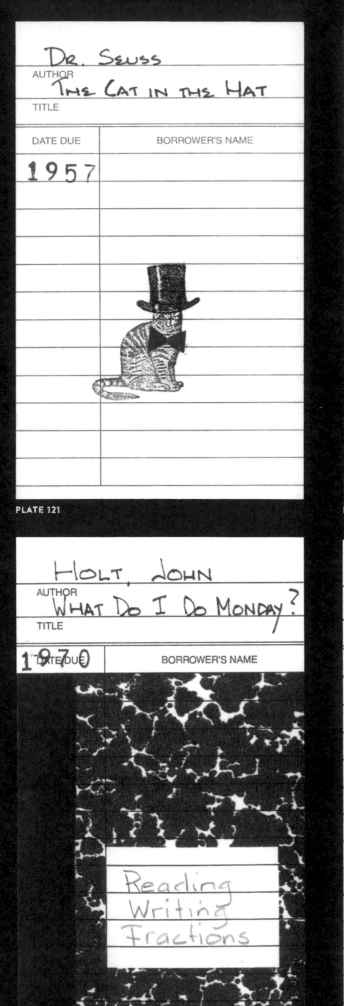

Reading
Writing
Fractions

PLATE 123

Plate 124

AUTHOR: Dr. Seuss
TITLE: The Sneetches and Other Stories

DATE DUE	BORROWER'S NAME
1953	Bodkin Van Horn
★	Hoos-Foos
	Blinkey
	Soggy Muff
★	Moon Face
	marvin o'gravel balloon face
★	Harris Tweed
	Sunny Jim
	Sneepy
★	Snimm
	Hot-Shot
★	Dave

PLATE 124

ELIOT, GEORGE
AUTHOR
MIDDLEMARCH
TITLE

DATE DUE BORROWER'S NAME

1874

"Time, like money is
measured by our needs."

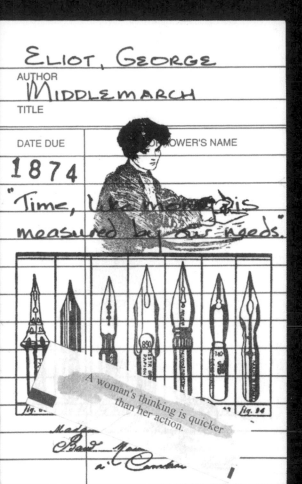

A woman's thinking is quicker than her action.

PLATE 125

FITZGERALD, F. SCOTT
AUTHOR
THE GREAT GATSBY
TITLE

DATE DUE BORROWER'S NAME

1925

PLATE 126

NEILL, A. S.
AUTHOR
SUMMERHILL
TITLE

DATE DUE BORROWER'S NAME

1964

P.T.A. 1897 1972 8¢ Parent Teacher Association U.S.

PLATE 127

WOOLF, VIRGINIA
AUTHOR
MRS. DALLOWAY
TITLE

DATE DUE BORROWER'S NAME

1925

PLATE 128

COPELAND, ALAN
AUTHOR
PEOPLE'S PARK
TITLE

1969 DATE DUE BORROWER'S NAME

PLATE 129

DIDION, JOAN
AUTHOR
SLOUCHING TOWARDS
TITLE BETHLEHEM

1901 DATE DUE BORROWER'S NAME

PLATE 130

CASTANEDA, CARLOS
AUTHOR
THE TEACHINGS OF
TITLE DON JUAN

DATE DUE BORROWER'S NAME

1968

PLATE 131

NICHOLS, JOHN
AUTHOR
THE MILAGRO BEAN
TITLE FIELD WAR

DATE DUE BORROWER'S NAME

1974

PLATE 132

SHULMAN, ALIX KATES
AUTHOR
MEMOIRS OF AN EX-PROM
TITLE
QUEEN

DATE DUE	BORROWER'S NAME
1969	

PLATE 133

FRIEDAN, BETTY
AUTHOR
THE FEMININE MYSTIQUE
TITLE

DATE DUE	BORROWER'S NAME
1963	

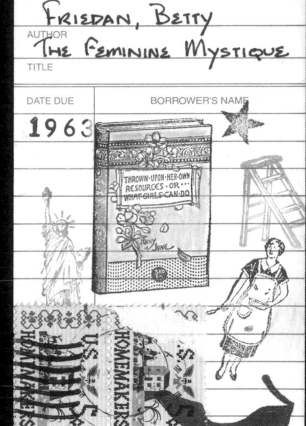

PLATE 134

KESEY, KENNETH
AUTHOR
ONE FLEW OVER THE
TITLE
CUCKOO'S NEST

DATE DUE	BORROWER'S NAME
1962	

PLATE 135

F
Conrad

Conrad, Joseph,
1857-1924.

Heart of
darkness.

DATE	BORROWER'S NAME
1902	

"I don't like ... — no man does — ... I like what is in the work, — the chance to find yourself."

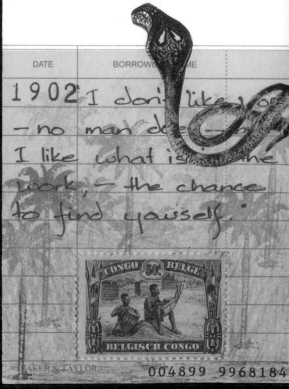

004899 9968184

PLATE 136

KRAMER, HILTON
AUTHOR
THE AGE OF THE AVANT-GARDE
TITLE

DATE DUE | BORROWER'S NAME

1972

Jackson Pollock 44 USA

PLATE 137

LÖVGREN, SVEN
AUTHOR
THE GENESIS OF
TITLE MODERNISM

DATE DUE | BORROWER'S NAME

1959

IA ORANA MARIA

PLATE 138

KANDINSKY, WASSILY
AUTHOR
CONCERNING THE SPIRITUAL
TITLE IN ART

DATE DUE | BORROWER'S NAME

1947

Artsy Fartsy

PLATE 139

GREENBERG, CLEMENT
AUTHOR
ART AND CULTURE
TITLE

DATE DUE | BORROWER'S NAME

1964

PLATE 140

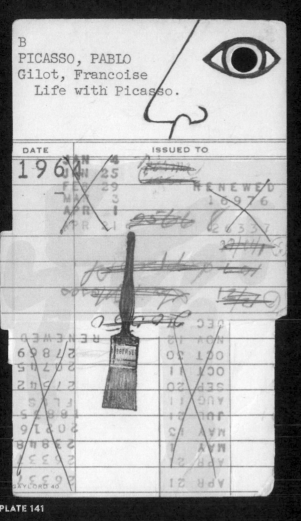

B
PICASSO, PABLO
Gilot, Francoise
Life with Picasso.

PLATE 141

marquis, don
AUTHOR
archy and mehitabel
TITLE

PLATE 142

J
Juster

Juster, Norton,
1929-

The phantom
tollbooth.

PLATE 143

J
Dahl

Dahl, Roald.

Charlie and the
chocolate
factory.

PLATE 144

PLATE 145

PLATE 146

PLATE 147

PLATE 148

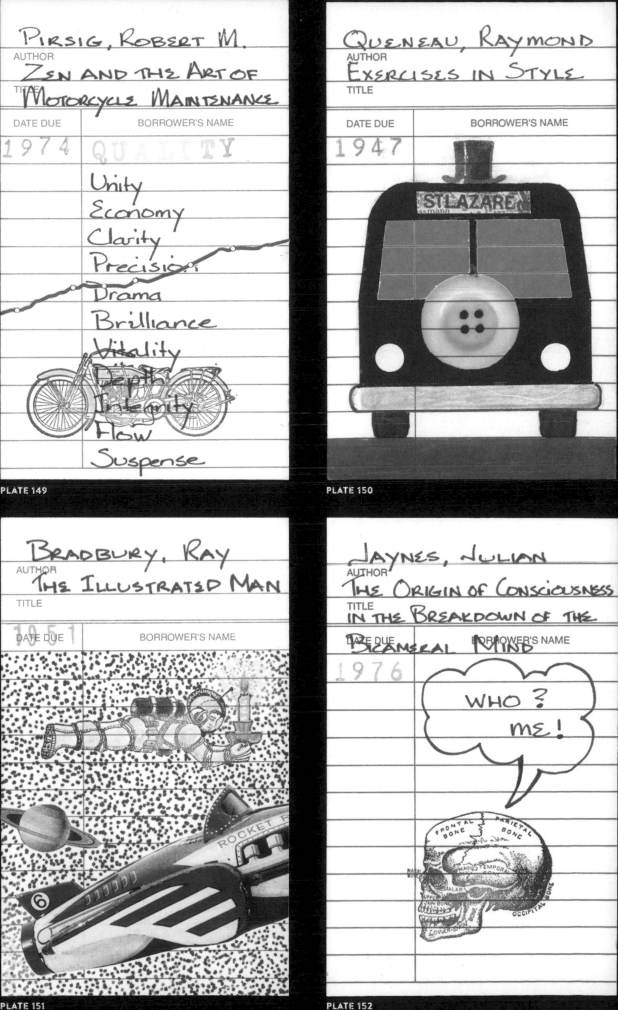

PIRSIG, ROBERT M.
AUTHOR
ZEN AND THE ART OF
MOTORCYCLE MAINTENANCE
TITLE

DATE DUE	BORROWER'S NAME
1974	QUALITY

Unity
Economy
Clarity
Precision
Drama
Brilliance
Vitality
Depth
Integrity
Flow
Suspense

PLATE 149

QUENEAU, RAYMOND
AUTHOR
EXERCISES IN STYLE
TITLE

DATE DUE	BORROWER'S NAME
1947	

PLATE 150

BRADBURY, RAY
AUTHOR
THE ILLUSTRATED MAN
TITLE

DATE DUE	BORROWER'S NAME
1951	

PLATE 151

JAYNES, JULIAN
AUTHOR
THE ORIGIN OF CONSCIOUSNESS
TITLE
IN THE BREAKDOWN OF THE
BICAMERAL MIND

DATE DUE	BORROWER'S NAME
1976	

WHO?
ME!

PLATE 152

Immediately after our marriage, George and I moved to a town in New Jersey near Princeton University, where he had been accepted as a doctoral student in mathematics. Our barely furnished apartment was three miles from campus. We had silver candlesticks, given to us as a wedding present, but no table to put them on, let alone a dining room. Without any friends of my own in the area, I felt lost and isolated. George was at the university most of the day, and in the evenings one or more of his colleagues would phone—always, it seemed, at dinnertime. They often engaged in convoluted discussions of homotopy groups of spheres, among other things, while I waited to serve supper. In order to run errands, I learned to operate a stick shift so I could drive George's aging Lancia Flaminia, a gift from an uncle. My excursions, after dropping George off at the university, were largely limited to taking the wash to the laundromat and shopping for groceries with a budget of seventeen dollars a week. On Tuesdays I took a sewing class and learned to insert zippers and make buttonholes, skills that came in handy when I made my own maternity dresses. I used Simplicity patterns and the new Singer sewing machine Gammy gave me along with a crib and complete layette.

Plate 91

In my new role as housewife, I studied Irma S. Rombauer's *Joy of Cooking* and *The Fannie Farmer Cookbook*. Unlike Gammy's Hungarian cook, I needed to follow recipes. As a kid I had learned only a few basic cooking skills. My mother never spent much time in the kitchen and would sooner take me to Parvin's Pharmacy, where we would sit side by side at the counter, drinking chocolate milkshakes, than make me lunch. My mother's typical menu featured ground beef and elbow macaroni combined with tomatoes she had chopped up in their tin before dumping them into a frying pan to cook for five minutes. We kids would liberally pour Parmesan cheese, with the flavor and texture of sawdust, out of its green cardboard container and onto this travesty of Italian cuisine, but it did little to improve the taste. Every now and then my father would enlist Carol and me to help him make brownies. He taught us how to measure out flour and melt squares of Baker's Chocolate in a double boiler. This led to my fixation on making desserts, my favorite being chocolate pudding pie. By the time I was fifteen, I could cook the simplest of dinners, which came in handy, since my mother was absent again, leaving me largely responsible for feeding the family. I relied almost exclusively on chicken, peas, and Success Boil-in-Bag White Rice.

As a child, I savored nicknames for food—like "alligator pears" for avocados—especially those my father had picked up when he was in the navy—"elephant dandruff" for corn flakes and "collision mats" for French toast. Some of the first meals I made for my husband probably deserved equally pejorative

epithets, though eventually I became a decent cook. One of my early fiascoes was the time I was boiling eggs and forgot to turn off the gas before rushing out the door to pick up George on campus. By the time we got back, our apartment smelled horrific, but at least the building hadn't burned down. Another time, George's parents came to dinner, and my first attempt at making fancy appetizers was such a failure—I forgot to cook the shrimp for the shrimp cocktail—that I fled into the bedroom, followed by my concerned husband, and cried.

In our first months of marriage, my loneliness tipped into despondency. Cooking and cleaning were not sufficient substitutes for human company. Consolation, and even provocation, came in the form of books. I lay in bed on long afternoons, weeping over Francie's thwarted efforts to escape poverty and go to college in *A Tree Grows in Brooklyn* or railing against the indefensible marital abuse described in *Rabbit, Run*. Anne Morrow Lindbergh restored my equilibrium with her hugely successful book *Gift from the Sea*. Her lyrical comparisons of seashells—pristine at first and eventually covered in barnacles—to the successive stages of marriage were comforting. Lindbergh also extolled the value of solitude. Knowing that the author was the wife of the most celebrated aviator ever, a pilot herself, and mother of a child who had been kidnapped and murdered, I was awed by her ability to translate sage insights into poetic passages to share with her readers, as well as the tranquility she was able to wrest from unimaginable sorrow in the midst of a life in the limelight.

That first fall in New Jersey, I decided to audit a class in Princeton University's classics department. I had studied Greek in my freshman year of college, along with English, math, psychology, and philosophy. My brief stint in higher education, however, provided no clear path forward except that my future would not focus on math, psychology, or philosophy. Despite Princeton's being an all-male university at the time, one of the classics professors allowed me to audit his course—unlike the first professor I had approached—and I spent a semester reading the *Odyssey* in its original Greek. In that ancient text, I learned an important lesson from Penelope,

ILLUSTRATION 23

***Book Marks* card for *The Fannie Farmer Cookbook*.**

Plate 95

Plate 90

Plate 93

Plate 77

who was as wily as her husband, Odysseus. As she wove her way through twenty years of waiting for her husband to come home to Ithaca, she taught me about patience. The hours I spent looking up words in my Homeric dictionary, along with my sewing projects, helped stave off the worries that my brain was prone to dredge up if not otherwise occupied.

The misgivings I was experiencing—resulting from the abrupt transition from college student to wife—vanished in March with the arrival of our son, weighing in at nine and a half pounds. Three weeks earlier I had written a valentine to my husband: "I am so glad we are having a baby... no regrets." The note continued with the wish that we would have a boy so that he could be named George after the man "I love so much." And as my wish came true, we followed the tradition that George's family had established long ago: naming all boys either James or George. Suddenly this warm, cuddly baby was in my arms, and my heart was full of concern that he would stop breathing. Dr. Spock's indispensable *Baby and Child Care* somewhat allayed my apprehension about breastfeeding and bathing an infant, but I didn't fully process the number of diapers one baby could go through. At least by then George had bought us a washing machine, though we didn't have a dryer. Over the next few years I hung thousands of diapers out to dry, memorized *The Little Engine That Could*, and took frequent walks behind a rickety stroller with splayed wheels. Three and a half years later I found myself stitching Georgie's Halloween costume, based on a toothy monster in *Where the Wild Things Are*, while awaiting the birth of our second son, who would be named Paul, after nobody in the family. (I sometimes joke that if I'd had two more sons, I would have called them John and Ringo.)

It took four years for George to complete his thesis, during which time he struggled with what, at the time, I saw as moodiness and occasional bursts of anger. He had expected to be a hotshot at Princeton, but in the intensely competitive atmosphere of the math department, he was just one star in a constellation of topologists, algebraists, number theorists, and differential geometers of the first magnitude. On a few occasions George grew so frustrated that he punched holes in the walls and broke furniture. I was furious when he flushed my watch down the toilet after I returned later than expected with the car he had needed to get to some appointment. Then there was the week he lay inert in bed, reading James Bond thrillers, escaping from the stress of writing his thesis.

After George's graduation, the three of us, plus Paul in utero, took a 12,000-mile road trip, skirting the boundaries of the U.S.A., with no seat belts or toddler car seat—Ralph Nader's *Unsafe at Any Speed* had not yet prompted automakers to install safety features nor the government to require them to do so. We sampled beignets in New Orleans, camped in Yosemite's backcountry, and visited the presidents at Mount Rushmore. The book *Blue Highways: A Journey into America* had not yet been written, but when I read it later, it would bring to mind the ups and downs of this

Plate 94

Plate 98

Plate 104

Plate 173

trip. The author, William Least Heat-Moon, counts off his woes and, looking for diversion, meanders around the back roads of his native land in a Ford Econoline van he named Ghost Dancing. As he passes through the small towns of Dime Box and Potato Neck, he doles out snatches of history and the recipe for Scripture cake. His poignant conversations with local folks shift away from the ordinary and slip deep into the American psyche.

We spent one more year in New Jersey while George did research at the Institute for Advanced Study. Paul was born in the fall, and in the spring my husband accepted a job offer from the University of California, Berkeley. At that time, Berkeley was wrapped up in the countercultural flamboyance of its hippie heyday and the social unrest spilling over from the Free Speech Movement. After we settled into our neighborhood, I volunteered at the local elementary school, dabbled in macramé, and paid little attention to the goings-on other than to add some tie-dyed clothing to my wardrobe. Yet it was impossible to ignore completely the upheavals on campus, since George would bring home reports of class disruptions and the radical political stances of the math department faculty. This was the first time I became cognizant of living history as it was happening.

ILLUSTRATION 24
Book Marks card for *Unsafe at Any Speed.*

Plate 56

Growing up, I had been almost entirely unaware of current events. My family only bought a television when my mother decided she wanted to watch the coronation of Queen Elizabeth II. I remember watching *Howdy Doody* and *The Mickey Mouse Club*, but I don't recall my parents watching the news. Granted, in grade school the specter of the atom bomb's mushroom cloud hovered over all our heads, and we were periodically instructed to hide under our classroom desks in case of attack. (Until I read journalist John Hersey's *Hiroshima* in high school, I had no idea how ridiculous that safety drill was.) I did watch news reports when I spent the night with Gammy, who was riveted by the McCarthy hearings in the U.S. Senate. And I was aware of the upcoming election of Dwight Eisenhower, because we third-graders, influenced by our Republican parents, wrote "I Like Ike" all over the blackboards. (The uncle of one classmate was a Democratic senator from Pennsylvania, and she alone was in the "America Needs Adlai" camp.) In my senior year of high school, our class watched John Glenn lift off to orbit the Earth on the small television in the school library. A year and a half later, I remember standing in my orange maternity dress when George telephoned from campus to report John Kennedy being shot. We had no television while living near Princeton, so I turned on the radio to hear that the president had died.

It took less than a year of living in Berkeley's hotbed of activism—brewing around the Vietnam War, the assassination of Martin Luther King Jr., women's liberation, and concern about the environment—for me to get personally involved, though my engagement was limited. I began by reading books that amplified my awareness of major upheavals in the cultural, political, and ecological spheres. I became convinced that George and I should have no more than two children after reading Paul Ehrlich's *The Population Bomb*, which predicted that Planet Earth would soon be overcrowded with starving people if human breeding was not curtailed. After reading Rachel Carson's *Silent Spring*, I stitched a flag to hang on our front porch to celebrate the first Earth Day, April 22, 1970. George and I attended a fundraiser for the Black Panthers. At the event, hosted by one of his colleagues, I met Eldridge Cleaver, whose book *Soul on Ice* had stoked my consciousness of the privilege bestowed on me solely on the basis of my white skin. With children in tow, George and I marched in San Francisco to protest the escalating Vietnam War. We also participated in a standoff between hippies and police backed by the National Guard, alternating childcare duty at a safe distance from the mayhem. At issue was the conversion of People's Park, a community green space on university property, into a campus parking lot. Back in Philadelphia, the evening after the protest, Gammy was watching *The Huntley–Brinkley Report* when she saw me on the television screen with my hair down to my waist, wearing a purple and orange minidress and putting daisies in the rifle barrel of a National Guardsman. She immediately telephoned to lament my transformation from mother to "flower child," which prompted George and me to go over to the neighbors who had a color television so we could witness my fifteen nanoseconds of fame when the evening news aired on the West Coast three hours later.

One summer, while still living in Berkeley, George, our two small boys, and I took a road trip to Canyonlands National Park in southeastern Utah. Halfway through the seemingly endless drive, George caught a bad cold, and for two days we were stuck in a dingy roadside motel in desolate Winnemucca, Nevada. The boys and I were bored stiff and ended up reading *The Five Chinese Brothers* about ten times, no doubt reinforcing cultural stereotypes. When we finally arrived at our destination, George rented a Jeep and loaded it with our tent, Coleman cookstove, and cooler. He took the wheel and began the white-knuckle drive down the cliff. The dirt road was a brutal introduction to the hundred-mile circuit that ran along the floor of the canyon, following the river between copses of cottonwoods, before leading back out again.

Just a few hours into the trip, we got a flat tire, which George replaced with the spare and a good deal of swearing. The narrow, one-way road, which was hardly visible on the rocky surfaces, had no other traffic and was patrolled by park rangers only every other day. For the remainder of the drive I worried about the consequences of another flat and remember hardly anything except one near-death experience I had while holding Paul in my

Plate 107

Plate 106

Plate 120

Plate 101

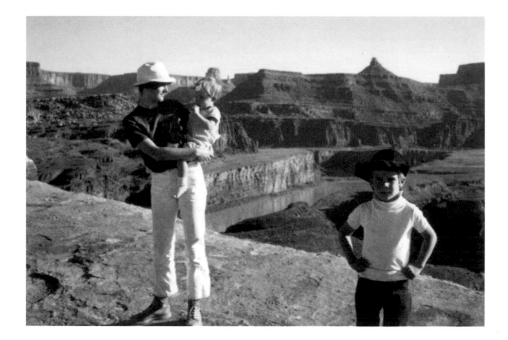

arms, when I barely avoided stepping on a rattlesnake. Before this excursion I had read *Desert Solitaire* by Edward Abbey, a well-known environmentalist and anarchist who worked as a park ranger in the backcountry of Utah. In the midst of his paean to the geology and ecology of this region, Abbey describes finding a dead tourist in the same remote area we were then traversing. Following my run-in with the rattlesnake, that unfortunate tourist, not surprisingly, rested uneasily in my mind.

After completing the harrowing drive, we turned in the Jeep and picked up our car. Since all of us were completely covered with a fine red dust, we decided to stop at a nearby lake for a swim. We rented a pontoon boat and headed out onto the water. But just minutes after we set out, a fierce sandstorm came up without any warning. There we were, completely exposed on what was hardly more than a raft. George and I lay down on top of the kids. The wind was so strong, it kicked up whitecaps and pelted us with pebbles torn off the surrounding cliffs. We never made it into the water, ultimately returning to the car dirtier than before and heading to a motel to shower. Not exactly a relaxing vacation—nor our last frightening descent along the face of a cliff, during which George would declare, "I have everything under control."

A few miles into our drive home, while still in Utah, George noticed a small airport outside of Moab. Perhaps wishing we could ditch the car and take a plane home, he announced his intention to start flying lessons as soon as we got back to Berkeley. And that was almost no sooner said than done. He joined the Cal Flying Club based at a nearby airport and signed up for lessons. When George was halfway through his student pilot training, Dave, his flight instructor, insisted that I learn some elementary maneuvers and how to operate the radio, in case of an emergency. Despite my thrill at going up in the Piper Cub with Uncle

Robin, learning to fly had never been on my radar. At that point in my life I wasn't much of an adventurer and could not imagine mastering either the mechanics of flight or basic navigation. But after Dave took me for a spin over San Francisco Bay, I was enchanted and gladly took up the challenge. George had supported my learning some practical skills for safety's sake, but I doubt he anticipated my doing anything more than assisting him with radio communications. He certainly didn't expect me to get a license myself, nor outscore him on the written exam that was now required. In fairness, I had extra tutoring. Dave would often drop by our house for a cup of tea, and our conversations ranged from angle of attack to compass deviation, before drifting onto the issues of the day. In addition, I followed George's example and dutifully read all the required books on our instructor's syllabus, including *The Student Pilot's Flight Manual* and Wolfgang Langewiesche's *Stick and Rudder*, the fundamental bible of aeronautics. Dave also recommended reading Richard Bach's *Jonathan Livingston Seagull*, a fable celebrating spiritual awakening by way of a brainy bird's flight maneuvers. I found the first two indispensable and the popular novella aspirational but a bit corny.

Plate 113

Plate 114

Plate 116

ILLUSTRATION 26

Logbook with the entry documenting my first solo flight in bold red ink.

Most of my training took place in a Citabria taildragger, a small single-engine plane with one seat behind the other. The sporty stunt plane with red and white sunbursts on its wings was operated with a stick instead of a control wheel. In order to log the minimum forty hours in the air required for a license, I spent a couple of hours at the airport on weekends, when George was home, and one weekday morning, when I traded babysitting duties with a friend who had three kids of her own. I vividly remember my first solo flight. In the middle of a lesson practicing takeoffs and landings, Dave got out of the plane and instructed me to continue on my own. I was exhilarated as I peeled down the runway at full throttle. Once up in the air, I climbed to an altitude of eight hundred feet, where the consequences of my ascent began to weigh heavily on me (as I imagined they had for Icarus). I had to bring the plane back to earth. With concentrated determination, I flew the downwind leg of the traffic pattern, remembering to turn on the carburetor heat, and then pulled back the throttle to begin my descent. On final approach, I aimed to set the plane down at the beginning of the runway, gritting my teeth

to stave off terror. I landed on target with an unintended bounce and a sigh of relief. Dave gave me a thumbs-up, and I repeated my performance with more confidence and without the bounce.

Before qualifying to take the flight test for a private pilot's license, at least at the time I took it, a student needed to log a minimum of ten hours of solo cross-country, meaning a number of flights to an airport more than twenty-five miles from the point of departure and at least one trip with a leg of more than one hundred miles. Each solo flight required someone at the designated airport to sign the student pilot's logbook as proof of arrival. As I plotted my final flight prior to the exam, I chose an airport in the vicinity of Sacramento, just far enough away to fulfill the remaining hour necessary. Franklin Field, the rural landing strip where I touched down, turned out to have no hangars and not even an office, but there was a group of people standing at the far end of the runway. I taxied the Citabria in that direction, killed the engine, and hopped out. Confronted by what I now saw was a gang of prisoners under the surveillance of an armed guard, I was dismayed. When I explained my need for a signature, one of the convicts, dressed in a blue uniform and wielding a pickax, graciously offered to write his name in my logbook. He asked me if he should add his prisoner number. In a surreal moment between fright and flight, I answered yes.

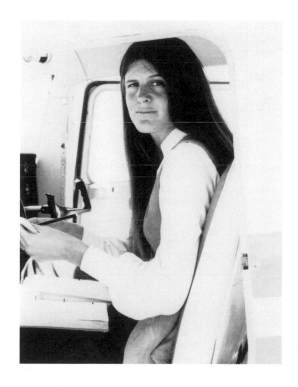

Earning my pilot's license substantially bolstered my self-confidence. Between that and other experiences garnered during our three years in Berkeley, my mind began to explore new horizons. Yet my vision of the future was hazy, and I was still a willing captive to the vicissitudes of my husband's career. After George's contract at Berkeley was terminated, he accepted a job offer from the math department at Cornell University, and we prepared to travel back across the country, this time to Upstate New York. I was sad about the impending move to Ithaca, and my gloom soon merged with frustration when my search, in the pouring rain, for suitable housing there proved more difficult than we had anticipated. My growing despondency was mitigated only by the knowledge that I would be closer to Gammy. While she had telephoned me every Sunday evening during our years in California, she didn't travel, and I had only been able to visit her once. Still, it was heartbreaking to sell our house and leave our friends in Berkeley, and ultimately I felt that the transition created complications that would eventually lead to the dissolution of our family.

That first fall in Ithaca, we settled into a rented house near the university. We now lived only a four-hour drive from Gammy's house, so we took the boys to see her every couple of months. Yet as her health began to fail, I was still too far away to provide the support she deserved. A year and a half after our return, Gammy died of a stroke. I wore a yellow wool coat to her funeral—the last gift of sunshine Gammy had given me—and was berated by the elder generation for not wearing black. Soon after the funeral, my mother divided up Gammy's property and, at my request, sent me some of her books. Among them was *The Picture of Dorian Gray* by the flamboyant Oscar Wilde. Both the author and the main character he created in this, his only, novel challenged societal norms, just as the benign yellow coat had done. Since the plot revolves around a man who sells his soul in order to remain forever young and handsome, the book makes me think of an oft-uttered saying of Gammy's: "Old age stinks."

Plate 58

As a new faculty member with a reputation as an excellent teacher, George was assigned the large introductory math course. He was deeply unhappy with this massive teaching load and worried he would never get tenure without ample time to do research. A severe depression, which neither of us fully recognized, began to work its way into his system. George decided to resign at the end of that first semester, and as soon as he finished grading final exams in mid-December, he informed his department chair of his intention. I was beside myself. Where would we go from here? My fears were temporarily allayed when the chair reduced George's course load and persuaded him to stay on.

A few days later we drove to the suburbs of Boston to spend the Christmas holidays with my parents, who had recently moved there. Shortly after we arrived, so did a big snowstorm. My brother, George and I, and our two boys began packing snow into cardboard boxes to create blocks of ice. The next afternoon we spent hours in my parents' backyard, using the frozen bricks to build an igloo almost five feet high, large enough for the kids to crawl through its tunnel entryway. That was the fun stuff. A few days later George had a big shouting match with my brother, and that night he woke me with paranoid ramblings about my making a pact with the devil. This went on for several nights, accompanied by some unusual behavior during the day. Yet despite their familiarity with mental illness, my parents did not pick up on the seriousness of the situation or offer me any guidance. I hoped that returning home after a week in Boston might ease the tension and curtail George's irrational behavior. Clearly, I was in denial myself, reflecting the

ILLUSTRATION 28

Georgie, age 8, inside the unfinished igloo we built in my parents' backyard at Christmastime.

way society at the time ignored issues of mental health. Still, on the day of our departure, I was afraid to share the driving with George in his unstable state of mind, so I motored through the seven endless hours with only one brief rest stop. And upon our return, I drove us directly to a medical clinic. George was evaluated and dismissed with a vial of pills, and all I could do was drive us home.

That night, very late, George went berserk. When I threatened to call for help, he cut the telephone cord, slammed out of the house, and disappeared. I vividly remember pulling on my boots and running down the dark, icy street in just my nightgown to rouse a neighbor so I could call the police. My recollections of that night jerk along in a series of movie stills, with one unforgettable snapshot of my two young boys standing backlit at the open front door of our home as I sprinted toward them. They had awakened at the commotion downstairs. Two policemen soon showed up to inform me that a squad car had picked up my husband and taken him to the emergency room. The sympathetic officers attempted to calm the three of us as we huddled together on the sofa, trembling in terror, opposite our festive Christmas tree.

In the immediate aftermath of that incident, I had to make many decisions regarding George's care. There was no psychiatric ward at the hospital nearby, where George was in temporary custody. The two closest psychiatric facilities were each an hour away, a difficult drive in midwinter conditions, especially with two young children in the back seat. I picked the one with an available bed, and a few days later George was transferred there by ambulance. The morning after his transfer I went to meet his appointed psychiatrist, who recommended electroshock therapy. As he offered his counsel, my mind conjured up the insane asylum described by Ken Kesey in his tragic novel *One Flew Over the Cuckoo's Nest*. Not that I needed literature to underscore the cruelties of this procedure, which my own mother had been subjected to on more than one occasion. The doctor was surprised when I steadfastly refused to consider his prescribed therapy, which often caused some confusion and memory loss. I knew how important George's logical capabilities were to his research and surmised that he would never forgive me if I permitted the treatment. Within a week I had him transferred to the Upstate University Hospital in Syracuse, where several months of group therapy, medication, and a large dose of Carole King songs seemed to have a good effect.

Plate 135

While George was in the hospital, I slept fitfully. It was extremely difficult to reconcile myself to the possibility that my boys might grow up in the same shadow of mental illness that had plagued my own childhood. Sometimes in the middle of the night I would turn on the light to interrupt my dark forebodings and read a chapter from the newly published feminist novel *Memoirs of an Ex-Prom Queen*. The thing about the book I remember most clearly is author Alix Kates Shulman's mention of "slam books." I had almost forgotten about these notebooks that, as young

Plate 133

Plate 134

teenagers, we passed around at slumber parties. Written at the top of a page was a question, to which each of us was required to write a candid response, usually a snide remark about someone we knew, like a teacher or boyfriend. During this period I also read *The Feminine Mystique*, Betty Friedan's critique of society's expectations of women. She debunked the myth of the happy housewife—the only role I had expected to play in life—claiming that a woman would not find fulfillment or her identity without a meaningful career or at least a higher education.

At the time I was reading Friedan's book, I was becoming increasingly aware that the welfare of our family might become my responsibility. Finding fulfillment or identity, let alone a meaningful career, would have to wait. I might actually need to get a job to put food on the table. But I had no marketable skills and was terrible at typing. I had been brought up in a society in which wives expected their husbands to support them, so thoughts about a career or any path to financial independence had never crossed my mind, either before or after my wedding. I had spent one directionless year in college and later audited a couple of courses in ancient Greek and one studio art class. I was at a loss how to proceed. At least for the time being, the university was holding my husband's position for him and paying his medical bills.

When George was released from the hospital in the spring, classes were already in session, so he couldn't go back to teaching right away. To occupy his time, he bought an upright piano and resumed taking music lessons, which he had given up after college. George continued searching for proofs in number theory and algebraic topology, routinely flooding the dining room table with paper. He also taught our sons to sing on key, play baseball, and repeat "billions of blistering blue barnacles" and other colorful "swear" words uttered by Captain Haddock in Hergé's *The Adventures of Tintin*. In the fall, he was able to return to teaching, and things began to feel almost normal. Nonetheless, George still had to face some consequences of his breakdown, one of which was the automatic revocation of the medical certificate the FAA required for all pilots. Since he was no longer able to fly, I considered it a slap in George's face to leave him home while I took off for the Ithaca airport, where we had both been renting planes. Besides, we couldn't really afford our membership in the local flying club, and its monthly meetings, where I was the only woman in attendance, always made me uncomfortable. I got the feeling that, absent my presence, the guys would probably have spent part of the hour sharing off-color jokes.

Plate 99

I quit flying in September, and since both the kids were now in school, I signed up for extramural classes at Cornell to begin carving out a path toward a career. Despite my enjoyment of reading, I didn't consider taking a literature course, since I hadn't written a paper in years. The fear of writing after such a long hiatus and my past love of drawing propelled me toward the visual arts, with the hope that this course of study might also satisfy a deep-rooted need for both mental and manual engagement while

producing something tangible. Though I had spent my adult life in one academic community or another, I had never fully considered the length of time it might take to get a degree, nor that a degree wouldn't necessarily guarantee getting a job, let alone that a career in the arts was inherently risky and likely poorly paid. I avoided discussing any long-range objectives with George and tried to hide my insecurity about our future. My deliberate pursuit of a career might have threatened his self-esteem, which derived at least in part from his role as breadwinner; my "job" was to support him in his profession and raise the boys. Regardless, the mere decision to go back to college became a source of tension between us.

After a year of extramural courses, one of my professors suggested that I apply to graduate school, despite my lack of an undergraduate degree. When I was accepted into the MFA program at Cornell, George claimed that my studio practice would be the kiss of death for his getting tenure. This was based on his having to be home by three o'clock one day a week to watch the kids while I attended a graduate seminar. I spent the other weekdays on campus, in my studio, or in class, until the boys were dismissed from school. In the evenings, I graded art history papers for extra money to pay my tuition, while George read *The Hobbit* and then *The Lord of the Rings* to the boys.

Demands on my time restricted my reading to artists' monographs, art history, and art criticism, much of which I found opaque. I wondered if pursuing a profession in the arts was wise, since it quickly became apparent that even the few

women who were eminent artists were largely ignored. In the first edition of H. W. Janson's *The History of Art*, the standard introductory art history text, no female artists are even mentioned. In addition, while most of the undergraduate art majors were women, half the grad students were male, and almost all of the art professors were men. One of my mentors in grad school introduced me to Clement Greenberg, the most influential art critic of the day, who was quick to point out the obstacles that women, especially those with a family, faced in the art world. His unspoken implication was that I didn't have a snowball's chance in hell of forging a successful art career. That seemed to be true for any woman, regardless of whether she had children, unless she was in some way attached to an established male artist or even a critic. I admired the work of Georgia O'Keeffe, who became visible to the art world through her relationship with Alfred Stieglitz. But I was truly inspired by the dogged persistence of Louise Nevelson as she struggled for three decades to establish herself, on her own terms, as a sculptor with an international reputation. I was quick to pick up the book

Dawns + Dusks, a transcription of taped conversations with Nevelson, as soon as it was published. In it she said that each of us must find our center. She didn't give a damn if you were a man, woman, or child.

Meanwhile, in the studio, I was examining my point of view as a pilot and the potential to incorporate that into my paintings and constructions. I began pasting aviation charts into collages and painting landscapes from an aerial perspective, techniques and themes that continue to resurface and play a role in my work. I have also used nautical charts as underpinnings for my paintings, though I find geological maps most intriguing; their bright color combinations resemble abstract art. These played a secondary role in a recent series of fictitious maps I created on wood panels, for which the primary collage element was sewing patterns. I didn't follow the pattern's dotted lines as I once had on my Singer sewing machine. Instead, I gave a new context to the guidelines for cutting, placement, and seams. This series explored imaginary networks, locations, and situations, and in the process of constructing these maps of nowhere, I arrived at many unexpected destinations. One of the first collages in the series, *Utopia Parkway*, began as a deconstructed pattern for a woman's dress and landed in Queens.

Painting is, in and of itself, a mapping process—a demarcation and delineation of the flat plane of a canvas. A painting gains power through what

is included and excluded, much like a map, and even a memoir. However, in the case of a painting or a memoir, there is no legend to explain artistic or biographical disclosures and omissions.

Toward the end of the second and last year of graduate school, I became seriously ill with the first of several bouts of an inflammatory disease. I was unable to complete my thesis and mount the required solo exhibition as scheduled. Though I didn't receive my diploma along with my classmates, I completed the work two months later and got my degree. As George had feared, he had been denied tenure, despite winning an award for his outstanding teaching. He immediately started applying for jobs and was soon offered a position at the University of Maryland.

We moved south to Washington, D.C., where we spent an unhappy year. The kids, now seven and eleven, were bullied in their new school. I stumbled through a part-time secretarial job, and George struggled with life in general. As his first year of teaching drew to a close, George decided he would spend the upcoming summer as a pianist in the Marlboro chamber music program in Vermont while searching for a teaching position at a different institution. I had just spent another week in the hospital recovering from a recurrence of my illness when I learned of his plans. I could no longer deal with the instability of our lives, and I made the decision to take the boys back to Ithaca once school was over. The three of us would stay there while George sorted things out. The boys' enthusiasm for moving back to a place where they had been happy did not assuage my guilt for taking them away from their dad, but with some financial help from my father, I rented an apartment in the neighborhood we had left the year before. That fall the boys returned to their former school and resumed their old friendships and routines.

As George waited for the job market to open up, he began his second year of teaching at Maryland. He soon slipped into another depression and was committed to a hospital in early October. Two months later he was released, on the very day I was offered a two-year teaching position in the art department at Cornell. I didn't have a chance to tell him my news. That evening his sister, who had been living near our house in D.C., called to say George hadn't shown up for dinner and she couldn't reach him. I was immediately and irrationally overtaken by a deep fear that he was driving to Ithaca to kill me for leaving with his boys. But that was not the case. George, my first love, devoted father, musician and mathematician, had chosen that day, the anniversary of Beethoven's birth, to take his own life.

At his funeral I broke down as friends bore my husband's casket up the aisle. My mother, sitting in the same pew, leaned over one of my sons to tell me to get ahold of myself. I have and I haven't. George's death left a void in me that I have only been able to fill with grief and guilt for failing to support him in his hour of need.

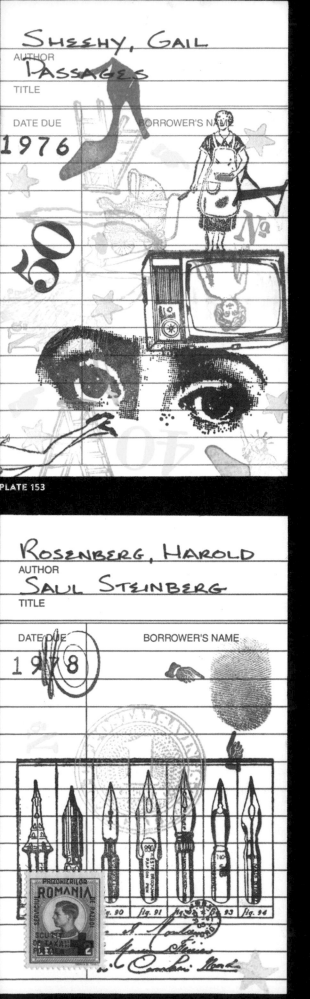

SHEEHY, GAIL
AUTHOR
PASSAGES
TITLE

DATE DUE | BORROWER'S NAME
1976

PLATE 153

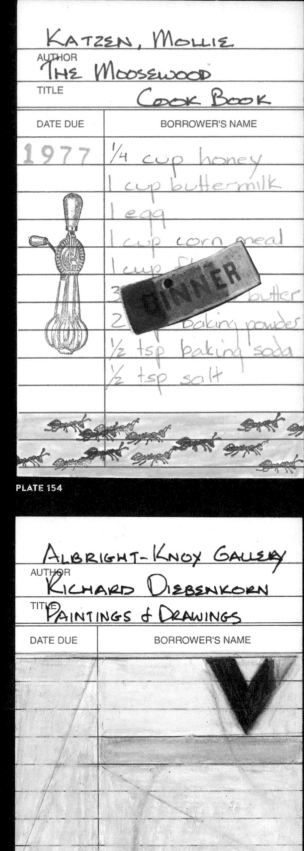

KATZEN, MOLLIE
AUTHOR
THE MOOSEWOOD
COOK BOOK
TITLE

DATE DUE | BORROWER'S NAME
1977 | ¼ cup honey
| 1 cup buttermilk
| 1 egg
| 1 cup corn meal
| 1 cup flour
| 3 DINNER butter
| 2 baking powder
| ½ tsp baking soda
| ½ tsp salt

PLATE 154

ROSENBERG, HAROLD
AUTHOR
SAUL STEINBERG
TITLE

DATE DUE | BORROWER'S NAME
1978

PLATE 155

ALBRIGHT-KNOX GALLERY
AUTHOR
RICHARD DIEBENKORN
TITLE
PAINTINGS & DRAWINGS

DATE DUE | BORROWER'S NAME

1977

PLATE 156

BESTON, HENRY
AUTHOR
THE OUTERMOST HOUSE
TITLE

DATE DUE	BORROWER'S NAME

1928

A year indoors
is a journey
along a paper
calendar—

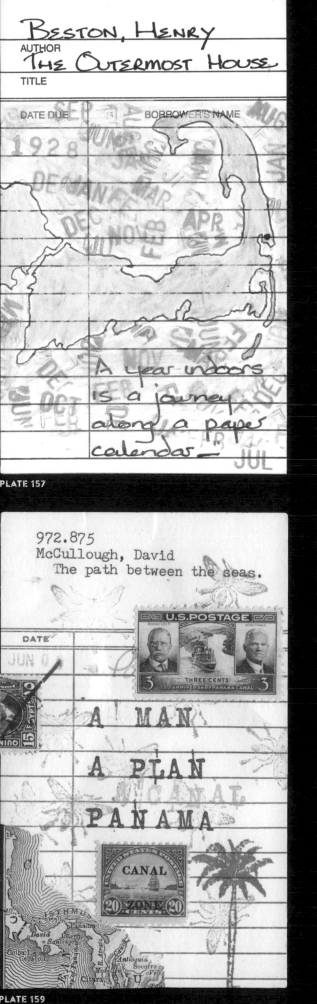

PLATE 157

MACLEAN, NORMAN
AUTHOR
A RIVER RUNS THROUGH IT
TITLE

DATE DUE	BORROWER'S NAME

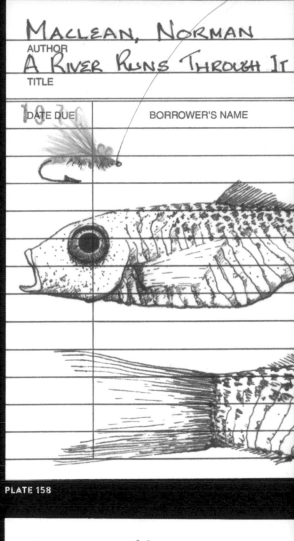

PLATE 158

972.875
McCullough, David
 The path between the seas.

DATE	

JUN 0

A MAN
A PLAN
CANAL
PANAMA

U.S. POSTAGE
THREE CENTS
35TH ANNIVERSARY PANAMA CANAL

CANAL
ZONE

PLATE 159

LOWRY, MALCOLM
AUTHOR
UNDER THE VOLCANO
TITLE

DATE DUE	BORROWER'S NAME

1947

PLATE 160

GRAVER, DENNIS
AUTHOR
PADI DIVE MANUAL
TITLE

DATE DUE	BORROWER'S NAME
1978	

PLATE 161

STEINBECK, JOHN
AUTHOR
THE LOG FROM THE
TITLE SEA OF CORTEZ

DATE DUE	BORROWER'S NAME
1959	

PLATE 162

WARNER, WILLIAM W
AUTHOR
BEAUTIFUL SWIMMERS
TITLE

DATE DUE	BORROWER'S NAME
1976	

PLATE 163

SKUTCH, ALEXANDER F
AUTHOR
A NATURALIST ON A
TITLE TROPICAL FARM

DATE DUE	BORROWER'S NAME
1980	

COSTA RICA
CORREO AEREO
¢0.50
GUARIA MORADA

PLATE 164

FEYNMAN, RICHARD B.
AUTHOR
SURELY YOU'RE JOKING,
TITLE
MR. FEYNMAN

DATE DUE	BORROWER'S NAME

1995

$$f_i = \sum_j e_{ij} g_i = \sum_i e_{ij}$$

$$N = \sum_{ij} e_{ij} =$$

$$\bar{x} = \sum_{ij} e_{ij} X_i / N \qquad \qquad Y_i / N$$

Let A and B be arbitrary values, usually integral measures near X and Y, respectively.

$$u_i = (X_i - \qquad v_j = (Y_j - B)/k;$$

$$\bar{u} = \qquad = h\bar{u} + A, \; v = \Sigma g_j v_j / N, \; \bar{Y} =$$

$$\sigma_u^2 = \qquad (u_i^2/N) - \bar{u}^2, \; \sigma_x = h\sigma_u. \} \text{ Apply}$$

$$\sigma_v^2 = (\mu_2) \qquad v_j^2/N) - \bar{v}^2, \; \sigma_y = k\sigma_v. \} \quad \text{cor}$$

$$U_i = \sum_j \qquad = \sum_j e_{ij} v_j, \; P =$$

$$p_{uv} = \sum \qquad - \bar{u})(v_j - \bar{v})/N$$

$$- (p/N) \ldots \bar{u} \bar{v}.$$

$$p_{xy} = hk p_{uv}.$$

$$r = p \ldots / (\sigma_x \sigma_y) = p_{xy}/(\sigma_x \sigma_y) \text{ (pr}$$

correlation. In every case $-1 \le r \le 1$.

$$Y - \bar{Y} = \frac{\sigma_y}{\sigma_x}(X - \bar{X}), \text{ or } y = \frac{r \cdot}{\sigma_x} x, \text{ regression}$$

$$X - \bar{X} = \qquad (Y - \bar{Y}), \text{ or } x = \frac{\sigma_x}{\sigma_y} y, \text{ regression}$$

PLATE 165

ADAMS, DOUGLAS
AUTHOR
THE HITCHHIKERS GUIDE
TITLE
TO THE GALAXY

DATE DUE	BORROWER'S NAME

1979

LIFE

UNIVERSE

42

EVERYTHING

**DON'T
PANIC**

PLATE 166

MARKHAM, BERYL
AUTHOR
WEST WITH THE NIGHT
TITLE

DATE DUE	BORROWER'S NAME

1983

PLATE 167

KELLER, EVELYN FOX
AUTHOR
A FEELING FOR
TITLE
THE ORGANISM

DATE DUE	BORROWER'S NAME

1983

BARBARA
MCCLINTOCK

PLATE 168

MORRIS, JAMES
AUTHOR
HEAVEN'S COMMAND
TITLE

DATE DUE	BORROWER'S NAME
1982	

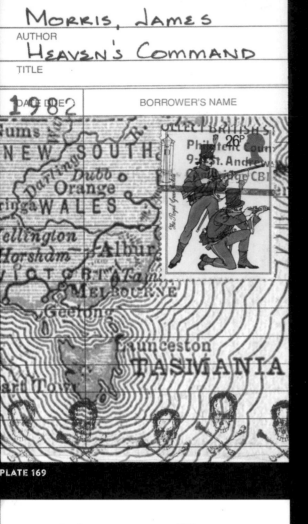

PLATE 169

STRACHEY, LYTTON
AUTHOR
EMINENT VICTORIANS
TITLE

DATE DUE	BORROWER'S NAME
1918	Florence Nightingale
	Arnold
	Cardinal Manning
	General Gordon

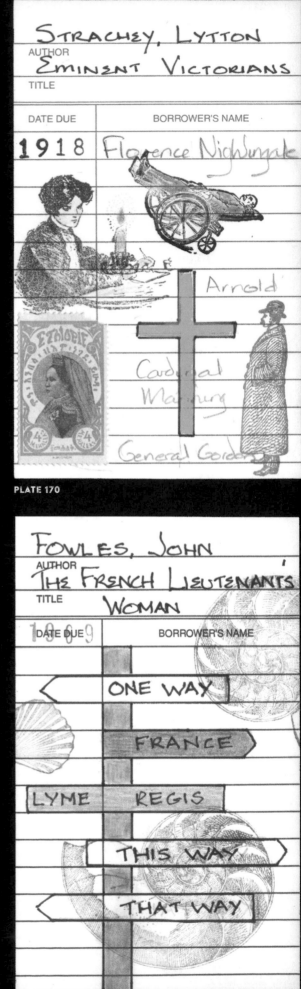

PLATE 170

DU MAURIER, DAPHNE
AUTHOR
REBECCA
TITLE

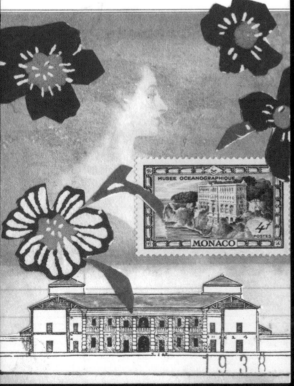

1938

PLATE 171

FOWLES, JOHN
AUTHOR
THE FRENCH LIEUTENANT'S
TITLE WOMAN

DATE DUE	BORROWER'S NAME
1969	

ONE WAY

FRANCE

LYME REGIS

THIS WAY

THAT WAY

PLATE 172

917.3
Heat Moon, William Least.
Blue highways :

DATE	ISSUED TO
APR 2 '83	
APR 30 '83	
MAY 14 '83	
MAY 28 '83	
JUN 11 '83	
JUL 9 '83	
JUL 30 '83	
AUG 13 '83	
AUG 20 '83	
SEP 3 '83	Renewed
OCT 14 '83	
OCT 29 '83	Renewed
NOV 12 '83	

GAYLORD 40

PLATE 173

F Forster, E. M.
Forster (Edward Morgan),
 1879-1970.

 A room with a
 view.

DATE	BORROWER'S NAME

PLATE 174

F Tolstoy, Leo,
Tolstoy graf, 1828-
 1910.

 Anna Karenina.

BORROWER'S NAME

PLATE 175

Garcia Marquez, Gabriel,
Love in the time of cholera

PLATE 176

CHENG, NIEN
AUTHOR
LIFE AND DEATH
TITLE
IN SHANGHAI

1987
DATE DUE BORROWER'S NAME

The past is for
ever with me and
I remember it all

PLATE 177

HULME, KERI
AUTHOR
THE BONE PEOPLE
TITLE

1983
DATE DUE BORROWER'S NAME

PLATE 178

ERDRICH, LOUISE
AUTHOR
LOVE MEDICINE
TITLE

DATE DUE BORROWER'S NAME

1984 BINGO

PLATE 179

CHATWIN, BRUCE
AUTHOR
SONGLINES
TITLE

DATE DUE BORROWER'S NAME

1987

PLATE 180

ESQUIVEL, LAURA
AUTHOR
LIKE WATER FOR CHOCOLATE
TITLE

DATE DUE	BORROWER'S NAME

PLATE 181

ECO, UMBERTO
AUTHOR
THE NAME OF THE ROSE
TITLE

DATE DUE	BORROWER'S NAME

PLATE 182

McMURTRY, LARRY
AUTHOR
LONESOME DOVE
TITLE

DATE DUE	BORROWER'S NAME

PLATE 183

MAHFOUZ, NAGUIB
AUTHOR
MIDAQ ALLEY
TITLE

DATE DUE	BORROWER'S NAME

1947

PLATE 184

KIDDER, TRACY
AUTHOR
House
TITLE

DATE DUE BORROWE...

1985

PLATE 185

COLWIN, LAURIE
AUTHOR
Home Cooking
TITLE

DATE DUE BORROWER'S...

1988

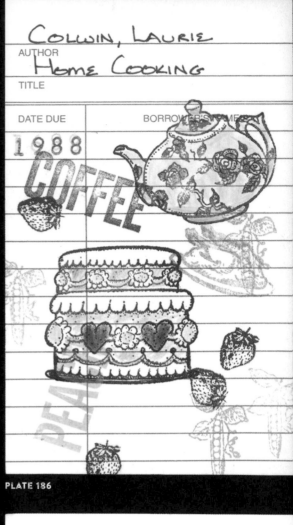

COFFEE

PEA...

PLATE 186

DIRR, MICHAEL
AUTHOR
Manual of Woody
TITLE Landscape Plants

DATE DUE BORROWER'S NAME

1990

PLATE 187

PICKVANCE, RONALD
AUTHOR
Van Gogh in Arles
TITLE

DATE DUE BORROWER'S NAME

VAN GOGH — L'Arlésienne

الجمهورية العربية اليمنية
3.68 YEMEN ARAB REPUBLIC
٦
AIR MAIL
بريد جوي

1984

PLATE 188

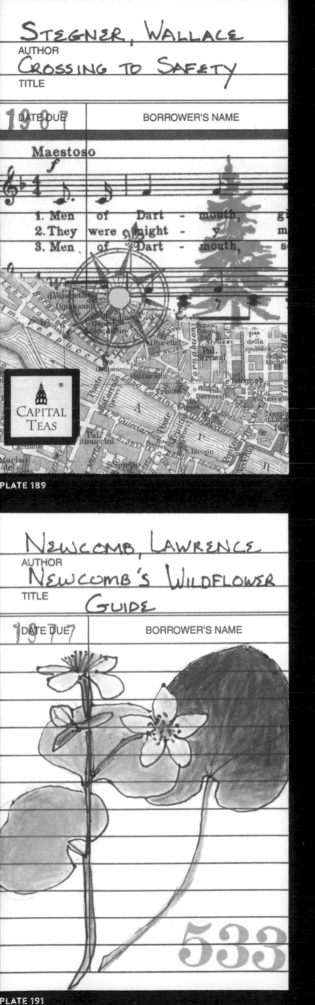

STEGNER, WALLACE
AUTHOR
CROSSING TO SAFETY
TITLE

DATE DUE	BORROWER'S NAME

1997

Maestoso

1. Men of Dart - mouth,
2. They were might - y
3. Men of Dart - mouth,

CAPITAL TEAS

PLATE 189

NEWCOMB, LAWRENCE
AUTHOR
NEWCOMB'S WILDFLOWER GUIDE
TITLE

DATE DUE	BORROWER'S NAME

1997

533

PLATE 191

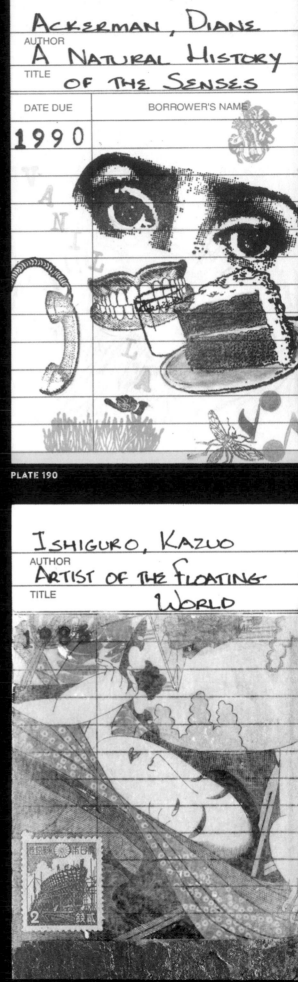

ACKERMAN, DIANE
AUTHOR
A NATURAL HISTORY OF THE SENSES
TITLE

DATE DUE	BORROWER'S NAME

1990

PLATE 190

ISHIGURO, KAZUO
AUTHOR
ARTIST OF THE FLOATING WORLD
TITLE

2 錢

PLATE 192

GAINES, ERNEST J.
AUTHOR
A LESSON BEFORE DYING
TITLE

DATE DUE	BORROWER'S NAME
1993	GRANT — JEFFERSON

PLATE 193

MAYER, MUSA
AUTHOR
NIGHT STUDIO
TITLE

DATE DUE	BORROWER'S NAME
1988	

PLATE 194

EDWARDS, KIM
AUTHOR
THE SECRETS OF
TITLE A FIRE KING

DATE DUE	BORROWER'S NAME
88	

PLATE 195

SCHAMA, SIMON
AUTHOR
THE EMBARRASSMENT
TITLE OF RICHES

DATE DUE	BORROWER'S NAME
1988	

PLATE 196

F McCarthy
McCarthy, Cormac, 1933-
All the pretty horses
Alfred A. Knopf,
c1992.

GAYLORD 40

PLATE 197

Atwood, Margaret
Cat's eye.

DATE	ISSUED TO
1988	
MAY 1 2	
MAY 2 7	
JUN 0	
JUN 1 0	
JUL 9	

GAYLORD 40

PLATE 198

F
Proulx
c.2

Proulx, Annie.

The shipping
news.

1993 BORROWER'S

© BAKER & TAYLOR 000930 6379285

PLATE 199

634.9 Maclean
Maclean, Norman, 1902-
Young men & fire
University of Chicago
c1992.

DATE ISSUED TO

GAYLORD 40

PLATE 200

AUTHOR WENDEL, BRUCE & DORANNA

TITLE GAMEBOARDS OF NORTH AMERICA

DATE DUE	BORROWER'S NAME

PLATE 201

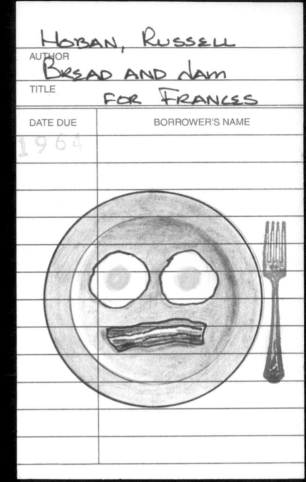

AUTHOR HOBAN, RUSSELL

TITLE BREAD AND JAM FOR FRANCES

DATE DUE	BORROWER'S NAME
1964	

PLATE 202

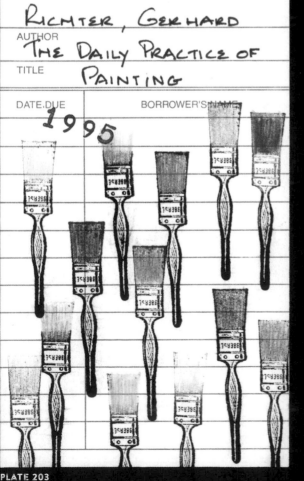

AUTHOR RICHTER, GERHARD

TITLE THE DAILY PRACTICE OF PAINTING

DATE DUE	BORROWER'S NAME
1995	

PLATE 203

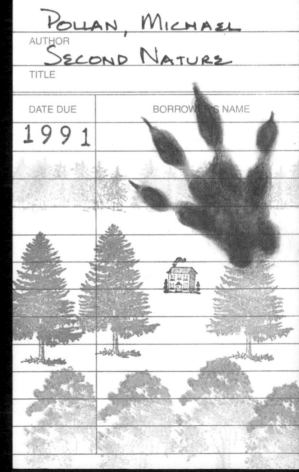

AUTHOR POLLAN, MICHAEL

TITLE SECOND NATURE

DATE DUE	BORROWER'S NAME
1991	

PLATE 204

SMITH, ALEXANDER McCALL
AUTHOR
THE №1 LADIES
TITLE
DETECTIVE AGENCY

DATE DUE BORROWER'S NAME

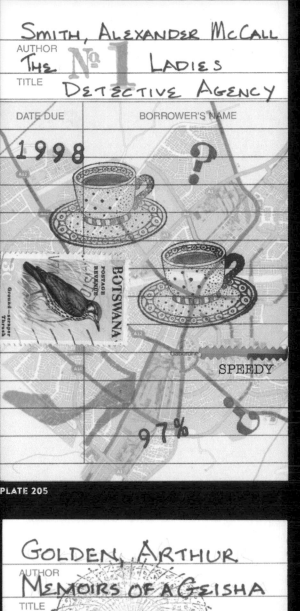

PLATE 205

SINCLAIR, HOCKNEY, TARBOTON
AUTHOR
BIRDS OF SOUTHERN AFRICA
TITLE

DATE DUE BORROWER'S NAME

PLATE 206

GOLDEN, ARTHUR
AUTHOR
MEMOIRS OF A GEISHA
TITLE

PLATE 207

BAINBRIDGE, BERYL
AUTHOR
THE BIRTHDAY BOYS
TITLE

DATE DUE BORROWER'S NAME

PLATE 208

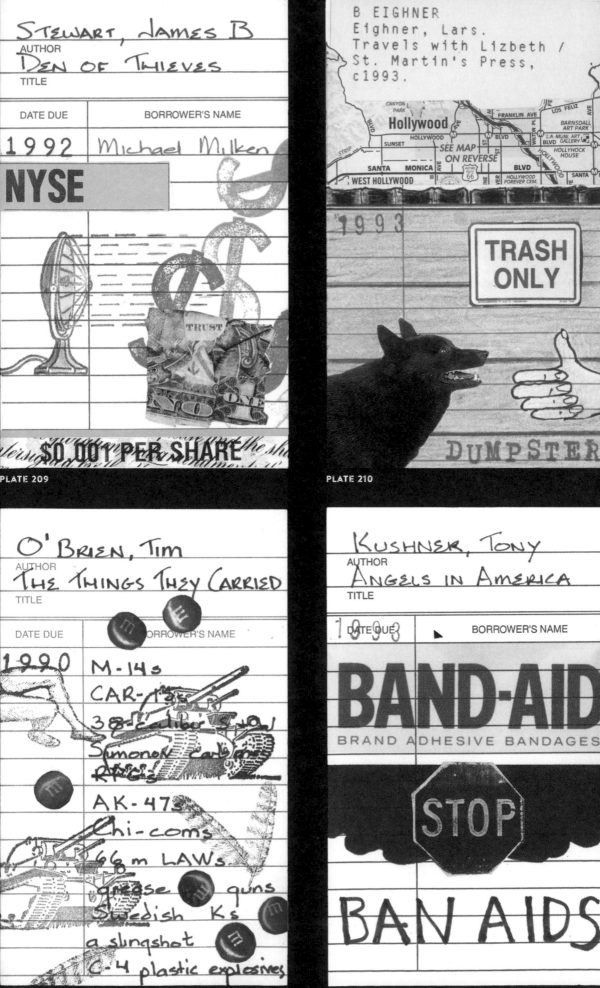

STEWART, JAMES B
AUTHOR
DEN OF THIEVES
TITLE

DATE DUE	BORROWER'S NAME
1992	Michael Milken

NYSE

TRUST

ONE

$0.001 PER SHARE

PLATE 209

B EIGHNER
Eighner, Lars.
Travels with Lizbeth /
St. Martin's Press,
c1993.

CANYON PARK
Hollywood
FRANKLIN AVE LOS FELIZ AVE
HOLLYWOOD BARNSDALL ART PARK
SUNSET BLVD L.A. MUNI. ART BLVD GALLERY
SEE MAP HOLLYWOOD HOUSE
STRIP ON REVERSE BLVD HOLLYHOCK HOUSE
SANTA MONICA AVE BLVD
WEST HOLLYWOOD HISTORIC ROUTE 66 HOLLYWOOD FOREVER CEM. SANTA

1993

TRASH
ONLY

DUMPSTER

PLATE 210

O'BRIEN, TIM
AUTHOR
THE THINGS THEY CARRIED
TITLE

DATE DUE	BORROWER'S NAME
1990	M-14s
	CAR-15s
	38 caliber pistol
	Simonov carbines
	RPGs
	AK-47s
	Chi-coms
	66 m LAWs
	"grease" guns
	Swedish Ks
	a slingshot
	C-4 plastic explosives

PLATE 211

KUSHNER, TONY
AUTHOR
ANGELS IN AMERICA
TITLE

DATE DUE	▶ BORROWER'S NAME
1993	

BAND-AID
BRAND ADHESIVE BANDAGES

STOP

BAN AIDS

PLATE 212

BOYLE, T. CORAGHESSAN
AUTHOR
THE TORTILLA CURTAIN
TITLE

DATE DUE	BORROWER'S NAME
1995	GABACHO

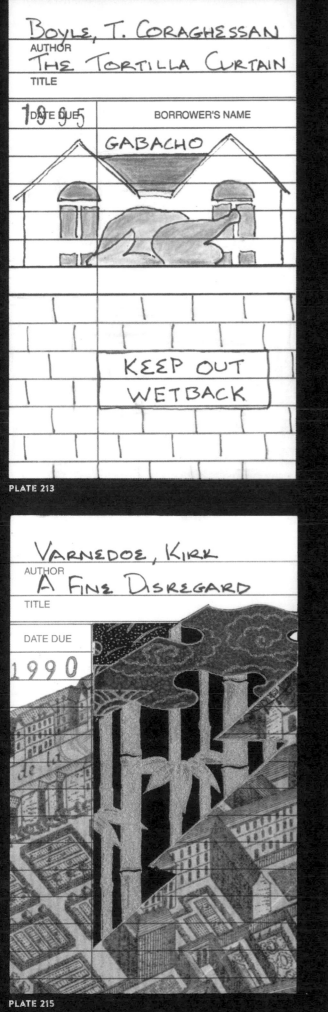

KEEP OUT
WETBACK

PLATE 213

KINGSOLVER, BARBARA
AUTHOR
ANIMAL DREAMS
TITLE

DATE DUE	BORROWER'S NAME

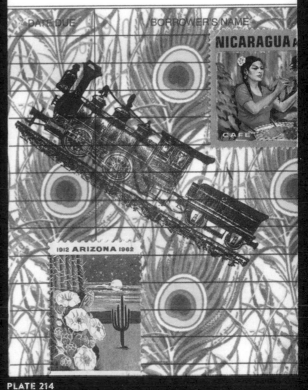
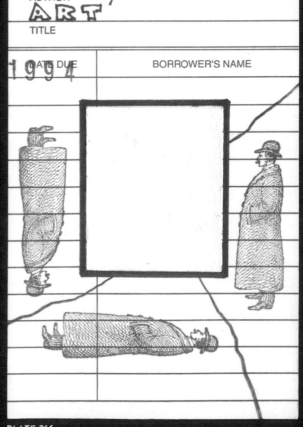

PLATE 214

VARNEDOE, KIRK
AUTHOR
A FINE DISREGARD
TITLE

DATE DUE

1990

PLATE 215

REZA, YASMINA
AUTHOR
ART
TITLE

DATE DUE BORROWER'S NAME

1994

PLATE 216

WEINER, JONATHAN
AUTHOR
BEAK OF THE FINCH
TITLE

PLATE 217

NOVACEK, MICHAEL
AUTHOR
DINOSAURS OF THE
TITLE **FLAMING CLIFFS**

DATE DUE BORROWER'S NAME

1996

PLATE 218

HINKLEY, DANIEL
AUTHOR
THE EXPLORER'S GARDEN
TITLE

DATE DUE BORR

1999

PLATE 219

NEWHOUSE, VICTORIA
AUTHOR
TOWARDS A NEW MUSEUM
TITLE

DATE DUE BORROWER'S NAME

1998

PLATE 220

QUAMMEN, DAVID
AUTHOR
SONG OF THE DODO
TITLE

DATE DUE	BORROWER'S NAME
1997	

PLATE 221

DANIELS, FRANK J.
AUTHOR
PETRIFIED WOOD
TITLE

DATE DUE	BORROWER'S NAME
1998	

PLATE 222

DATE	ISSUED TO
4\3\86	FAIR
MAY 5 -	
JUN 2	
AUG 1	
AUG 1	
CARO 9-89	
NOV	

"Camero
Basement of Unknown Orig

PLATE 223

FORTEY, RICHARD
AUTHOR
LIFE: A NATURAL HISTORY
TITLE

DATE DUE	BORROWER'S NAME
1998	

PLATE 224

During the aftershocks following George's death, several of his former colleagues stepped up to give me much-needed emotional support and practical counsel. They looked after my sons when I made the wrenching trip to D.C. to retrieve George's belongings. The most traumatic task was picking up the car in which he had killed himself. As I drove the station wagon back to Ithaca, I began to panic. I had almost no financial resources and had not yet qualified for a credit card. The future began to look brighter when a formal letter confirming the offer of an instructorship at Cornell finally arrived. My two-year appointment would not start until the following fall, which gave me time to deal with practical matters. Once I started teaching the large introductory courses for painting and drawing, I had no time to read a magazine, let alone a book. Nevertheless, between looking after my kids, maintaining a studio practice, and doing my job, I somehow managed to engage in a few romantic affairs. But, immersed in my role as breadwinner, I wasn't looking for a committed relationship. That changed when I met Dick.

I was first introduced to him while my son George and I were standing in line to check him in at a 4-H summer camp outside Ithaca. Dick was in line with his son, Bryan. The boys, friends since eighth grade, had just finished their freshman year of high school and would soon form the Fuzz Tones, the first of their various rock bands.

My initial observation was that Dick could best be described as a tall drink of water topped off with a wide grin. All that was missing was the cowboy hat. (I later learned there were several Stetsons in his collection of baseball caps, Panama hats, and Tilley field gear.) Despite my attempt at a tight-lipped smile, a habit I had developed long ago to conceal my crooked front teeth, Dick had me laughing within minutes. His exuberance was contagious.

After we left the boys and were heading to our cars, Dick and I agreed to drive back together at the end of the week to pick them up. That next Sunday, on the way to camp, I learned that Dick was a professor of ecology at Cornell, and his research involved the long-term monitoring and manipulation of insects on goldenrod, the aptly named harbinger of fall commonly found in unmown fields. Aside from his academic pursuits, Dick revealed that his personal life was in tatters. He was separated from

his wife and, until recently, had been sharing a place with a bachelor colleague, though now he and Bryan were living together in the family house and surviving on instant ramen noodles. His daughter, who yearned to be part of a happy family, had recently decided to go out into the world and create her own.

During the week the boys were in camp, I was unaware that Dick was grilling one of his graduate students about the dating game. She later told me how he had sat in her office, dithering, as only Dick could dither. He was smitten but had no idea how I felt, and, even if I agreed to go out with him, he had no clue where to take me. Having resolved half of his quandary, he asked me out to dinner as we drove back to camp. A few weeks after our first date, Dick took me sailing. At one point, his small boat floated backward in a wayward wind. I tactfully refrained from teasing him as he attempted to steer us in the right direction. Dick's enthusiasm for sailing soon waned, but the pleasure we took in each other's company did not. From that day on we moved forward, toward falling in love.

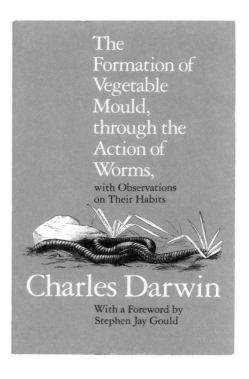

Dick was an old-fashioned naturalist whose copious field notes, now in the archives of Cornell University, were written in meticulous cursive. One of his many appealing qualities was his love of rambling through meadows and thickets looking for bobolinks or blue-gray gnatcatchers. I had never taken any biology courses, yet my conversations with this plainspoken outdoorsman resonated in a way that discussions of mathematical topics with George never had.

ILLUSTRATION 32

The cover of my assigned reading for a seminar I audited with Dick, Darwin's biggest fan.

If Dick had an idol, it was Charles Darwin. In a small nod to the English naturalist, he always used the name Darwin when he made a dinner reservation. To assist me in my research for a commission from the Museum of the Earth in Ithaca, an art project based on the history of life, Dick labeled a file folder "Notes from Darwin" and put in it every article on paleontology that he culled from his issues of *Science* magazine. For several years after that project was completed, he continued to add to the folder, and a decade later, when I received a similar commission in North Carolina, I dusted it off and smiled at how supportive of my career Dick was. Bryan once humorously described his father, long recognized as an exceptional mentor, as "a professor to his children and a father to his students." It was only natural that I willingly became Dick's unofficial pupil.

With Dick's encouragement, I joined him in auditing a history of science seminar, for which I had to give a presentation on Darwin's treatise *The Formation of Vegetable Mould through the Action of Worms*. I did my homework and learned more than I needed to know about soil science, reinforcing my preference for books about ecology that are written for

Plate 221

the layperson. One of my favorites in this category is David Quammen's *The Song of the Dodo*. The author himself retraced the far-flung expeditions of Alfred Russel Wallace, a nineteenth-century explorer and biologist who jointly published a paper on natural selection with Darwin. Quammen's lucid prose deepened my appreciation for Dick's research and also reminded me of my own early explorations of the natural world.

My happiest days as a child were spent scouring the countryside, coming up with myriad ways to use sticks and stones. When my mother told us to go outside, I would collect rocks, twigs, ferns, and violets to decorate the miniature garden I was fashioning among the roots of the huge beech tree in our backyard. My parents expressly forbade me to gather toadstools, which would have been ideal for fairy furniture—or so I believed, based on the illustrations in my books. Instead, I made water features by sinking flowerpot saucers into the ground and letting the rain fill them up. A visit to a Japanese garden many years later brought to mind my primordial drive to create an artificial landscape long before I was aware of such a tradition.

ILLUSTRATION 33

A page from the leaf collection I made during the summer vacation before sixth grade.

I was endlessly curious about plants, but trees, in particular, have held me in their thrall ever since I was ten and read about Yggdrasil, the immense ash tree allegedly supporting the nine worlds of gods and monsters in Norse mythology. I still have the copy of John Kieran's *An Introduction to Nature* given to me in sixth grade as a prize for my collection of pressed leaves. After collecting and pressing the seventy-odd leaves, I enveloped each one in Saran wrap and mounted it on white construction paper. I labeled every specimen, wrote out a short description, and drew a picture of the parent tree. Doing the research for that project provided an introduction to binomial nomenclature, the system of giving Latin names to organisms, which I didn't really understand at the time and would not appreciate until many years later, when Dick explained the merits of this classification.

Plate 35

Dick also taught me how to calibrate binoculars and introduced me to scuba diving and the tropics, taking me to biological reserves that would otherwise have been inaccessible to me. A few years into our courtship, Dick had to attend a meeting of the Organization for Tropical Studies in

Costa Rica. He invited me to tag along and also arranged for us to visit a field station in Panama. At that point, I had never been outside the United States except for one border crossing for a quick dinner in Tijuana, which, at the time, didn't require a passport.

In preparation for our trip, Dick snapped my picture, attached it to a passport application, and mailed it in. He also suggested I read David McCullough's *The Path Between the Seas* about the construction of the Panama Canal, which included a detailed description of U.S. Army physician William C. Gorgas's role in controlling malaria. I found McCullough's book—with its focus on a specific feat of engineering and its attendant cast of characters—even more engaging than the best fiction.

Plate 159

Dick also recommended *The Old Patagonian Express*, a travelogue in which author Paul Theroux describes his journey, mostly by railroad, from Boston to the tip of South America. I was particularly taken with his description of the train ride from San José, the capital of Costa Rica, in the middle of the country, to Limón, on the Atlantic coast. The route passes through coffee and banana plantations, continues along rickety elevated trestle tracks clinging to steep hillsides beside a raging river, then descends into steamy jungle plains before reaching the coast.

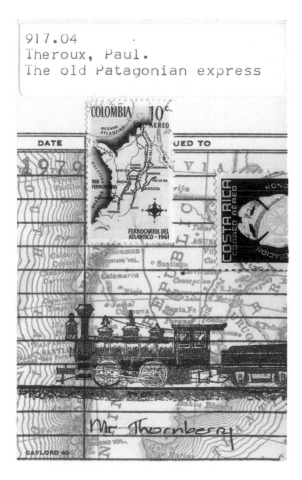

I was intent on replicating this segment of Theroux's expedition—an eight-hour round-trip journey with fifty-six scheduled stops. Over Dick's mild objections, we boarded a second-class railway carriage on our last day in San José and settled onto the hard wooden seats. Some of the stops had no station house; people just stood by the tracks waiting in what seemed like the middle of nowhere. We had the whole day, but our adventure was taking much longer than scheduled, and about halfway to Limón, Dick started to get anxious about missing our flight the next morning. I conceded, and we got off in the sizable town of Siquirres, where we planned to take a bus back to San José. At the bus depot, however, we found a long line of people waiting. It was already midafternoon, and we knew that the ride would take at least four hours. My heart sank. When a coach finally pulled up, it was much nicer than we expected and turned out to be an express bus to San José. A one-way ticket cost around $2.50, a small sum to us but too expensive for most of those standing in line. Dick and I easily found two seats next to each other, and I was relieved to be spared the remarks of an annoyed POSSLQ ("person of the opposite sex sharing living quarters"), an acronym coined

ILLUSTRATION 34

Book Marks **card for**
The Old Patagonian Express.

ILLUSTRATION 35

Terra Infidel, 1989.
One of my many
watercolors inspired
by trips to Central
America and the
Caribbean with Dick.
30 x 41 inches.
Collection of Nelson
and Whit Hairston.

by the U.S. Census Bureau in the late 1970s and one that applied to Dick, who was not yet my husband and who no doubt wished he had never suggested my reading Theroux's book.

It took about ten years for Dick and me to settle on a wedding date. Initially I had serious reservations about attaching myself to any man, especially one who might upend my family by taking a job elsewhere. My principal concern was providing a stable environment for my sons during their remaining years at home. At the time I met Dick, I was living with the boys in a small house we owned in Ithaca, across the street from their school. A year after George died, his life insurance policy had enabled me to afford the down payment, providing us a security blanket. The house's weathered brick and shingle exterior, casement windows, and small garden gave it the welcoming aspect of an English cottage. After my two-year teaching appointment ended, I managed to pay the monthly bills by selling botanical watercolors and large oils of coral reefs, both popular with corporate clients.

Despite this income, I was often stressed about money, and I found doing the job of two parents challenging. I still recall that June morning, three years after George died, when the boys wished me a Happy Father's Day, a bittersweet acknowledgment of my dual role. I was not a helicopter parent, however; I trusted my teenagers to stay out of trouble—more than I should have, it seems. As an adult, my older son occasionally reminisces about mischief and romantic dalliances I never suspected at the time. But I do remember grounding him for two weeks after finding an empty vodka bottle in the back seat of the station wagon. (I would later learn from Bryan that his father was an even more lackadaisical parent.)

Dick had his own problems to resolve before we got married. It took him many moons and much financial haggling to reach a divorce settlement. In the intervening years, we inevitably had issues over our vacillating levels of

commitment, but a therapist helped us work through them. After Paul left for college, we finally began searching for a property to buy together, with the intention of merging our households and starting anew. Dick wanted to live in the country, and I wanted to live within walking distance of a post office and library, with ready access to some sort of community. Unlike Dick, I couldn't stroll down the hall to chat with colleagues. I needed a social outlet to balance the solitude inherent in my profession as an artist. We looked at properties on and off for over two years, to no avail. Out of frustration, I began to draw up designs for a new home. Despite my efforts to keep costs down by restricting the floor plan's square footage, quotes for new construction turned out to be prohibitively higher than anticipated.

In midwinter, Dick and I finally shifted into high gear after I was unexpectedly evicted from my downtown studio when the building was sold. Almost immediately we found an old farmhouse on five acres, with fields backed by woodland. The house was overshadowed by two large silver maples, stately but messy. A derelict barn on the property had the potential to be my studio. Farther afield was a pond nearly hidden by a large briar patch. (It would take several years to remove the invasive honeysuckle and multiflora rose brambles that were tangled in a territorial dispute.)

The house was a perfect compromise, far enough from campus to appease Dick and close enough to the small village of Trumansburg for my short walk to the library. We signed a contract on the property in January and in April moved in. I had dreams of creating flower beds, a vegetable garden, and an arboretum, but first I had to strip old wallpaper and design a studio. My initial inclination was to remodel the barn for my workspace. Tracy Kidder's *House*, an instructive description of the sometimes-fraught relationships among architect, client, and builder, would be my guide throughout the construction process. After sketching out a few ideas, I hired an architect, who quickly convinced me that my studio should be built from scratch. For little more than the cost of remodeling the barn, I could have a brand-new, two-story building with clerestory windows running the length of the roofline, flooding the upstairs studio with light, and with room enough downstairs for a workshop, storage racks, and a small furnace. It was a no-brainer. By the fall I had refined my original sketches, adding a balcony and built-in flat files. The architect translated the sketches into blueprints and selected a builder who could begin work the following spring.

Plate 185

I spent that first winter reading Michael A. Dirr's *Manual of Woody Landscape Plants*, studying the growth habits of native trees and exotic cultivars. I made a wish list and spent days scrutinizing plant catalogs, searching for the perfect specimens. While Dick was not a gardener, I have never felt grounded without a garden. However, drawing up a landscape plan for a property this size was daunting. Given the scale, I used trees to form the backbone of my layout. Dick, who preferred the open skies of his Midwestern boyhood and hated mowing around obstacles, was not enthusiastic about

Plate 187

my tree-planting scheme. Once again, though, we found a compromise: I would plant most of the trees at the edges of the lawn or in the fields.

Dick and I both worshipped the natural world, but our responses to plants, large and small, were different. Whenever I joined Dick on his walks through meadows or woods, he would always carry with him *Newcomb's Wildflower Guide* in case we came across a plant he didn't recognize. Standing there, Dick would methodically use Newcomb's numerical key system to arrive at the page that identified the specimen, whereas when I was given the task, I would casually flip through the book until I saw the illustration that most resembled it. Dick was an observer, the owner of binoculars and a microscope, a naturalist writing detailed descriptions of birds, insects, and plants in one of his many notebooks, with one of his many fountain pens. I was inclined to grab a pickax, shovel, and wheelbarrow and tackle the weedy underbrush on our property.

Plate 191

I'm still at it. The two hundred daffodil bulbs I planted after we moved in thirty years ago have multiplied fiftyfold. Kentucky coffeetrees, grown from big fat seeds, now stand twenty-five feet tall. Today the property has more than forty-five species of trees, not including the apple orchard, and the flower beds feature perennials purchased years ago from Elisabeth Sheldon, an outstanding plantswoman and my late friend who once lived across the lake. Her book *A Proper Garden* describes personal horticultural triumphs and disasters in our fickle climate around the Finger Lakes and has pride of place in my collection of gardening books. On the topic of horticultural disasters, anyone who has a vegetable garden can relate to Michael Pollan's all-out war against woodchucks, vividly recounted in *Second Nature*, a collection of his essays about gardening, both amusing and profound.

Plate 204

My enthusiasm for gardening can wax and wane depending on the complexities of life, the weather, and the population of deer in the neighborhood. Generally, weeding is a tiresome chore, though on a warm spring afternoon, it is a welcome alternative to sitting at the computer. As I watched my four grandchildren grow up in the age of digital technology, I sometimes complained about the amount of time they were squandering on their various electronic devices. I enjoy posting my most recent *Book Marks* card on Instagram, but I wonder if the imagination of the younger generations is affected by spending so many hours on social media, sharing photos, videos, and rapid-fire tweets. While in cranky-old-lady mode, I provoked my sons with these musings, to which they teasingly responded, "Yes, Mom, we know you only played with rocks and sticks."

When Frances, my oldest grandchild, came to visit me for the first time without her parents, I went to Boston to pick her up. To keep her entertained on our long drive back, I borrowed a book on tape from the library. For four hours and twenty-five minutes of the drive, she dozed on and off as we listened to *Julie of the Wolves*, Jean Craighead George's novel about a young Inuit who got lost in the Arctic wilderness. Though Julie relied on the

Plate 248

practical skills passed on from her father, she might not have survived had she not been adopted by a wolf pack. Not until a few days later did I realize how much attention my seven-year-old granddaughter had paid to the book. I was preparing supper while she gathered sticks in the backyard. After a while Frances came in to ask me for some string. I gave her a ball of kitchen twine and a pair of blunt scissors. Once dinner was ready, I went out to fetch her and saw that she had arranged her collection of sticks into the shape of a ladder. The rungs and side rails were tied together with elaborately knotty knots. When I asked what she was up to, she explained that she was making an Inuit sled. I called my son George to warn him that his daughter was playing with sticks and that the next day we might play with rocks.

Years later, shortly after graduating from college, Frances came for a visit, and we went walking beside a creek bed, where we found a cluster of cairns built by passersby, perhaps as an homage to British sculptor and environmentalist Andy Goldsworthy. Frances and I decided to make one, too. When we finished stacking the stones, we balanced a stick on top, took a snapshot with my phone, and sent it to her parents.

After Dick and I moved into our house, I had to wait a year and a half for the studio to be completed. In good weather, I ventured out into the surrounding hills, wading along streambeds and carrying my new French easel, purchased for its portability. Painting *en plein air* was a challenge. I found it difficult to contain wide vistas on a small canvas, reduce verdant foliage to tiny brushstrokes, and cope with shifting sunlight. In bad weather, I focused on painting the interior walls of our century-old house. Once the studio was finished and before my art supplies were unpacked, Dick and I were married under the new structure's freshly painted cathedral ceiling in the presence of family and friends.

When I was ready to begin working, I had to confront the pristine walls and unsullied floor—appropriate for a wedding but intimidating to an artist inclined to spill paint. It took me quite a while to regain my artistic bearings. I was finally inspired by the leftover construction materials lying around the studio and began to incorporate those discarded items into my work. For one such project I used asphalt shingles as my canvas. I painted skyscapes on the back of nine shingles before placing them, sequentially by size, in a box I had built out of wood scraps. Each is separated by tarpaper and stacked like a page in a book. It would not be the first time, nor the last, that a wooden box would end up as a repository for one of my artworks.

ILLUSTRATION 36

Book Marks card for
A Proper Garden.

During that prolonged period when the studio floor remained spotless and my creative compass was pointing in no particular direction, I had spent my time reading books. Many of these took me elsewhere, whether across the Atlantic with aviator and author Beryl Markham as I read *West with the Night* or into the backstreets of Cairo, where the conniving characters portrayed in Naguib Mahfouz's *Midaq Alley* acted out their intertwining lives. But at the time, these armchair adventures fostered restlessness and did not prove conducive to creating new work. Worse, all that reading was letting the outside world into my private space.

Plate 167

Plate 184

Part of settling down in a new house or studio, I believe, is a desire to manufacture a semblance of control over our domain, to create a sort of psychological bulwark against the bad news of the day. Despite my best efforts, the outside world can sometimes infringe on my concentration and affect my ability to work, especially when an event takes hold of our collective consciousness—whether the horrors of a school shooting or the devastation wrought by a natural disaster. I scan the daily headlines but prefer to read about history in the context of a broad and critical overview, be it Bob Woodward's account of the mismanagement of the Iraq War in *State of Denial* or Dave Eggers's portrayal of one man's trials in the tragic aftermath of Hurricane Katrina in *Zeitoun*. And while not a straightforward account of historical events, Tony Kushner's play *Angels in America* weaves a stunningly complex tapestry in which politics and religion provide the warp, while AIDS and its devastation provide the weft.

Plate 291

Plate 289

Plate 212

One of the great benefits of being an artist, aside from the liberty to read until some ungodly hour of the night, is the freedom to wake up without an alarm, allowing the mind to lie fallow during that delicious period of half dozing. After dragging myself out of bed, the first order of business is a good cup of coffee, which primes me for exploring new artistic territory. Some days I stroll for only an hour before coming to a dead end. Other days I walk clear across a continent. Sometimes I immerse myself in trivialities. Other times, global events direct my work.

As our planet noticeably shuffled toward more extreme ecological imbalance, I began to examine and revise my belief in the resilience of nature, absorbing deeper truths through Dick's influence and a string of books on the subject. I was particularly struck by *The World Without Us*, in which author Alan Weisman imagines that humans, the world's most invasive species, are removed from the planet overnight. He first identifies the immediate results, such as the rapid collapse of our massive infrastructure, and then envisions how Earth would eventually recover and even thrive without us. Weisman underscores mankind's seeming inability to comprehend the effect of depleting Earth's limited reserves as the needs of an ever-increasing population grow. While we are bombarded by advertisements convincing us to buy nonessential products, we have ignored the intrinsic costs of consuming irreplaceable resources, manufacturing indestructible plastics, and relying on

Plate 296

long-distance transport. These costs are borne by an ecosystem that has taken millions of years to evolve, and the consequences have been devastating and swift.

I decided to take a break from producing work that left my studio and reappeared in banks, corporate boardrooms, and who knows where else, and explore an idea that had originated with a pile of my personal journals. It was not their content that caught my attention. It was the physical characteristics of the stack itself. Only the edges of the pages were visible within their thick cardboard covers. The striated pattern reminded me of the geological features of Taughannock Falls State Park, where, just a few miles away from my studio, the tallest waterfall east of the Mississippi plunges over two hundred feet into a rocky pool. I often walk along the rim trail overlooking the gorge, wondering how many years it took for sediments to form the layers of shale and limestone seen in the face of the cliffs. Like my stack of journals, only the outer edge of each narrow band of rock is exposed. The evidence of time's passage is visible, but the fossils that are the key to determine the age of a particular stratum are hidden deep within the rock face. I felt an urge to jackhammer into geological history and uncover its buried secrets.

Originally I intended to create an artist's book, an art object that uses the form or function of a book as inspiration. In this instance, however, I wanted to retain the book's traditional format in which the act of turning pages sets the pace as a narrative of sorts gradually unfolds. My goal was to establish a visual sense of time, since geological strata were the inspiration for the project. The most obvious way to do this was to use the planet's fossil record.

ILLUSTRATION 37
Book Marks card for *Wonderful Life*.

My introduction to paleontology was Stephen Jay Gould's *Wonderful Life*, which describes the discovery and interpretation of fossils from the Cambrian Period, when the earliest visible organisms appeared, over five hundred million years ago. It was one of many books I borrowed over the next few years from the library at the nearby Paleontological Research Institution (PRI). The illustrations in these books depict now-extinct creatures in a clear and concise manner, while the actual fossil specimens generally require a trained eye to discern their finer features. I also read *Annals of the Former World* by John McPhee, one of my favorite authors. His books have introduced me to an assortment of specialized occupations—from tugboat captain to tennis player—all of them intriguing.

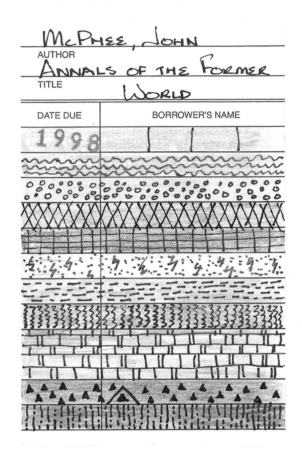

In this particular book, he probes the geological history of America, ranging from New Jersey to California, in the company of experts. My research continued as I threaded my way through dusty paleontological tomes and got permission to study fossils housed in the bowels of science museums. I knew next to nothing about dinosaurs—far less than the group of first graders I encountered on a trip to the American Museum of Natural History in New York City. Unlike those six-year-olds, I couldn't distinguish between a sauropod and theropod, but I would learn how as I slowly began to get a handle on the sequence of evolutionary developments and, equally important, extinctions.

I had been doing research on the project—tentatively titled *Rock of Ages*—for about a year, when a local gallery invited me to do a show. Among the works I included was a stack of the sketches I had made on paper while working out my ideas for the artist's book. At my invitation, Warren Allmon, the director of the PRI, whom I had gotten to know from my hours spent in the institute's library and collections, attended the opening. Impressed with the sketches, Warren told me that, in a few years, PRI was planning to build a museum to display its extensive fossil collections. He then proposed that I create a more ambitious version of *Rock of Ages* for the museum to have on permanent display, as a bridge between art and science. I thought he was joking; however, several months later I was offered a commission, pending approval by the board of directors. Given the project's new context and scale, I clearly had to rethink the format. My original sketches supplied the stimulus, but what had started as an artist's book expanded into a permanent installation towering two stories high and given the full title *Rock of Ages, Sands of Time*.

From the beginning, the installation was a central part of the new museum's design. By the time I met with the architects, my enterprise was well underway, and they were already prepared for the challenge of accommodating its lengthy sprawl. The pictorial history of visible life is displayed on 543 contiguous panels, each of which represents the passage of one million years. Fossils, of both flora and fauna, are depicted at true scale and placed in their appropriate stratigraphic positions, making their appearance in reverse chronological order, from mankind to dinosaurs and finally to the earliest marine organisms. When seen from a distance, the slim divisions between panels dissolve, and time appears to flow in a continuum. While painting them, I felt I was composing a visual symphony, resurrecting and celebrating ancient life.

Today, visitors enter the museum on the second floor, then walk down a very long ramp, traveling back in time as they pass through eleven geological periods. Almost every type of plant and animal included has been subjected to the forces of extinction and succumbed. My mission was to remind the visitor how implausibly long it has taken to arrive at the climactic complexities of the twenty-first century from so simple a beginning an eon ago. And how quickly we are approaching the sixth extinction.

Rock of Ages began with the notion of capturing time, so I found it appropriate that after the project was finished, the question most frequently asked of me was how long it had taken to complete it. My answer was: "Five years of research and production on my end, and an eon for Mother Earth and Father Time to create my subject matter." Similarly, the *Book Marks* project, to date, has absorbed many hours of my attention over a period of years, but in that time I have merely distilled the contributions of hundreds of authors, spanning the centuries from Homer to Toni Morrison. Parallels between these two projects abound: temporal structure, many independent parts forming a whole, and metaphoric use of color. In *Book Marks*, however, I have exchanged the vastness of an eon for one human life span, and, more significant, I have exchanged scientific objectivity for personal expression.

The nature of my research for writing the chapters in this book was vastly different than that for both art projects. This time I had to dig deep within myself, searching the recesses of my mind for distinctive details and stories about old acquaintances and deceased family members, all but gone except for a moment caught in a photograph. Like those old photographs, the *Book Marks* cards are a fossil record that can easily transport me back to earlier periods of my life, reminding me that time is my driver, my nemesis, and my "never-lasting" friend.

ILLUSTRATION 39

The west wall of *Rock of Ages, Sands of Time*, installed at the Museum of the Earth, Ithaca, New York, in 2003. Mixed media on 543 hardboard panels, each 11 x 11 inches. This photograph shows the lower level that represents the earlier periods.

MARTEL, YANN
AUTHOR
THE LIFE OF PI
TITLE

DATE ___ ___ER'S NAME

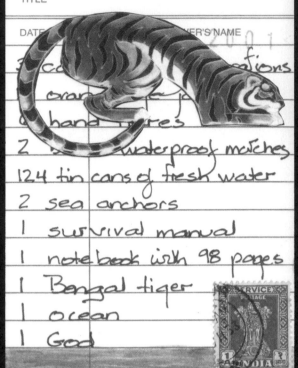

... c... ...tions
... oran... ...j...
... hand ...res
2 ... waterproof matches
124 tin cans of fresh water
2 sea anchors
1 survival manual
1 notebook with 98 pages
1 Bengal tiger
1 ocean
1 God

PLATE 225

PATCHETT, ANN
AUTHOR
BEL CANTO
TITLE

DATE DUE BORROWER'S NAME
2001

PLATE 226

DUBUS III, ANDRE
AUTHOR
HOUSE OF SAND AND FOG
TITLE

DATE DUE BORROWER'S NAME

72A - 1285
72W - 1352

Abstract of Title

PLATE 227

CHABON, MICHAEL
AUTHOR
THE AMAZING ADVENTURES
TITLE
OF KAVALIER AND CLAY

DATE DUE BORROWER'S NAME

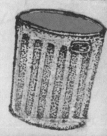

PLATE 228

CALVINO, ITALO
AUTHOR
LE COSMICOMICHE
TITLE

DATE DUE	BORROWER'S NAME
1993	

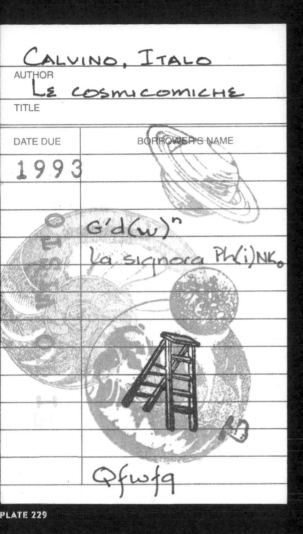

G'd(w)n

La signora Ph(i)NK.

Qfwfq

PLATE 229

ELDON, DAN
AUTHOR
THE JOURNEY IS THE DESTINATION
TITLE

DATE DUE	BORROWER'S NAME
1997	SEX

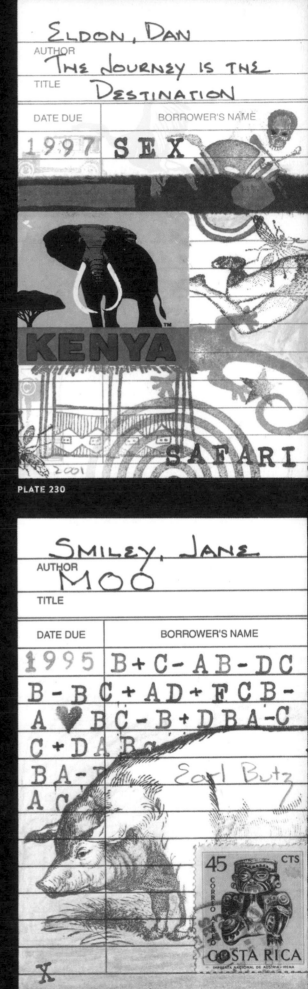

KENYA

SAFARI

2001

PLATE 230

TAN, AMY
AUTHOR
THE BONESETTER'S DAUGHTER
TITLE

DATE DUE	BORROWER'S NAME
2001	

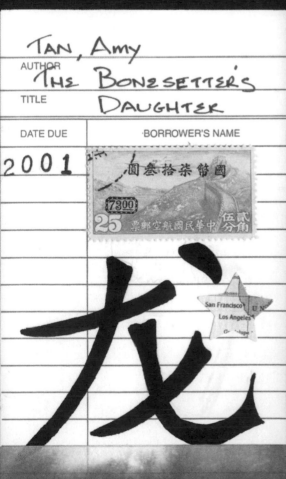

PLATE 231

SMILEY, JANE
AUTHOR
MOO
TITLE

DATE DUE	BORROWER'S NAME
1995	B + C - AB - DC
B - B C + AD + F C B -	
A ♥ B C - B + D B A - C	
C + D A B	
B A -	Earl Butz
A C	

45 CTS
CORREO
COSTA RICA

X

PLATE 232

BRYSON, BILL
AUTHOR
NOTES FROM A SMALL ISLAND
TITLE

DATE DUE | BORROWER'S NAME

PLATE 233

WAINWRIGHT, A
AUTHOR
A COAST TO COAST WALK
TITLE

DATE DUE	BORROWER'S NAME
2002	Beeline
	B...wall
	...rn
	...ence
(72)	Miles from St. Bees
	Waterfall
	Trees
	Bridge
	Buildings
	Good Footpath

PLATE 234

McEWAN, IAN
AUTHOR
ATONEMENT
TITLE

DATE DUE | BORROWER'S NAME
20..

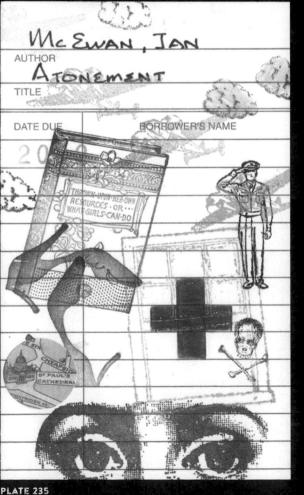

PLATE 235

BARNES, JULIAN
AUTHOR
A HISTORY OF THE WORLD
IN 10½ CHAPTERS
TITLE

MARITIMES
1990
CARGO-BOATS
FRANÇAIS

PLATE 236

F Ondaatje
Ondaatje, Michael
The English patient /

DATE	ISSUED TO
MAY 27 1997	1030
JUN 17 1997	561

1992

GAYLORD 40

PLATE 237

HODGSON, BARBARA
AUTHOR
ITALY OUT OF HAND
TITLE

DATE DUE	BORROWER'S NAME

PLATE 238

SAVIANO, ROBERTO
AUTHOR
GOMORRA
TITLE

DATE DUE	BORROWER'S NAME
2006	

PLATE 239

BASSANI, GIORGIO
AUTHOR
IL GIARDINO DEI FINZI-
CONTINI
TITLE

DATE DUE	BORROWER'S NAME
1976	

PLATE 240

c.6

Paton, Alan
Cry, the beloved country.

PLATE 241

B
Fuller

Fuller,
Alexandra,
1969-

Don't let's go to
the dogs
tonight.

PLATE 242

F
Haddon

Haddon, Mark.

The curious
incident of the
dog in the
night-time.

PLATE 243

F
Gordimer

Gordimer,
Nadine.

The pickup.

PLATE 244

F
Saramago

Saramago, Jose.

The cave.

DATE	BORROWER'S NAME

2002

937 9120614

PLATE 245

914.49 Mayle
Mayle, Peter.
A year in Provence /
Vintage Books,
1990, c1989.

DATE	ISSUED TO

70 ℃

PLATE 246

Pollan, Michael

AUTHOR

The Botany of Desire

TITLE

DATE DUE	BORROWER'S NAME

2001

PLATE 247

J
George, Jean
 Julie of the wolves.

DATE	ISSUED TO

SEP 15 1973

JUN 9 74

JUN 22 74

NOV 18 74

FEB 8 75

AUG 27 '77

OCT 1

PLATE 248

EHRENREICH, BARBARA
AUTHOR
NICKEL AND DIMED
TITLE

DATE DUE | BORROWER'S NAME

PLATE 249

GRUEN, SARA
AUTHOR
WATER FOR ELEPHANTS
TITLE

DATE DUE | BORROWER'S NAME

PLATE 250

BOURDAIN, ANTHONY
AUTHOR
KITCHEN CONFIDENTIAL
TITLE

DATE DUE | BORROWER'S NAME

PLATE 251

KURLANSKY, MARK
AUTHOR
COD
TITLE

DATE DUE | BORROWER'S NAME

PLATE 252

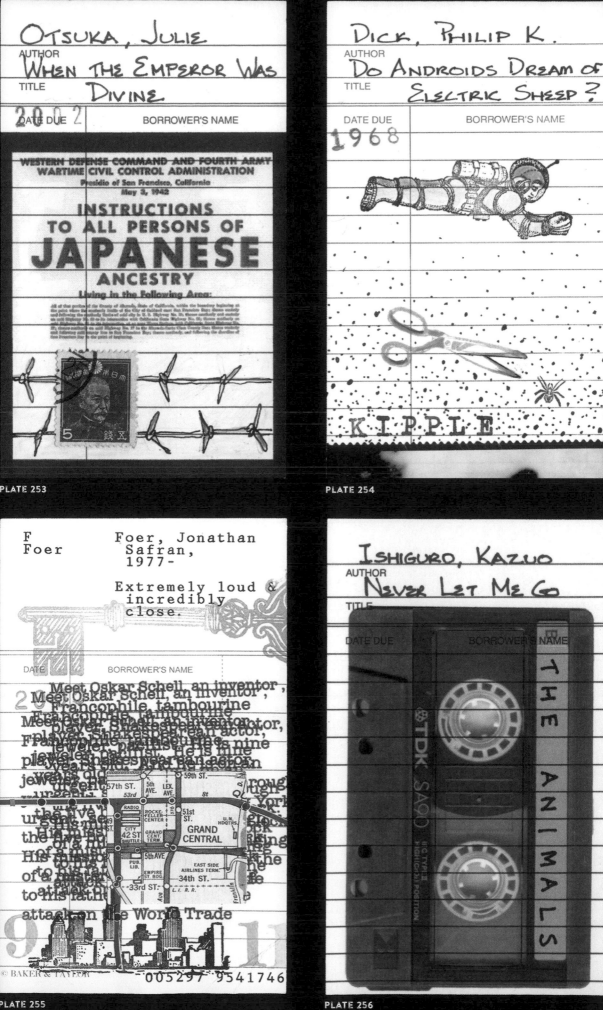

AUTHOR OTSUKA, JULIE
TITLE WHEN THE EMPEROR WAS DIVINE
DATE DUE 2002
BORROWER'S NAME

WESTERN DEFENSE COMMAND AND FOURTH ARMY
WARTIME CIVIL CONTROL ADMINISTRATION
Presidio of San Francisco, California
May 3, 1942

**INSTRUCTIONS
TO ALL PERSONS OF
JAPANESE
ANCESTRY**

Living in the Following Area:

PLATE 253

AUTHOR DICK, PHILIP K.
TITLE DO ANDROIDS DREAM OF ELECTRIC SHEEP?
DATE DUE 1968
BORROWER'S NAME

KIPPLE

PLATE 254

F
Foer
Foer, Jonathan
Safran,
1977-

Extremely loud &
incredibly
close.

DATE BORROWER'S NAME

Meet Oskar Schell, an inventor,
Francophile, tambourine
player, Shakespearean actor,
jeweler, pacifist. He is nine
years old.

© BAKER & TAYLOR 005297 9541746

PLATE 255

AUTHOR ISHIGURO, KAZUO
TITLE NEVER LET ME GO
DATE DUE **BORROWER'S NAME**

TDK SA90

THE ANIMALS

PLATE 256

BROOKS, GERALDINE
AUTHOR
MARCH
TITLE

DATE DUE	BORROWER'S NAME

2005

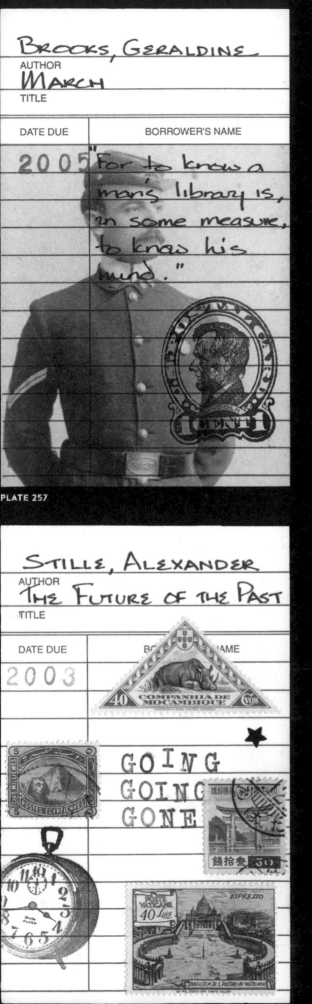

"For to know a man's library is, in some measure, to know his mind."

PLATE 257

HOEG, PETER
AUTHOR
SMILLA'S SENSE OF SNOW
TITLE

$$M = \frac{\pi D^2}{4} e_a L$$

1993

1 KR. KGL.POST
DANMARK

PLATE 258

STILLE, ALEXANDER
AUTHOR
THE FUTURE OF THE PAST
TITLE

DATE DUE	BORROWER'S NAME

2003

GOING
GOING
GONE

PLATE 259

BARRETT, ANDREA
AUTHOR
SERVANTS OF THE MAP
TITLE

DATE DUE	BORROWER'S NAME

2002

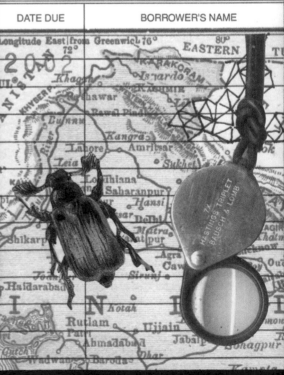

PLATE 260

PLATE 261

AUTHOR LIVIO, MARIO

TITLE THE EQUATION THAT COULDN'T BE SOLVED

DATE DUE	BORROWER'S NAME
2005	Abel

$$ax^5 + bx^4 + cx^3 + dx^2 + ex + f = 0$$

You will find your solution where you least expect it.

Galois

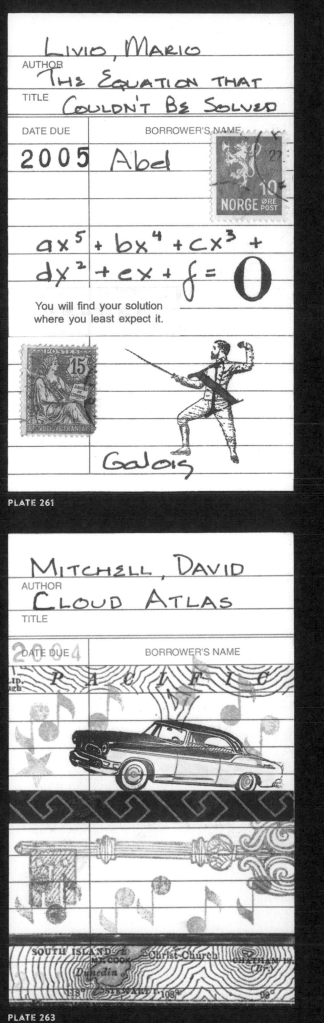

PLATE 261

PLATE 262

AUTHOR BRYSON, BILL

TITLE A SHORT HISTORY OF NEARLY EVERYTHING

DATE DUE 2003	BORROWER'S NAME

Your road to glory will be rocky, but fulfilling.

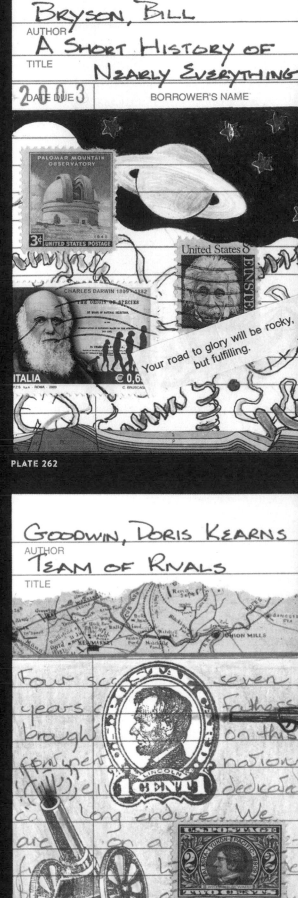

PLATE 262

PLATE 263

AUTHOR MITCHELL, DAVID

TITLE CLOUD ATLAS

DATE DUE 2004	BORROWER'S NAME

PACIFIC

PLATE 263

PLATE 264

AUTHOR GOODWIN, DORIS KEARNS

TITLE TEAM OF RIVALS

Four score and seven years ago our fathers brought forth on this continent a new nation... can long endure. We are ... as a final

PLATE 264

FADIMAN, ANNE
AUTHOR
EX LIBRIS
TITLE

DATE DUE BORROWER'S NAME

2000

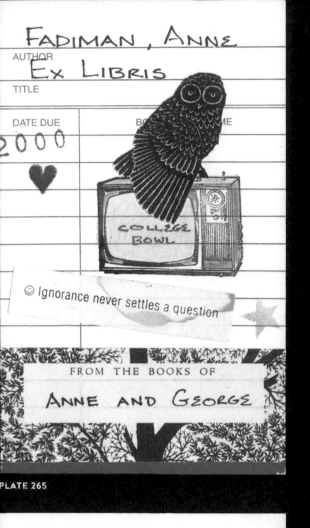

COLLEGE BOWL

☺ Ignorance never settles a question

FROM THE BOOKS OF
ANNE AND GEORGE

PLATE 265

SA, SHAN
AUTHOR
GIRL WHO PLAYED GO
TITLE

DATE DUE BORROWER'S NAME

2003

PLATE 266

Alexie, Sherman
AUTHOR
The Absolutely True Diary of a
TITLE Part-Time Indian

DATE DUE BORROWER'S NAME

2007

REZ

PLATE 267

GRANDIN, TEMPLE
AUTHOR
THINKING IN PICTURES
TITLE

DATE DUE BORROWER'S NAME

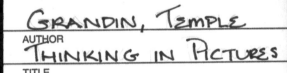

1995

HEATING DUCT

PLATE 268

ACKERMAN, DIANE
AUTHOR
THE ZOOKEEPER'S WIFE
TITLE

DATE DUE	BORROWER'S NAME

PLATE 269

F
Smith Smith, Zadie.
 On beauty.

DATE DUE	BORROWER'S NAME

VERITAS

001025 9881056

PLATE 270

DAVIDSON, CATHY N
AUTHOR
36 VIEWS OF MOUNT FUJI:
TITLE
ON FINDING MYSELF IN JAPAN

DATE DUE	BORROWER'S NAME

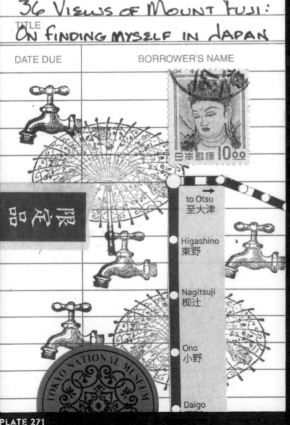

to Otsu
至大津

Higashino
東野

Nagitsuji
椥辻

Ono
小野

Daigo

PLATE 271

915.104 Troost, J.
Troost Maarten.

 Lost on planet
 China.

2008	BORROWER'S NAME

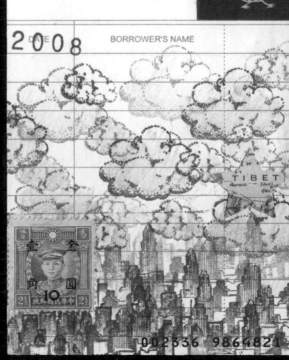

TIBET

002536 9864821

PLATE 272

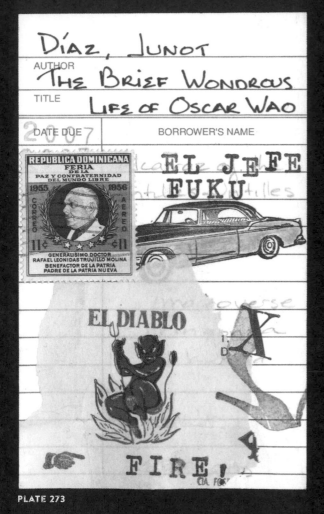

AUTHOR Díaz, Junot

TITLE The Brief Wondrous Life of Oscar Wao

DATE DUE 2007 | BORROWER'S NAME

PLATE 273

006.7 Mezrich Mezrich, Ben, 1969-

The accidental billionaires.

DATE 2009 | BORROWER'S NAME

© BAKER & TAYLOR 004517 9285856

PLATE 274

AUTHOR Verghese, Abraham

TITLE Cutting for Stone

DATE DUE | BORROWER'S NAME

PLATE 275

AUTHOR Watson, Christie

TITLE Tiny Sunbirds Far Away

DATE DUE 2011 | BORROWER'S NAME

PLATE 276

WROBLEWSKI, DAVID
AUTHOR
THE STORY OF EDGAR SAWTELLE
TITLE

DATE DUE | BORROWER'S NAME

A	B	C	D	E
F	G	H	I	J
K	L	M	N	O
P	Q	R	S	T
U	V			

PLATE 277

KINGSOLVER, BARBARA
AUTHOR
THE LACUNA
TITLE

DATE DUE | BORROWER'S NAME

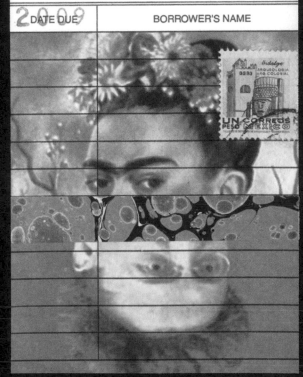

PLATE 278

McCARTHY, CORMAC
AUTHOR
THE ROAD
TITLE

DATE DUE

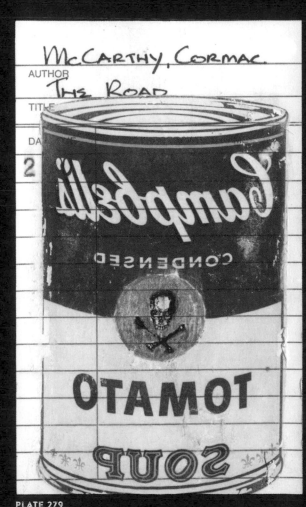

PLATE 279

STEIN, GARTH
AUTHOR
THE ART OF RACING
TITLE
IN THE RAIN

DATE DUE | BORROWER'S NAME

PLATE 280

AUTHOR Nafisi, Azar
TITLE Reading Lolita in Tehran

2003 DATE DUE	BORROWER'S NAME

DO NOT CRUSH

US

PLATE 281

AUTHOR Nabokov, Vladimir
TITLE Lolita

1958 DATE DUE	BORROWER'S NAME

Lo

MOT

PLATE 282

AUTHOR Austen, Jane
TITLE Pride and Prejudice

1813

PLATE 283

AUTHOR Stockett, Kathryn
TITLE The Help

DATE DUE	BORROWER'S NAME

PLATE 284

COLE, TEJU
AUTHOR
OPEN CITY
TITLE

PLATE 285

EUGENIDES, JEFFREY
AUTHOR
THE MARRIAGE PLOT
TITLE

DATE DUE	BORROWER'S NAME

PLATE 286

DONNELLY, JENNIFER
AUTHOR
REVOLUTION
TITLE

PLATE 287

FRANZEN, JONATHAN
AUTHOR
FREEDOM
TITLE

DATE DUE	BORROWER'S NAME

PLATE 288

B
Zeitoun

Eggers, Dave.

Zeitoun.

PLATE 289

FRIEDMAN, THOMAS L

AUTHOR

THE WORLD IS FLAT

TITLE

PLATE 290

WOODWARD, BOB

AUTHOR

STATE OF DENIAL

TITLE

DATE DUE BORROWER'S NAME

PLATE 291

347.73
Toobin

Toobin, Jeffrey.

The nine.

PLATE 292

OBAMA, BARACK
AUTHOR
DREAMS FROM MY FATHER
TITLE

DATE DUE	BORROWER
1995	

PLATE 293

330.973 Lewis, Michael
Lewis (Michael M.)

The big short.

2010	BORROWER'S NAME
	AIG FP
	CDS
	S&P
	ARM
	BBB-
	CDO
	FICO
	CEO
	ISDA
	SEC

© BAKER & TAYLOR

000527 4622983

PLATE 294

EGGERS, DAVE
AUTHOR
WHAT IS THE WHAT?
TITLE

DATE DUE BORROWER'S NAME

PLATE 295

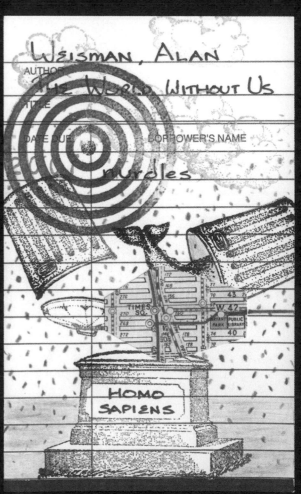

WEISMAN, ALAN
AUTHOR
THE WORLD WITHOUT US
TITLE

DATE DUE BORROWER'S NAME

hurdles

HOMO
SAPIENS

PLATE 296

RACHMAN, TOM
AUTHOR
THE IMPERFECTIONISTS
TITLE
2010 DATE DUE BORROWER'S NAME

PLATE 297

EGAN, JENNIFER
AUTHOR
A VISIT FROM THE GOON
TITLE SQUAD
2010 DATE DUE BORROWER'S NAME

PLATE 299

SLOAN, ROBIN
AUTHOR
MR. PENUMBRA'S 24-HOUR
TITLE BOOKSTORE
2012 DATE DUE BORROWER'S NAME

PLATE 298

JOHNSON, ADAM
AUTHOR
THE ORPHAN MASTER'S
TITLE SON
2012 DATE DUE BORROWER'S NAME

PLATE 300

AUTHOR FAULKS, SEBASTIAN
TITLE A WEEK IN DECEMBER

DATE DUE	BORROWER'S NAME

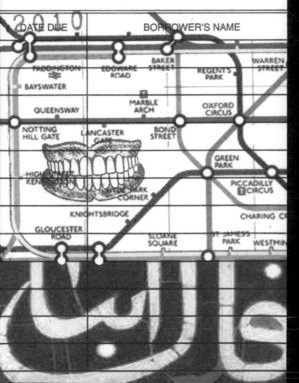

PLATE 301

AUTHOR THORNTON, SARAH
TITLE SEVEN DAYS IN THE ART WORLD

DATE DUE	BORROWER'S NAME
2008	

PLATE 302

AUTHOR BROOKS, GERALDINE
TITLE CALEB'S CROSSING

DATE DUE	BORROWER'S NAME

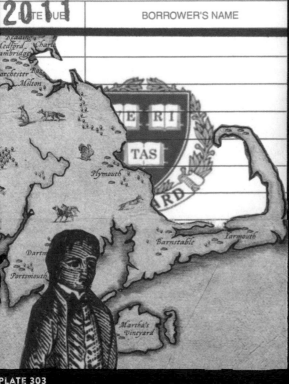

PLATE 303

AUTHOR ONDAATJE, MICHAEL
TITLE THE CAT'S TABLE

DATE DUE	BORROWER'S NAME

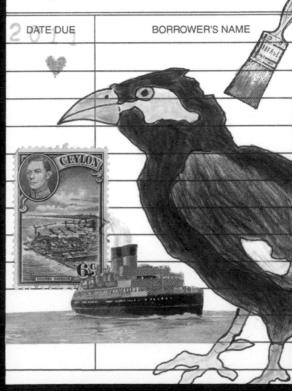

PLATE 304

AUTHOR HARUF, KENT

TITLE PLAINSONG

DATE DUE 1999	BORROWER'S NAME

PLATE 305

AUTHOR HARUF, KENT

TITLE EVENTIDE

DATE DUE 2005	BORROWER'S NAME

PLATE 306

AUTHOR ATKINSON, KATE

TITLE LIFE AFTER LIFE

DATE DUE 2013	BORROWER'S NAME

Born 1910

Died 1910, 1914, 1918
1940, 1945, 1947, 1967

PLATE 307

AUTHOR EDWARDS, KIM

TITLE THE MEMORY KEEPER'S DAUGHTER

DATE DUE 2005	BORROWER'S NAME

PLATE 308

GARDAM, JANE
AUTHOR
OLD FILTH
TITLE

DATE DUE
2004

avoid memory

LOSS

PLATE 309

MATTHIESSEN, PETER
AUTHOR
THE SNOW LEOPARD
TITLE

DATE DUE BORROWER'S NAME
1970

Dear Dad,
How are you.

By By a millyon
times for now.
Your sun
Alex

PLATE 310

PATCHETT, ANN
AUTHOR
STATE OF WONDER
TITLE

DATE DUE
2011

PHARMACY

UNITED STATES PO

PLATE 311

SCHWALBE, WILL
AUTHOR
THE END OF YOUR LIFE
TITLE
BOOK CLUB

DATE DUE BORROWER'S NAME
2012

Tropic of Cancer

THROWN-UPON-HER-OWN
RESOURCES · OR
WHAT·GIRLS·CAN·DO

WORLD REFUGEE YEAR

UNITED STATES POSTAGE 4¢

PLATE 312

How many days of my life have passed without distinction? Probably eighty-nine percent of them. Among the other eleven percent are the days I spent trekking long distances, whether hiking along the classic Tour du Mont Blanc or on the 150-kilometer Alta Via 1 through the Italian Dolomites. Maybe these remain vivid in my memory because of the steady and leisurely pace necessitated by carrying a heavy backpack. Or, maybe, walking for days on end through unfamiliar territory simply provides more stimulation than idling at home, bound up in routine and forgettable chores. Regardless, time seems to slow on the trail as my ability to pay attention to people and places recharges to full capacity.

Plate 180

Sometimes while I'm hiking and humming to myself, my musings turn to *The Songlines*, a funny and philosophical travelogue in which author Bruce Chatwin contemplates the value of a wandering life as he traverses the Australian outback with a bushwalker. The two men followed ancient and well-traveled pathways of Aboriginal tribes made visible by "songlines," oral "maps" that call up geological features and waterways, guiding travelers through the landscape. This rhythmical method of orientation sounds enchanting, but I am, of necessity, a devotee of maps on paper.

One notable hike began with an overnight flight from New York City to London. Meredith, my trekking partner, and I were crossing the Atlantic Ocean to meet up with Nancy and Ineke, two other friends from the States. We were heading to Northern England to do the Coast to Coast Walk, an adventure proposed by Ineke, our enthusiastic ringleader. I had begun long-distance hiking several years before with Meredith and Ineke, leaving our husbands behind, bound up in their jobs. Besides, Dick was not a hiking enthusiast except for day trips to observe birds, plants, and broad vistas. He routinely saw me off on such adventures, watching me put on my sturdy boots, without envy. Though for this trip he might have felt a little pang, since he cherished England and its people as much as I did.

Midway into the flight, I sat cramped and petrified in my window seat as storms below rocked our plane, producing a continuous pyrotechnic display in the night sky. I watched sprite lightning illuminate the tops of thunderclouds while Orion rolled around the plane's wingtips, bucking as if inebriated. Fear made me wonder why on earth I was taking this trip. Were we about to crash? Was our plan to walk the roughly 190 miles from the Irish Sea to the North Sea too ambitious? Even before the storm I had been anxious. We had booked rooms for only the first night. Accommodations for the following two weeks were left to chance. I knew we couldn't even count on good weather, only blisters. Plus, I have been nervous about commercial flights since 9/11. Now, as I sat looking out my window, the whole thing seemed like folly.

Meredith and I arrived sleepless at Gatwick and made our way to London to catch the Glasgow Central to Carlisle, three hundred miles north. At the station, I noticed that the platform where we were waiting had benches made out of solid stone. Each one had an inscription indicating the type and age of the rock and the locality in England from which it had been mined. Since the Coast to Coast Walk begins in the ancient village of St. Bees, I took it to be a good omen that one of the benches was fashioned out of St. Bees sandstone, dating from the Triassic Period, 250 million years ago. Having just completed the *Rock of Ages, Sands of Time* project, I found the reference to Earth's history comforting after our harrowing flight. It felt like that bench was welcoming me to the very country where the foundations of geological science are embedded.

My view of the English landscape had been forever altered by reading *The Map That Changed the World*, in which author Simon Winchester describes the feats of William Smith, considered the father of English geology. This miner and surveyor, born in 1769, was the first person to recognize that sedimentary rock was laid down in a predictable order and that the type of fossils embedded in a particular stratum indicated its relative age. It may seem obvious now, but at the time, the idea was revolutionary. Smith went bankrupt as a result of his efforts to publish the first map of Britain's underlying terrain, and he was sent to prison for his debts. It was only at the end of his life that the Geological Society of London recognized his achievements. On our impending walk across the very same terrain Smith had mapped, I intended to collect rock samples, even if they did add weight to my burden.

ILLUSTRATION 40

Book Marks card for *The Map That Changed the World*.

Before a hike, when I select what goes into my backpack, I always squeeze in my journal along with a couple of books about the country I'm visiting. I often resent the extra weight, but at least books don't need to be recharged. On this trip, I packed a trail guide and two paperbacks, not expecting to read much, since we would be walking most of the time, and, in the evenings, I planned to record the salient details of each day's activities in my journal.

The Glasgow Central arrived at noon, as scheduled. Meredith and I boarded and settled into our seats. I pulled out Bill Bryson's *Notes from a Small Island*, and for the next four hours I either stared out the window in a sleep-deprived coma or laughed out loud at snatches of Bryson's humorous love

Plate 233

letter to Great Britain. I was about to spend fifteen days walking across the hills, dales, and moors of the same countryside that Bryson had traveled by train, bus, and foot. Perhaps the four of us, like Bryson, would soon be ambling through a marsh in a typical English drizzle, and our own hiking boots would end up laden with a heavy mixture of mud and gravel, which Bryson uproariously likens to muffins with raisins. Or did I dream up this simile as I dozed off during the train ride?

When we arrived at Carlisle, our train tickets for the last leg of the trip were essentially invalid, since the railroad workers had just gone on strike. As we headed to the bus station to catch a red double-decker to our destination, I considered it another good omen that we had been able to travel this far before the strike began. Once at St. Bees, we walked a short distance to the bed-and-breakfast near the start of the trail. There we found our two friends waiting out front. Ineke and Nancy had flown into Manchester and, finding themselves stranded there by the railway strike, had hitchhiked the 125 miles to St. Bees, the last three in a cement truck.

The next morning, September 11, we found a small American flag stuck into a vase of phlox in the center of the breakfast table. This sympathetic gesture of remembrance on the first anniversary of the tragic attack on American soil was very touching. The weather was just as clear and mild as it had been the day the planes flew into the towers of the World Trade Center and the Pentagon. After a breakfast of bangers, poached eggs, and cold toast, we pulled on our backpacks and headed out to the lighthouse overlooking the Irish Sea. We had decided to take the scenic route along the seaside bluffs and proceed inland to the village of Cleator for lunch. That morning, the owner of the bed-and-breakfast had recommended a certain shop there, insisting we try their highly touted meat pies.

ILLUSTRATION 41

My copy of Alfred Wainwright's indispensable and charming guide to the 190-mile hike across England.

We climbed the first of many stiles and passed a sign, QUIET BULL IN FIELD, which, without a comma after "quiet," I incorrectly read as a reassurance rather than a warning. Fortunately, the "quiet bull" was nowhere to be seen. By the time we arrived in Cleator, the pies were already sold out. We ate our emergency rations before pressing on to the small town of Ennerdale Bridge, following the directions in A. Wainwright's essential guidebook *A Coast to Coast Walk*. Foremost among this book's charming attributes are the author's numerous and dense pen-and-ink sketches of churches, bridges, and waterfalls. The intricately rendered details of landmarks are paired with his invaluable directions, printed as if handwritten. Astonishingly, this compact book also contains hundreds of maps with sharp twists and unexpected turns, all drawn by the author. These route maps are reproduced at a scale of two inches to every mile, and we would move through the guide's 160 pages at an average rate of 11 pages, or about 13 miles, per day.

Plate 234

136 **BOOK MARKS**

That first day's route took us across a boggy field, where Meredith sank into a foot of mud while crossing a ditch. After swearing profusely, she trudged onward in wet boots without further complaint. On the long climb to the upper reaches of Dent, the high moorland we were passing through, we met a friendly farmer who filled our nearly empty water bottles from a tap in his barnyard. We learned that he and his wife had planned to do the Coast to Coast Walk when they retired. They had finally paid off the forty-year mortgage on their farm that May. Not even two months later, before they had a chance to make the trek, his wife died suddenly. Now sixty-eight and a widower, the farmer just kept on working the land. As we left him, I had the distinct feeling he would have liked to drop everything and join us. I imagine that whenever he encounters hikers crossing through his farm on the trail, he recalls the dream he and his wife would never realize together.

Within an hour we reached the top of Dent Fell, where we beheld a splendid panorama stretching out in all directions. To the west we could see the Isle of Man, and northward lay the coastal plain stretching toward Scotland. We turned eastward to continue our journey, sparing a few more moments to take in the green hills of the Lake District ahead of us. The profile of Scafell Pike, the tallest mountain in England, was easily visible against the cloudless sky. (We would not climb it on this trip, but some years later I would do so with my son Paul and his family. We shamelessly used chocolate to bribe Declan, the youngest, to keep going, but at six years old, he rightfully grumbled through much of the tough, eight-hour hike.)

Having chosen, at the urging of our guidebook, to take this more picturesque route over Dent Fell instead of the direct road, we were somewhat taken aback by the extremely steep, five-hundred-foot descent before us. Was Wainwright possibly trying to discourage fainthearted travelers from completing the Coast to Coast Walk? The four of us had just started downhill, weaving back and forth in self-imposed switchbacks, when we dropped to our knees in terror as a low flying RAF fighter plane streaked above our heads. Its deafening sonic boom thundered a few seconds behind it. We immediately thought of the victims of the incessant bombing reported from Afghanistan and continued our descent in silent empathy.

ILLUSTRATION 42

My hiking partners on the Coast to Coast Walk, as we head to England's Lake District, 2002.

We eventually made it safely to the bottom. A mountain biker, resting beside a brook, confirmed that we were on the correct path to our destination, and so we headed upstream through the steep and narrow Nannycatch Valley.

Within a few minutes the bicyclist passed us, weaving among stones in the shallow water beside us. Then, right before our eyes, his bike wobbled and fell over, and he grabbed his obviously dislocated shoulder in agony. We didn't take time to remove our packs before wading in to help him up and drag his bike out of the stream. After recovering from his shock, the young man was determined to push his bike the rest of the way without assistance. He walked only a few feet before he admitted the pain was too great. I pulled a red silk scarf out of my backpack and made a sling to bind his arm in place. We then proceeded uphill for two miles through what was really a ravine, the four of us taking turns pushing his bike. At the head of the valley, we left our grateful companion at the house of his father's friend, and he promised to have my scarf returned to me at the inn he recommended in nearby Ennerdale Bridge.

Our weary troop of four headed into town, quickly reaching the Shepherds Arms Hotel, only to learn that there was no vacancy. We had just hiked a full fifteen miles, and none of us was able to go any farther. Seeing the look on our faces, the proprietor called the owners of a nearby bed-and-breakfast that had been closed due to slow business resulting from an outbreak of hoof-and-mouth disease the previous year. Agreeing to take us in, the elderly couple gave us tea and set Meredith's still-soggy boots in front of the fire to dry. While our hosts made up our beds, the four of us put our feet up, too exhausted even to talk. We finally gathered the energy to shuffle back to the Shepherds Arms for dinner. Upon arriving, we learned that someone had tried to return my scarf but, finding we weren't registered, had left with it in hand. I hope our biking friend still has it as a memento of a day I, for one, will never forget.

The night passed, and after breakfast we pulled on our backpacks to continue our trek. Over the next fourteen days we would walk through the towns of Seatoller, Kirkby Stephen, and Danby Wiske by way of Greenup Gill and Clay Bank Top. England has such charming place-names that part of the joy of traveling through the countryside immortalized by both Beatrix Potter and the Brontë sisters is twisting your tongue around these names. We crossed fields dotted with flocks of sheep, varieties called Derbyshire Gritstone, Wensleydale, Hebridean, and Manx Loaghtan. I haven't the faintest idea how I learned those different breeds, as I didn't record the source. But the names are in my journal, following an entry about enjoying a pint of Black Sheep Ale at a pub in Reeth, so no doubt our bartender must have supplied the information.

The first thing we did on arriving at Robin Hood's Bay was to walk through the village to the North Sea and photograph our boots in the seaweed as proof we had just completed the Coast to Coast Walk. After taking in the salt air and observing the distant clouds that looked like waves about to break over the cargo ships on the horizon, we went to Wainwright's Bar, named in honor of the author of our guidebook. We each raised a pint in a toast to him—a fitting finale to our journey.

The next morning, Meredith and I made our way to London by express train; the strike was over. As we traveled south, the sands of time began to trickle more rapidly through the hourglass. My sense of time was further warped as I blasted through *A History of the World in 10 ½ Chapters*. In only a few hours, author Julian Barnes took me on a bizarre ride through several thousand years, beginning with the tale of Noah's Ark as told from a shipworm's point of view and ending with a 450-yard touchdown thrown on the moon.

Plate 236

One of the challenges of traveling to foreign countries can be communication. In second grade Madame Périchon had taught my French class to play bingo with images instead of numbers on the cards, matching pictures of sharks and watermelons to words she pronounced in French. I can still stump friends who have degrees in French literature with my unusual vocabulary, including *requin* and *pastèque* (see above for English), but I can barely put a phrase together beyond *J'ai oublié tout*—I *have* forgotten everything. Later, I chose to study Latin and ancient Greek, but these nearly dead languages are rarely spoken. In fact, I couldn't imagine anyone casually discussing the weather in Latin, at least not until reading *The Future of the Past*, a collection of Alexander Stille's essays on disappearing histories and their reincarnations. He wrote about Reginald Foster, a charismatic and popular papal secretary who taught conversational Latin to enthusiastic students, using the streets of Rome as his classroom. Perhaps if Foster had been my teacher, I might have shed my anxiety about stammering in a foreign language—dead or alive.

Plate 259

Three years after getting married, Dick and I began to plan a trip to Italy together. I listened to language tapes for a couple of months with the intention of learning a few essential phrases. My background in Latin helped, and by the time we arrived in Montalcino, a small hilltop town in Tuscany, I had improved enough to have my inept attempts to communicate rewarded by our wizened innkeeper with a kiss bestowed on each of my cheeks. His appreciation for my effort was all the incentive I needed to dig deeper into

the language. I wanted to speak Italian without having to translate each word from English. I wanted to dream in Italian. A few years ago, when I read Jhumpa Lahiri's memoir, *In Other Words*, in its original Italian, I related to her passion to master the vocabulary. All of her previous books had been written in English, her native language. Her parents had emigrated from India to London, where she was born. Soon after, the family moved to America. When reading about Lahiri's sojourn in Rome, I was impressed that she had uprooted her family with the sole purpose of immersing herself in yet another language. I respected her absolute commitment to the exercise, underscored by her refusal to do the English translation for the bilingual edition of *In Other Words*. Moving to Italy was a drastic option I wasn't ready to pursue, so I simply enrolled in an Italian class soon after Dick and I got home.

The class was taught once a week, in the evening. The teacher was not a native speaker and, unfortunately, had no sense of what was appropriate reading material for a beginner. She assigned the class an Italian novel that recounted, in part, the trials of partisans slogging through rain during World War II. I will never forget *fango*, the word for "mud," but I have long since forgotten the title of the book. Almost all my classmates dropped by the wayside like the wounded soldiers in the story. The two remaining stalwarts—Joan and Mary Ellen—would become my friends and travel companions. After finishing the course, we struck out on our own without the aid of a teacher, tangling with irregular verbs and mangling pronunciation in our unique dialect. These efforts would eventually lead to our being able to tackle *Le Cosmicomiche*, Italo Calvino's fanciful romp around our galaxy—yet another book about the passage of time in which the unpronounceable Qfwfq, the indefinable narrator, leads the reader from the Big Bang to Wall Street at the speed of light.

Plate 229

A few years later, after the three of us thought we had reached a basic level of competence, we decided to take a two-week course in Italian at the Scuola Dante Alighieri in Siena, stopping off in Milan and Venice beforehand, with plans to spend four days in Rome afterward. On our first day at the school for foreign students, we were required to take a placement exam. Joan was put in one class, while Mary Ellen and I were assigned to another. Our energetic teacher began with the subjunctive used as an independent clause—useful if you wish to say, "May Jove strike down all my enemies with a single thunderbolt." Mary Ellen and I were struck dumb, as we were still struggling with how to say, "Please pass the salt." My blunders were frequent and often embarrassing. One morning, during our break from class, I went down to the "bar" on the piazza for a cappuccino. I was hungry and asked the young man behind the counter for a croissant, calling it a *cornuto*. He looked at me askance as he put the pastry in a bag. The Italian word for "croissant" is *cornetto*. *Cornuto* means "cuckold."

When not at school, the three of us would lose ourselves in Siena's maze of streets. Already fluent in Spanish, Joan had the confidence to chatter happily in Italian with waiters and shopkeepers, while Mary Ellen and I

stood by, befuddled by a crippling awareness of our shortcomings. Hoping to improve our fluency, the two of us had dropped into a lower-level class to focus on conversation and not ever more complicated grammar. We were dismayed when the new instructor started with the *passato remoto*—a past tense used almost exclusively in literature—and with the peculiarities of Italian prepositions.

One day we were handed a homework assignment that required us to insert the correct prepositions into a literary passage littered with blank spaces. I happened to recognize this lengthy quotation from Antonio Tabucchi's *Notturno Indiano*, a mysterious novella describing one man's odyssey through India. I took advantage of this fortuitous opportunity and went straight from school to a *libreria* to buy the book. That afternoon Mary Ellen and I sat on the sunny terrace of our small hotel and chuckled as we copied the correct answers onto the homework sheet. Needless to say, taking this tack didn't help us gain a proper grasp of either grammar or conversational Italian.

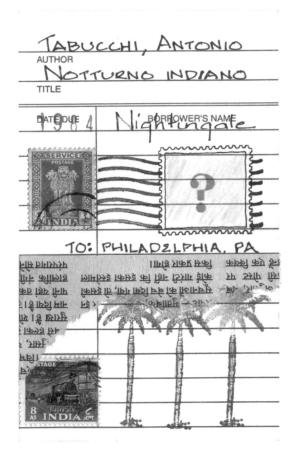

ILLUSTRATION 44

Book Marks card for *Notturno Indiano.*

Plate 319

When the course ended, Mary Ellen and I felt we had paid $300 to learn how to pronounce *qualsiasi* correctly—"whatever" being a useful term in Italian, without the dismissive overtones of American slang. I suppose the school wasn't entirely to blame.

From Siena, the three of us made our way to the Eternal City, subject of Robert Hughes's meticulously researched *Rome*, which many years later would become my wake-up-in-the-middle-of-the-night-reading-in-bed book. When we had begun planning the trip, an expat friend of Joan's, knowing she didn't squander money, booked us two rooms in an inexpensive *pensione* in Rome's Trastevere quarter. Mary Ellen, unlike Joan and me, typically stayed in good hotels and was not prepared to carry her suitcase up three flights of stairs, especially at age seventy. Even more of a shock to her system was finding her room furnished like a nun's cell, with a cross hanging on a wall, one straight-backed wooden chair, a single bed, and a shared bathroom at the far end of the corridor. Leaving Mary Ellen to settle in, Joan and I trudged up to our fifth-floor room with heavy baggage and even lower expectations. The room did not disappoint. We opened the door to our garret with two single beds, each covered by an atrocious corduroy spread the color of cheap red wine.

Not long after we finished unpacking, Mary Ellen appeared at our door in her bathrobe, begging for help. She had gone down the hall to take a shower, first turning on the faucet marked "C." Scalding water instantly

streamed from the showerhead, preventing her from reaching for the other faucet to turn on the cold water. Joan and I poked our heads out into the hallway and saw steam rising up the stairwell from two flights below. Joan, given her ability to communicate in Italian, was delegated to go down to speak to the proprietor. He gave her a stern lecture about turning on the cold water first, which Mary Ellen thought she had done, forgetting that, in Italy, the faucet marked "C" stands for *caldo*, meaning "hot." While Joan was downstairs getting a lecture she didn't deserve, Mary Ellen and I collapsed on the beds in gales of laughter.

Plate 320

When I got home, I continued to study Italian, having learned that travel inevitably generates situations in which dictionaries are no help. My *Cassell's Italian-English, English-Italian Dictionary*, however, has been indispensable for translating the many books I have read in their original Italian, from Giuseppe Thomasi di Lampedusa's *Il Gattopardo* to all four volumes of Elena Ferrante's Neopolitan saga. Most of these I read as part of the Italian reading group Mary Ellen, Joan, and I started shortly after getting back from our trip. Our weekly congregation, since expanded to six members, still meets under the tutelage of a native speaker. A few years ago I switched to e-books, downloading our selections onto my iPad. After spending over twenty years shuffling through Cassell's pages, I was pleased to discover that by my simply touching an Italian word on the screen, its definition pops up. Modern technology does have its advantages!

Dick and I took a trip to England a few months after my return from Italy. Even though on the surface the King's English is comprehensible to Americans, I am always confounded by colorful British slang, words such as "chuffed," "whinger," and "chin wag." Dick and I had traveled there several times since our first trip together over ten years before, when I joined him on his spring sabbatical at Merton College in Oxford. For this trip, we had a full agenda. Dick was looking forward to reconnecting with colleagues in London at an annual ecology conference, while I planned to visit the delightfully esoteric house of neoclassical architect Sir John Soane. I was in the beginning stages of working on the *Rock of Ages* project, so I also spent time at the Natural History Museum, studying their fossils.

After Dick's conference was over, the two of us indulged in a pleasant holiday on the coast of Cornwall. Every morning we would sling binoculars around our necks, put on our daypacks, and follow winding footpaths through the countryside, visiting small towns for lunch or cream tea. Somehow during those six days in Cornwall, Dick got it into his head that he wanted a corgi. I'm not positive that Queen Elizabeth's passion for this particular breed of dog had anything to do with his choice, but the timing was suggestive.

A few days after announcing he wanted what the Welsh call a "dwarf dog," Dick and I were walking to the small fishing village of Polruan, when we passed the Church of St. Willow. In the middle of a discussion having

nothing to do with corgis, Dick commented that "Willow" would be a very good name for the prospective puppy I had not yet agreed to get. At first I was not enthusiastic about the idea, so Dick embarked on a mission to convince me. After returning to the States, he purchased several books describing the different characteristics of every breed of dog in America. He also insisted we go to the annual dog show sponsored by the Finger Lakes Kennel Club, at which 132 breeds were competing that year, or so I remember. By the end of the show, the furry beasts had me figuratively wrapped around their leashes.

It also helped Dick's cause that I have always been a sucker for novels about dogs, starting with *Lassie Come-Home* and, more recently, Garth Stein's *The Art of Racing in the Rain*, a sentimental read that was written as if narrated by a golden retriever. I soon surrendered and consented to share the responsibilities of raising a corgi. Dick and I went to a kennel to choose a puppy, and soon six-week-old winsome Willow came to live with us. She had oversized ears and outsized paws, but her legs were so short, she couldn't climb a step by herself. We kept her in the back half of our home until she was housebroken, blocking access to the front rooms with a six-inch-high board we referred to as the Berlin Wall.

Plate 29

Plate 280

Once a week Dick and I took Willow to puppy obedience class, where she was interested only in snooping for dog treats accidentally dropped into the sawdust. The three of us often ended up on the sidelines while the other dogs learned to sit, stay, and lie down. Feeling like a failure because of Willow's refusal to cooperate, I paid close attention to the instructor so I could learn how to teach each of the commands. At home, Willow and I went through the exercises out in the backyard, with me bestowing treats for heeling and rolling over. Without distractions, Willow was a quick study and soon acquired a large vocabulary.

Three years after Willow joined our household, Dick decided to spend his upcoming six-month sabbatical at the Bodega Marine Laboratory in California, where he intended to finish a research paper. Dogs were not allowed in the apartment we were assigned by the lab, so my older son and his wife, who were expecting a baby, did us the tremendous favor of sharing their home in Boston with Willow. When my first grandchild was born three months later, I flew back East. Willow, of course, thought the visit was all about her, so I spent most of the week holding the corgi and baby Frances together in my arms. As Frances adores corgis to this day, we suspect that she imprinted on Willow, who often stuck a damp black nose in her face.

Over the years, Willow grew older, and so did we. The children and grandchildren in our extended family grew up and got married beneath the two enormous maples still in our backyard. Dear friends passed away, and I planted birch trees in their memory. Dick and I had made a good life together. Long ago we had pledged to stand by each other

for better or for worse, and we were fortunate to have had almost twenty years of "better" before an unanticipated, worst-case scenario began to unfold.

At first the changes in Dick's behavior were barely perceptible: incomplete sentences, substitution of the word "thing" for specific names of common objects, inability to calculate a tip, and difficulty following directions. He also began to spend hours in front of the television. I can't say that I was always patient through this process of gradual diminishment, partly because I didn't understand why it was happening. Later I recognized the parallels between how I acted with Dick as he became more lethargic and how I had responded to what was ultimately diagnosed as my first husband's schizophrenia. In both cases I found myself unable to confide in anyone or solicit advice. Instead, I fumbled about in a state of denial—maybe as a consequence of a childhood during which so much was left unspoken or shoved under the rug, and maybe in part because I knew that telling a man his behavior was concerning would likely lead to his feeling insecure, which never has a happy ending.

Dick continued to decline for several years, but nobody in his department at Cornell mentioned any slippage to me, and I certainly wasn't going to point it out to them. Then one day his department chair called me to report that Dick's teaching abilities were deteriorating. That phone call finally prompted me to insist that we seek a medical evaluation.

Since he had often complained about brief episodes of double vision, we first made an appointment with an ophthalmologist. At the end of the visit she said that Dick's faulty eye-tracking movements were likely symptoms of a neurological disorder and referred him to a specialist for further examination. At the first of many doctor visits to follow, Dick was asked to draw the face of a clock—one of the standard tests to determine adult cognitive impairment—and was unable to do so. Subsequently he was diagnosed with dementia. We finally had to deal head-on with the consequences of what Dick referred to as "my malady." I started by pursuing my now-familiar path of research and checked out a number of books from the local library.

Studies of the brain have attracted my attention since I was a teenager. And as a freshman in college I enrolled in a psychology course with the hope of understanding my mother better after finally learning her diagnosis of paranoid schizophrenia. When George was institutionalized

Plate 152

for the last time, I was reading Julian Jaynes's *The Origin of Consciousness in the Breakdown of the Bicameral Mind*. The book describes the evolution of mental skills in humans, positing the controversial theory that early social groups were guided by auditory hallucinations, often a symptom of schizophrenia. His studies of early civilizations led the author to believe that people were only able to make decisions after developing a spoken language sophisticated enough to express metaphors and analogies.

Ultimately, no book could prepare me for the challenges of dementia that we would face over the next few years. As Dick's executive functions, including decision-making, began to fail, I read *In Search of Memory*, written by the neuroscientist Eric Kandel. He had won a Nobel Prize for the research that forms the basis of this book. Kandel describes his investigations into the biological structures of memory formation and the relationship between short- and long-term memory, while simultaneously forging a personal narrative based on his own recollections. He concludes that without memory, we are nothing. As Dick's ability to communicate lessened, and his memories faded, I hoped this was not entirely true.

Eventually Dick, already past retirement age, was relieved of his teaching responsibilities. In gratitude for his contributions over the years, his valued mentorship not the least of them, the department gave Dick a full year and a half to clear out his office. Afterward they provided him a desk in a small shared workspace, offering a link to the academic life he loved. No longer able to drive, Dick took the bus to Cornell to meet colleagues for lunch once a week. His friends found it remarkable that he dealt with the consequences—and symptoms—of his malady with such equanimity, grace, and resilience. No doubt Dick's study of Zen Buddhism and his longtime practice of meditation had fortified his ability to accept the vicissitudes of life.

Meanwhile, I was having trouble adjusting to my new role as his caregiver. The task I found most unpleasant was to incrementally curb the activities of my once-self-reliant husband for his own safety. Dick had always been the professor, and he did not want to hear a lecture on the dangers of operating a microwave or on why he should no longer use the treacherous basement steps to raid his wine cellar—neither the wine nor the stairs being a good idea. I had difficulty assessing what he could do himself and when he required assistance, and I could not rely on his judgment. Sometimes he wanted to dress himself and could. Sometimes he wanted to dress himself but couldn't. What he was capable of doing varied from day to day, and the most difficult part was having to interpret his constantly shifting needs and wants. My formerly gregarious husband didn't want to carry on a conversation during meals because it was hard for him to concentrate on both eating and what I was saying. He continued to retreat into silence, and I felt more and more isolated. I found myself raising my voice as I grew impatient, got angry, and became unforgiving of situations beyond

ILLUSTRATION 45

Book Marks card for *In Search of Memory*.

his control. When this happened, Dick would wryly call me "Inspector General." In retrospect, I recognize that I was passing through the five stages of grief as the man who was my main source of love, support, and companionship was disappearing before my eyes.

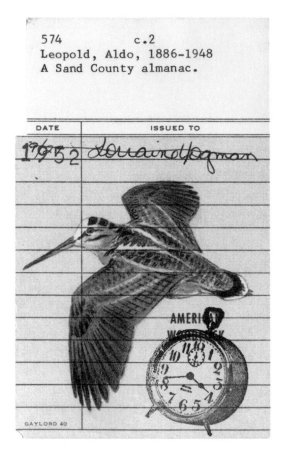

574 c.2
Leopold, Aldo, 1886-1948
A Sand County almanac.

DATE ISSUED TO

1952 Lorraine Hagman

AMERICAN WOODCOCK

GAYLORD 40

ILLUSTRATION 46

Book Marks card for *A Sand County Almanac,* one of Dick's favorite books.

One night, a year before he died, Dick suffered a sudden and sharp decline in his mental and motor skills, requiring a trip to the emergency room. After a week in the hospital, he came home to his study, which had been transformed into a hospital room with 24/7 caregivers. Dick's son and daughter, along with their children, had moved within a few blocks of our house and were on call. A visiting social worker predicted Dick would survive only a few more weeks, as he was eating almost nothing. To our surprise, he rallied somewhat when I began feeding him avocados and eggs, and a few weeks became twelve months.

That last year was a gift to me. Although Dick could no longer do anything for himself, with the help of family and other caregivers I was able to relinquish my role as supervisor and become his sidekick, accompanying him wherever he happened to be in his head that day. When friends came to visit, we would sit beside Dick's bed and chat. He seemed to know who they were and sometimes even voiced a barely audible comment or two. After five months, despite our care, Dick started to get bedsores. It was very difficult to shift my husband's gangly body, and even with round-the-clock help, the time had come to move him into a nearby nursing home that had the equipment and additional staff to keep him comfortable.

I visited him there nearly every day to feed him and read excerpts from some of his favorite books. Dick was a fan of Archie Ammons, a poet and fellow Cornell professor, so we started with his epic poem *Garbage.* We then moved on to Aldo Leopold's *A Sand County Almanac,* which lays down the foundation for conservation science and is rife with descriptions of animal behavior. We began, but never completed, *The Snow Leopard,* which had always appealed to Dick because its author, Peter Matthiessen, was an environmental activist and teacher of Zen Buddhism who gave a spiritual twist to his scientific expedition in the Himalayas. As I read Matthiessen's words out loud, I hoped Dick still found them as soothing as I did.

Back home, I was reading *The End of Your Life Book Club,* Will Schwalbe's gentle excursion through literature with his mother, who was dying of cancer. In the process of selecting books to read aloud, I began to think more about

Dick and me and our life together. We made a good pair because he was ten percent wannabe poet or artist, and I was ten percent wannabe scientist, though I wasn't properly able to articulate this until I was writing his eulogy.

During those last months, there were long periods when Dick and I could hardly communicate. He either was unable to speak, or his fumbling phrases, full of filler words, had no discernible substance. Sometimes, if you knew Dick's code words, you could figure out what he was trying to say. His favorite meal had always been a hamburger, French fries, and a chocolate milkshake. The arrival of the Five Guys burger joint in Ithaca had been his food fantasy fulfilled. When it opened, Dick was no longer driving, so either his friend David or his son, Bryan, took him there for lunch nearly every Thursday before assisting him with routine errands, like buying socks. After Dick moved to the nursing home, he started referring to Five Guys as "Six Men" and eventually "Six Miles," further confusing things by conflating that reference with our local Six Mile Creek. But that was enough to remind Bryan to bring his father a Five Guys hamburger the next time he came to see him at the nursing home.

In addition to reading books aloud, I would occasionally bring a map to Dick's bedside and reminisce about places we had visited. He had introduced me to overseas travel, and travel had been good for us. Our daily concerns and petty irritations would drop away as we went snorkeling in Hawaii, visited Monet's garden at Giverny, or jogged along the bluffs of Bodega Bay. We relived those adventures in the curtained confines of his half of a semiprivate room. I also reminded Dick of our trips to New York City, where we enjoyed visiting art museums and going to the theater. Sometimes I would reminisce about his colleagues, whom I had met over the years.

One afternoon, on a warm fall day, I pushed him in his wheelchair along the Ithaca sidewalks on an imaginary outing to the Oxford University Museum of Natural Sciences. He wanted to look at their collection of insects. Along the way, I pointed out the bright yellow goldenrod growing in a garden, but he no longer recognized the plant he had studied for twenty years. After we got back to the nursing home, he didn't realize that we had never arrived at the museum.

I continue to savor the many moving moments from our last year together. Every once in a while Dick would break out in laughter for no apparent reason. That would make me smile and be grateful that his foggy brain still harbored amusing thoughts. Toward the very end of his life, Dick had moments of painful lucidity. On New Year's Day, he asked me why it was taking so long to die. I didn't answer him, knowing it would not be much longer. Just another few weeks.

ALBOM, MITCH
AUTHOR
TUESDAYS WITH MORRIE
TITLE

DATE DUE BORROWER'S NAME

1997

PLATE 313

ZAFÓN, CARLOS RUIZ
AUTHOR
THE SHADOW OF THE WIND
TITLE

DATE DUE BORROWER

2001

PLATE 314

HOROWITZ, ALEXANDRA
AUTHOR
ON LOOKING: ELEVEN WALKS WITH EXPERT EYES
TITLE

DATE DUE BORROWER'S NAME

2013

PLATE 315

LONELY PLANET
AUTHOR
SPAIN
TITLE

DATE DUE BORROWER'S NAME

PLATE 316

AUTHOR SKLOOT, REBECCA

TITLE THE IMMORTAL LIFE OF HENRIETTA LACKS

DATE DUE	BORROWER'S NAME
2010	

PLATE 317

AUTHOR BARBERY, MURIEL

TITLE THE ELEGANCE OF THE HEDGEHOG

DATE DUE	BORROWER'S NAME

PLATE 318

AUTHOR HUGHES, ROBERT

TITLE ROME

PLATE 319

AUTHOR FERRANTE, ELENA

TITLE L'AMICA GENIALE

DATE DUE	BORROWER'S NAME
20 1	

PLATE 320

PAMUK, ORHAN
AUTHOR
My Name Is Red
TITLE

DATE DUE	BORROWER'S NAME
1998	

PLATE 321

KANON, JOSEPH
AUTHOR
ISTANBUL PASSAGE
TITLE

DATE DUE	BORROWER'S NAME
2012	

PLATE 322

BOO, KATHERINE
AUTHOR
BEHIND THE BEAUTIFUL
TITLE
FOREVERS

DATE DUE	BORROWER'S NAME
2012	

PLATE 323

F Seth
Seth, Vikram
A suitable boy : a novel /

DATE	ISSUED TO
1993	

PLATE 324

MAXWELL, VIRGINIA
AUTHOR
LONELY PLANET ISTANBUL
TITLE

DATE DUE 20 15	BORROWER'S NAME

PLATE 325

WESCHLER, LAWRENCE
AUTHOR
MR. WILSON'S CABINET
 OF WONDER
TITLE

DATE DUE 1995	BORROWER'S NAME

So, go figure.

PLATE 326

RUSHDIE, SALMAN
AUTHOR
MIDNIGHT'S CHILDREN
TITLE

DATE DUE 1981	BORROWER'S NAME

PLATE 327

F
Adiga

Adiga, Aravind.
The white tiger.

PLATE 328

BECHDEL, ALISON
AUTHOR
FUN HOME
TITLE

2006 DATE DUE	BORROWER'S NAME

PLATE 329

BACKMAN, FREDRIK
AUTHOR
A MAN CALLED OVE
TITLE

2013 DATE DUE	BORROWER'S NAME

PLATE 330

FOER, JOSHUA
AUTHOR
MOONWALKING
TITLE WITH EINSTEIN

2011 DATE DUE	BORROWER'S NAME

PLATE 331

PERELMAN, DEB
AUTHOR
THE SMITTEN KITCHEN
TITLE COOKBOOK

2012 DATE DUE	BORROWER'S NAME

PLATE 332

F Hamid Hamid, Mohsin
Hamid 1971-

How to get filthy
rich in rising
Asia.

PLATE 333

F Butler Butler, Robert
Butler Olen.

Perfume River.

PLATE 334

LOGEVALL, FREDRIK

AUTHOR

EMBERS OF WAR

TITLE

PLATE 335

PHAM, ANDREW X.

AUTHOR

CATFISH AND MANDALA

TITLE

PLATE 336

PLATE 337

WOLITZER, MEG
AUTHOR
THE INTERESTINGS
TITLE

DATE DUE	BORROWER'S NAME

2013

PLATE 337

PLATE 338

INSIGHT GUIDES
AUTHOR
BELIZE
TITLE

DATE DUE

2003

2014

BRITISH HONDURAS

SUB·UMBRA·FLOREO

ARMS OF THE COLONY

1¢ POSTAGE & REVENUE

CROWNED MOTMOT

BELIZE

BELIKIN

PLATE 338

PLATE 339

HOSSEINI, KHALED
AUTHOR
A THOUSAND SPLENDID
TITLE
SUNS

DATE DUE	BORROWER'S NAME

2007

PLATE 339

PLATE 340

HARMON, KATHARINE
AUTHOR
THE MAP AS ART
TITLE

DATE DUE	BORROWER'S NAME

2009

FRONT

PLATE 340

AUTHOR HAWKINS, PAULA

TITLE THE GIRL ON THE TRAIN

DATE DUE / BORROWER'S NAME

London Dry GIN

40% ALC/VOL (80 PROOF)

PLATE 341

AUTHOR McLAIN, PAULA

TITLE THE PARIS WIFE

DATE DUE / BORROWER'S NAME

REPUBLIQUE FRANÇAISE 20 POSTES

PLATE 342

910 Debotton

De Botton, Alain.

The art of travel.

2003

GARE St. LAZARE

Republic Kalmykia

08·9801790

PLATE 343

AUTHOR ROBINSON, MARILYNNE

TITLE LILA

DATE DUE / BORROWER'S NAME

1.
we gather at the river
bright a feet have
its crystal reve
ing by the thro
es, we'll gather at
aut the beautiful
ints at

PLATE 344

GREENE, GRAHAM
AUTHOR
OUR MAN IN HAVANA
TITLE

DATE DUE	BORROWER'S NAME
1958	

PLATE 345

GARCÍA, CRISTINA
AUTHOR
DREAMING IN CUBAN
TITLE

DATE DUE	BORROWER'S NAME
1992	

PLATE 346

HIAASEN, CARL
AUTHOR
NATURE GIRL
TITLE

DATE DUE	BORROWER'S NAME
2006	

PLATE 347

HARLAN, WILL
AUTHOR
UNTAMED
TITLE

DATE DUE	BORROWER'S NAME
2014	Carol Ruckdeshel

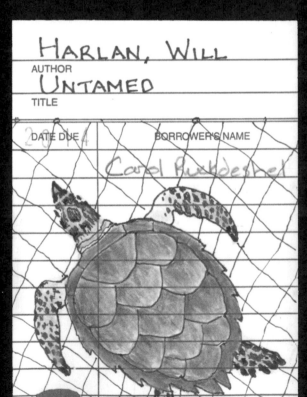

CUMBERLAND ISLAND

PLATE 348

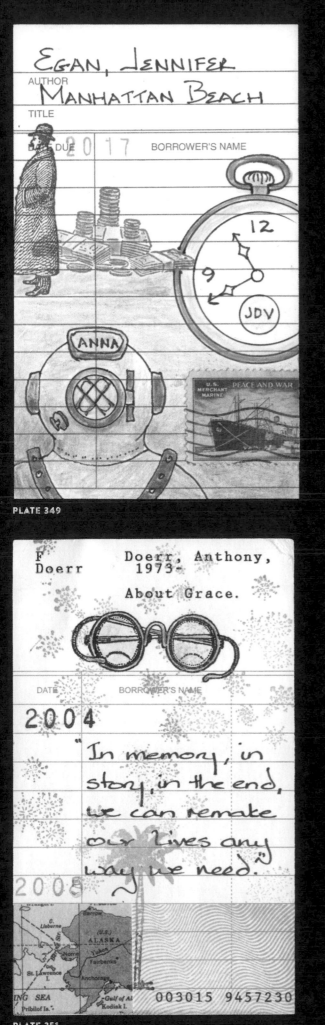

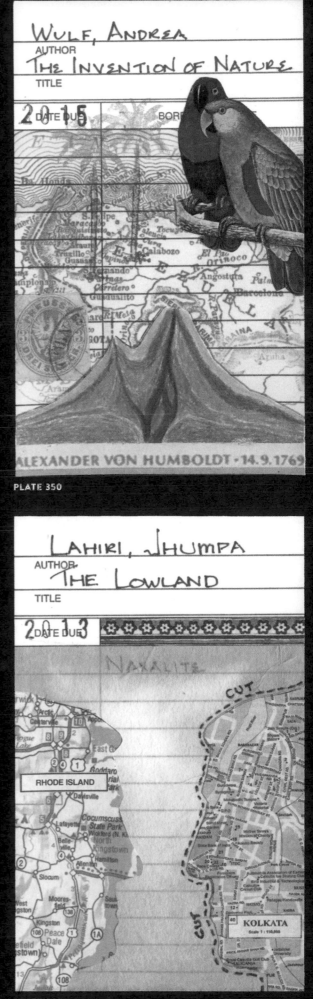

EGAN, JENNIFER
AUTHOR
MANHATTAN BEACH
TITLE

DATE DUE 20 17 · BORROWER'S NAME

ANNA

PEACE AND WAR
U.S. MERCHANT MARINE

PLATE 349

WULF, ANDREA
AUTHOR
THE INVENTION OF NATURE
TITLE

20 15 DATE DUE · BORROWER'S NAME

ALEXANDER VON HUMBOLDT · 14.9.1769

PLATE 350

F
Doerr Doerr, Anthony,
 1973-

 About Grace.

DATE BORROWER'S NAME

2004

"In memory, in
story, in the end,
we can remake
our lives any
way we need."

2008

ALASKA

003015 9457230

PLATE 351

LAHIRI, JHUMPA
AUTHOR
THE LOWLAND
TITLE

20 13 DATE DUE

NAXALITE

RHODE ISLAND

KOLKATA
Scale 1: 115,000

PLATE 352

HOROWITZ, ANTHONY
AUTHOR
THE MAGPIE MURDERS
TITLE

PLATE 353

PENNY, LOUISE
AUTHOR
A TRICK OF THE LIGHT
TITLE

DATE DUE BORROWER'S NAME

MUSEUM OF ART

Custom Tattoo

MONTRÉ...

PLATE 354

BRAITHWAITE, OYINKAN
AUTHOR
MY SISTER, THE SERIAL
TITLE KILLER

DATE DUE BORROWER'S NAME
2018

CLOROX

PLATE 355

LOGAN, JOHN
AUTHOR
RED
TITLE

DATE DUE BORROWER'S NAME
2009

PLATE 356

ADICHIE, CHIMAMANDA NGOZI
AUTHOR
AMERICANAH
TITLE

2 0 1 2 DATE DUE | BORROWER'S NAME

PLATE 357

EGGERS, DAVE
AUTHOR
THE CIRCLE
TITLE

2 0 1 3 DATE DUE | BORROWER'S NAME

PLATE 358

STANLEY, BOB
AUTHOR
YEAH! YEAH! YEAH!
TITLE

2 0 1 4 DATE DUE | BORROWER'S NAME

PLATE 359

MURAKAMI, HARUKI
AUTHOR
COLORLESS TSUKURU
TITLE
TAZAKI

2 0 1 3 DATE DUE | BORROWER'S NAME

PLATE 360

DOERR, ANTHONY
AUTHOR
ALL THE LIGHT
TITLE
We Cannot See
20 14 DATE DUE | BORROWER'S NAME

PLATE 361

COLLINS, LAUREN
AUTHOR
WHEN IN FRENCH
TITLE
20 16 DATE DUE | BORROWER'S NAME

PLATE 362

BADKHEN, ANNA
AUTHOR
THE WORLD IS A CARPET
TITLE

PLATE 363

YOUSAFZAI, MALALA
AUTHOR
I AM MALALA
TITLE

PLATE 364

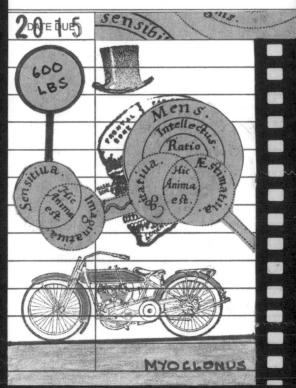

SACKS, OLIVER
AUTHOR
ON THE MOVE: A LIFE
TITLE

DATE DUE
2015

600 LBS

MYOCLONUS

PLATE 365

TRIPP, DAWN
AUTHOR
GEORGIA
TITLE

DATE DUE
2016

BORROWER'S NAME

PLATE 366

SCHIFF, STACY
AUTHOR
CLEOPATRA
TITLE

Beware of what you want. You may get it.

2010

PLATE 367

DE WAAL, EDMUND
AUTHOR
THE HARE WITH
TITLE THE AMBER EYES

DATE DUE BORROWER'S NAME

15

2010

PLATE 368

F
Vasquez

Vasquez, Juan
Gabriel,
1973-

The sound of
things falling.

BORROWER'S NAME

002450 98 2283

PLATE 369

364.152
Leovy

Leovy, Jill.

Ghettoside.

2015 LOS ANGELES

BORROWER'S NAME

002963 9322033

PLATE 370

338.7
Coll

Coll, Steve.

Private empire.

EXXON VALDEZ

DATE BORROWER'S NAME

PLATE 371

973.924
Packer

Packer, George,
1960-

The unwinding.

USA FOREVER

O

DATE BORROWER'S NAME 99%

HOMELESS

* FORECLOSURE

OCCUPY
WALL
STREET

1% ★ ★ ★ ★ 1%

© BAKER & TAYLOR 004548 9765519

PLATE 372

AUTHOR **LEVITSKY, S AND ZIBLATT, D**

TITLE **HOW DEMOCRACIES DIE**

DATE DUE	BORROWER'S NAME
2018	RESIST

BULLY
FROG

KING OF THE SWAMP

PLATE 373

AUTHOR **FRANKFURT, HARRY G**

TITLE **ON BULLSHIT**

DATE DUE	BORROWER'S NAME
2005	BULLSHIT

PLATE 374

AUTHOR **TABUCCHI, ANTONIO**

TITLE **SOSTIENE PEREIRA**

DATE DUE	BORROWER'S NAME
	1938

Diario de Lisboa

Consolidada a vitória do Movimento Militar

170 PIDES NAS CELAS DE CAXIAS

cerca de 200 fugiram por um subterrâneo

1889 SALAZAR 1970

1 ESC.

PORTUGAL

1994

PLATE 375

AUTHOR **HOBBS, JEFF**

TITLE **THE SHORT AND TRAGIC LIFE OF ROBERT PEACE**

DATE DUE	BORROWER'S NAME
2014	

YALE

PLATE 376

6 | Departures and Arrivals

In the ten days before Dick's memorial service, I was like a top unleashed from its tether, spinning at maximum velocity. I made the necessary arrangements with the help of his children, including one small but important gesture I knew Dick would appreciate: vases full of goldenrod to grace the chapel. I thought it would be impossible to find any in the dead of winter, but on a trip to the grocery store, there they were. The most difficult undertaking was writing a fittingly eloquent eulogy. I woke up some mornings at four o'clock, wrapped myself in a blanket, and wrote until I ran out of things to say. At the service I managed to read my tribute and honor the man who had been both my anchor and, at the end, a sinking ship. After his colleagues and former students and our friends and families—including my recently widowed mother—departed, my momentum dissipated. I had become somewhat accustomed to a solitary life with Dick in the nursing home, but now I felt unmoored and lonely. One night I dreamed I was on a road trip and had lost my way. I unfolded a large paper map and was distraught to find the section where I thought I was, missing. Then, as the dream continued, I remembered having cut out that piece of the map to use in a collage.

Once again, I was without direction. I had recently finished a commission for the North Carolina Museum of Natural Sciences. During the two years it took to complete several hundred porcelain tiles for a pedestrian bridge, as well as a mural on the history of life, I drove down to Raleigh a number of times. With Dick's health declining, I had needed to prepare each time for a worst-case scenario, should he fail during the three to four days I was out of town. In contrast to that frenetic period of work under high pressure, I was now laid low, my torpor compounded by a respiratory virus, and for eight weeks after the memorial service, my journal contains no entries. In very short order two significant men in my life—my father and Dick—had passed away. Death dominated my thoughts, and I resented it.

Four months before I lost Dick, my father died from complications of Parkinson's disease. I had last spoken with him late one afternoon when I called to let him know I'd be coming to visit the following day. He and my mother were still living outside of Boston but had moved into an assisted living residence in the same neighborhood where my older son and his family had settled twenty years earlier. When he heard I was coming, my father summoned the energy to utter one word: "Hurray." But in the middle of the night George called to say his grandfather—my father—had passed away. I regretted not having gotten into my car that afternoon, immediately after speaking with my father on the phone. Not knowing what to do with myself, I went for a walk. It was a beautiful September night. The blue moon drifted toward the western horizon, while off to the east, Jupiter

and Venus outshone the stars that my father—a navigator who knew his constellations—had pointed out to me in my childhood: Sirius, Aldebaran, and Betelgeuse.

After a fitful sleep, I left for Boston, first stopping at the nursing home to see Dick and let the staff know I would be gone for a few days. As I drove, I listened to *Tuesdays with Morrie*, a touching conversation between a dying professor and a former student. Mitch Albom's wisdom gave me solace and helped to pass the hours. My mind wandered, and I recalled a black-and-white photograph of my father taken when he was ten years old. In it he is standing on a fence, dressed in knickers and a shirt and tie. Attached to his outstretched arms are two five-foot-long wings, with three members of his family providing support. I had been told that my father constructed this elaborate contraption—sheeting fastened to a wood framework—with the intention of flying the three miles to his cousin's house. He crashed, I learned, as soon as he leapt off the fence, and everyone laughed, much to his chagrin.

Plate 313

About ten years before my father died, I had dedicated a series of drawings to him. Each work on vellum depicts an early flying machine, a few of which also never got off the ground. I drew them directly on top of some engineering drawings my father had drafted for industrial plants. I was happy that he had lived to see what I considered our joint project, titled *Double Vision*. As I drove, I also remembered the time I took my father for a flight over San Francisco Bay in a Cessna 150 shortly after getting my pilot's license. He had trusted me with his life that day, and perhaps I gave him back a piece of his childhood dream of flying.

ILLUSTRATION 47

My father, age 10, prepares for takeoff with wings he constructed himself, foreshadowing his rather more successful engineering career.

When I arrived, I went directly to my parents' apartment, opening the door with the key my mother had given me. Nobody was there. I walked into the bedroom and saw my father's bed stripped of its sheets. His absence was overwhelming. I called George from my mother's landline, and he told me to come to his house. When I pulled into the driveway, I found my two sons and their families gathered to greet me with hugs. My mother was sitting inside, and I was grateful that she was able to recount for me some of the details of the past few days. After a take-out dinner, we all sat around a bonfire in the backyard. The children began a sing-along with, "We're goin' to the zoo, zoo, zoo, how about you," and the grown-ups finished off the evening, hours later, with "Ring of Fire" and "Hallelujah." (Almost everyone

in my family sings well, like my father did, except for my mother and me, who essentially lip sync.) In the middle of a song accompanied by guitars passed among the musicians in the family, an Eastern Screech-Owl flew down close to us and chortled its whinnying trill, joining the chorus for about five minutes. The spirit of Grandpa? We all smiled at the thought.

My mother would live another six years, during which she withdrew into her apartment with her beloved cat, Sophie. She could still be difficult, but in those years she learned how to say "I love you." Not wanting to be a recluse like my mother, I finally roused myself after a few months and started to get up and get out. For my birthday, friends rallied to cheer me up with a dance party and a cake ablaze with Crayola-crayon candles—bright pink, yellow, and indelibly blue. Eventually the letters of sympathy dwindled, and that spring I signed up for a field course in bird identification that was scheduled for the quickly approaching avian migration. Dick had left me a couple of pairs of binoculars and quite a number of handbooks for birders, including the edition of Roger Tory Peterson's classic series *A Field Guide to the Birds* suited to our neck of the woods. During that two-month course I spotted scarlet tanagers, wood ducks, and a Saw-Whet Owl, all the while thinking how much Dick would have enjoyed joining us as we trudged through the marshes and meadows of Central New York.

Observing bird behavior was grounding me and making me appreciate my home territory even more, but I still felt stuck in a dreary zone within the walls of my house. I wondered if travel might shake me out of this state of mind. So when Meredith, my dependable globe-trotting partner, suggested a trip to Spain, I instantly agreed. Our itinerary would include Madrid, Córdoba, Seville, Granada, and Barcelona. As I packed my bag, anxiety about the upcoming flight overcame me. To me, leaving home always feels a bit like dying. What keeps me traveling is the promise of landing in paradise. Fantasizing about the terraced gardens of the Alhambra and the voluptuous architecture of Gaudí lifted my spirits, but nothing could compare to the trip itself, which proved to be good medicine, distracting me from my sadness.

ILLUSTRATION 48

Book Marks card for *A Field Guide to the Birds.*

The bucket list of countries I want to visit continues to grow, despite my guilt over the serious ramifications of every flight's carbon footprint. I hate to admit it, but, like many, I choose not to forego travel, as curiosity about other cultures outweighs my scruples. However, as I age, my tolerance for jet lag decreases, and my aversion to immobilization increases; so, while I can still handle the conditions in economy class,

ILLUSTRATION 49

Old Delhi: 5pm, 2018, in the *Arrivals and Departures* series. Mixed media on board, 11 x 12 inches.

I've been giving priority to destinations that require the longest flights. Vietnam, India, New Zealand, South Africa—check, check, check, and check. Enduring impressions of these journeys prompted me to start a series of artworks I titled *Arrivals and Departures*. Each mixed-media panel contains some fragment of a memory or sentiment about a foreign destination. So far, I have completed two dozen works based on trips to Hanoi, Rome, Delhi, Copenhagen, and Havana, among other places. Several of them have geographically apt newspaper clippings collaged into the background, sometimes obscured and sometimes revealing the specific place and date of my journey.

Sometimes a country or city lures me because of a powerful description I read in a book. For example, I enthusiastically agreed when two friends suggested a week-long stopover in Istanbul on our way to India; I had put it on my bucket list after reading *The Museum of Innocence*. In this novel, which portrays in obsessive detail an obsessive love affair, author Orhan Pamuk also describes the city's Çukurcuma neighborhood as it was fifty years ago. When I was halfway through the volume, I wanted to kick Kemal, the protagonist, tell him to get over his heartbreak, and shut the book. But I persisted, and so did Kemal in the ill-fated romance with his beloved Füsun. The plot finally evolves into a meditation on the preservation of memory in its different forms, particularly as manifested

PAMUK, ORHAN
AUTHOR
THE MUSEUM OF INNOCENCE
TITLE

in small museums dedicated to unusual personal visions or the everyday lives of individuals. Toward the end of the book, Pamuk lists a number of such collections around the world, several of which I had visited before reading his novel, including the Museum of Jurassic Technology in Los Angeles, a veritable cabinet of wonders hidden behind an unpretentious storefront.

In the course of writing his book, Pamuk bought a dilapidated house in Çukurcuma, refurbished it, and collected objects that could have belonged to his fictional characters in the 1970s. In this unremarkable house on a street corner, Pamuk reconstituted the ambience of his youth and created an unusual museum to enshrine, in exquisite detail, the fictitious romance of Füsun and Kemal—a perfect instance of memory inhabiting the gap between art and life. He named it the Museum of Innocence and opened it to the public. A host of paraphernalia mentioned in the book—posters, snapshots, clothing, and thousands of other flea-market items—is displayed throughout the house where, in the author's imagination, Füsun lived with her parents. The actual museum in Istanbul is a mirror reflecting the narrative in which Kemal collects objects related to his encounters with Füsun, buys a house, and opens his own museum dedicated to his lost love. About ten pages from the end of the novel, I found an illustration of an admission ticket for free entry to the museum that Kemal had created in Pamuk's land of fiction. A few months later I scanned the page and took the copy with me to Turkey.

In Istanbul, my friends and I stayed in an apartment overlooking the Golden Horn, Topkapi Palace, and the magnificent Blue Mosque, whose minarets pierced the distant skyline. A loudspeaker broadcasting the calls to prayer marked the swift passage of time during those magical days. At the end of the week, we walked through cobbled streets to the Museum of Innocence. While my friends were obliged to pay the admission fee, the copy I had made granted me free entry after it was stamped with an image of a butterfly, symbolizing the earring lost by Füsun in chapter one. Near the reception desk, an imposing vitrine contained an orderly array of 4,231 lipstick-stained cigarettes that had been smoked by the novel's heroine and collected by her lover, Kemal. I marveled over the multiple junctures Pamuk had created between a story written down in 83 chapters and the same story told by objects carefully arranged in 83 display cabinets. Imagination is memory carried forward. The author made his fiction a reality and, in a creative twist, blurred the distinction between his protagonist and himself.

From Istanbul, the three of us flew directly to Delhi to begin our tour, which would include viewing the marigold-laden tomb of Gandhi and my finally riding a camel. It is wonderful to be introduced to a place through a good book. An astute author can condense the history, culture, and social mores of a country into a narrative that opens the gate to travelers and profoundly enhances their experiences. While more than a few times a book has deepened my appreciation of a place I subsequently visited, the one I read in preparation for the trip to India was particularly enlightening. That was journalist Katherine Boo's *Behind the Beautiful Forevers*, which describes the survival tactics of those living in the slums beside the Mumbai airport, hidden by billboards from the sight of travelers. The book profiles members of this community and their methods of coping with extreme deprivation. As we toured Jaipur, we passed a destitute family living on the median strip of a busy street, reminding me of the hardships Boo had detailed.

Plate 323

Another day, while I was swimming in our hotel pool, a young woman and her friend stopped to talk to me. Much to my delight, she invited me to her brother's wedding that evening. The groom, mounted on a bejeweled white stallion, rode behind the ornate carriage that bore his bride in a slow procession of dancers, singers, and a blaring jukebox mounted on a truck. Like the United States, the land of plenty where the homeless sleep under bridges and on sidewalk grates, India is a land of both privation and extravagance.

ILLUSTRATION 51

Lucky, the camel I rode at the Pushkar Festival during my trip to India, 2015.

Plate 327

On the last night of our tour, I was reading a paragraph in Salman Rushdie's *Midnight's Children* in which the holy lions of Sarnath are mentioned. I only understood the passing reference because we had just seen this imposing sculpture the day before, and our tour guide had given us a thorough lecture on its artistic and historical significance. This was an example of how travel might, conversely, inform one's reading, as was also the case

Plate 324

when I read Vikram Seth's bulky saga *A Suitable Boy*. I had plowed through 600 of the book's 1,400 pages before departing for Istanbul, but it was far too heavy to carry with me, so I left it on my bedside table. When I finally picked it up again months later, my ability to envision the panoply of Indian life the book so vividly describes was profoundly enriched by my having just traveled across Rajasthan and Uttar Pradesh.

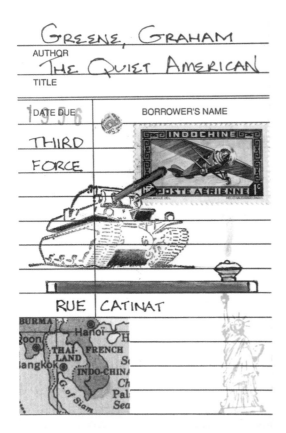

ILLUSTRATION 52

Book Marks card for *The Quiet American*.

Seth clearly and evocatively presents the spectrum of his native country's caste system, politics, and religious strife, but no book can fully convey the pandemonium that a foreigner encounters while being driven along the crowded streets of India. The unwritten rules of the road designate who has priority: first are sacred cows, then elephants, camels, buffalo, oxen-pulled carts, heavy trucks, official cars, buses, pedal rickshaws, private cars, motorcycles, scooters, handcarts, and, finally, pedestrians. All drivers honk all the time, and no one has any compunctions about steering onto the wrong side of the road and staying there. For good luck, trucks and camels alike are decked out in marigolds, beads, and tassels. Limes, sold by the side of the road, may be added to the ornamental display—on trucks, not camels—as extra insurance against accidents. And this was just a glimpse of India from the passenger seat of a three-wheeled taxi known as a *tuk-tuk*.

And then there was Vietnam. The atrocities that American foreign policy condoned there and then tried to cover up have been sitting uncomfortably in the back of my mind for the nearly fifty years since the war ended. Every generation, it seems, has its war, and that one was mine. Americans in general had been brainwashed into accepting the domino theory of encroaching communism, and many of us sorely lacked any knowledge of Vietnam's colonial history. Furthermore, most of us knew nothing about Ho Chi Minh's unanswered requests for American support in the early stages of his country's struggle for independence. I better understood the conflict, and the atmosphere surrounding it, after reading Fredrik Logevall's history of the French occupation of Vietnam, *Embers of War*, and Graham Greene's novel *The Quiet American*. I read both before traveling to the country with three friends for a tour that we took from Hanoi to Ho Chi Minh City,

formerly Saigon. The book I carried with me was the memoir *Catfish and Mandala*, written by Andrew X. Pham, a Vietnamese immigrant living in California who had returned to his native land and found himself out of place even without a language barrier.

While there, I expected to encounter enmity toward Americans. That was not the case—maybe because half the population was under twenty-five years old and venerated American pop songs and blue jeans. Those dark days of devastation from Agent Orange and cluster bombs, however, are painfully evident at the War Remnants Museum in Ho Chi Minh City. Among other exhibits, huge black-and-white photographs of the war's human carnage are on display. These images were on all of our minds as our group traveled to the Cu Chi district on the outskirts of the city. There, those of us on the tour who could fit crawled through a section of the claustrophobic Cu Chi tunnels, which connected three levels of underground living quarters for the Vietcong guerrilla troops. In these deep bunkers protected by spiked bamboo traps and under constant bombardment from B-52s, the officers had plotted the capture of Saigon. The underground maze, similar to an ant farm, was ventilated by hollow bamboo tubes inserted into tall termite mounds on the surface. These towering mounds made of mud had foiled the three thousand German shepherds that General Westmoreland imported to sniff out Vietcong soldiers and sympathizers.

Another day our group rode in rickshaws out to the countryside, where we walked among rice paddies to a Buddhist cemetery. While making our way along the narrow dikes separating the flooded fields, we noticed farmers herding flocks of ducks and were told that their function was to eliminate snails, a serious threat to the crops. As we approached the cemetery, we saw that the aboveground tombs were painted in various pastel colors and differently oriented. Our guide explained that their alignment was based on the recommendations of necromancers. In front of one of the tombs we met the parents of a seventeen-year-old girl who had died in a motorcycle accident two years before. They told our guide that they came to the cemetery every day. To help honor their dead daughter, the guide gave each of us a stack of fake paper money to burn, a Vietnamese ritual ensuring that the deceased has a good afterlife. As we all added

ILLUSTRATION 53

The ceremonial bill I brought home from Vietnam as a souvenir.

our money to the flame, I noticed that the back of the bills had a blurry image of Independence Hall and the motto "In God We Trust," mimicking an American hundred-dollar bill. I kept one as a souvenir to remind me of the strange melding of American and Vietnamese cultures.

Aside from language barriers, another challenge for me when traveling can be getting sufficient exercise. Unless the trip includes a vigorous activity ubiquitous in that country, such as biking in Holland or swimming in Iceland, I try to get in as much walking as possible. This is especially important if I'm on a guided tour with door-to-door bus transport. But I almost never jog while traveling, since in many countries my Lycra running gear would, no doubt, be inappropriate.

Regular exercise is my most reliable method for staving off bone loss and breathlessness. I kid around with my athletic—and a bit arthritic—friends about the possibility of our having a stroke during a hard workout. So far, it's only a joke. But sometimes as I mount my road bike, a little niggling voice tells me that I won't be able to fling my leg over the top bar forever—possibly not even after next year. But I push that chatter to the back of my mind and focus on staying physically strong and mentally sharp. Now, more than ever, both are necessary for completing household chores as well as fulfilling professional obligations and personal ambitions. After all, I still have a bucket list of countries to visit.

Plate 380

In a feeble attempt to enter this next phase of life on a positive note, I added to my library a book about coping with the inevitable decline ahead. That book is Dr. Atul Gawande's *Being Mortal*. He offers a sensitive and practical approach to aging, regarding it as a natural process and not as a chronic disease requiring an onslaught of medical tactics. His excellent advice, however, has not yet breached my fortress of denial. The prospect of eventually downsizing—giving up my studio, leaving behind the trees I've planted in the yard—is something I'm not ready to face. Yet the clock ticks faster as I run more slowly.

I have participated in athletic activities since sixth grade—first lacrosse and, later, biking, rowing, and swimming. Occasionally I pick up books about these sports. (The last one I bought from Buffalo Street Books, our local bookstore, is Bonnie Tsui's *Why We Swim*.) Even though I have never had the fortitude or aspiration to train for serious competition, the mind-set of athletes—actually anyone who takes on an extreme challenge—fascinates me. I very much enjoyed *What I Talk About When I Talk About Running*. I

Plate 384

had no idea that the novelist Haruki Murakami ran marathons until I read this book. Written by a master of style, it imparts much quotable wisdom about running, writing, and living life to the fullest.

For the past four decades, rowing has been my one constant pastime. The sport received national attention when the U.S. Women's Rowing Team won their first gold medal at the 2004 summer Olympics. Their remarkable rise

ILLUSTRATION 54

Back in the good old days with my friend Kevin, who encouraged me to start rowing. We are sitting in a pair, a shell for two rowers who each use one oar, c. 1982.

came two decades after I dragged my son Paul, a teenager at the time, to a boathouse down on Cayuga Lake to sign us up for the Learn to Row class, at the suggestion of my friend Kevin. The class was being offered by the newly formed Cascadilla Boat Club, which was equipped with old racing shells cast off from a local college's crew program. For our first session on the water, each participant took in hand either a port or starboard oar before dropping awkwardly onto one of eight sliding seats. Once settled in the long, narrow shell, we managed to pull away from the dock, but our lack of coordination resulted in a short haul to nowhere.

When I read *The Amateurs* a few years after I began rowing, I was inspired to stick with it and get some coaching. The author, David Halberstam, wrote about four top-notch rowers in competition with one another, each striving toward perfection. Halberstam's journalistic talents were effectively put to use in the detailed portraits of these dedicated but unsung athletes and their coaches. The sport was celebrated again in *The Boys in the Boat*, Daniel James Brown's stirring saga of the University of Washington crew that, against all odds, won a gold medal in the 1936 Olympics in Berlin. At first Paul, who had continued to pursue rowing through high school and college and went on to become the head coach of men's crew at Brown University, resisted reading the book since the University of Washington is one of Brown's biggest rivals. But he, too, succumbed to the uplifting story when he finally read it.

My attraction to rowing lies in the ambience and meditative exertion inherent in the sport, at least for those of us not racing. I eventually learned to row a single scull, or racing shell, mastering the switch from one to two oars. I usually go out on the lake early in the morning. Flat water signals perfect rowing conditions. The surface mirrors the sky and hills, with no hint of what might lie beneath: submerged logs, old tires, and the watches, keys, and sunglasses that have fallen overboard. On days like these I glide back and forth on the seat like a metronome, observing my wake as it cuts the reflective surface. Conditions can initially appear calm, but then

Illustration 55

Plate 381

an unexpected breeze kicks up whitecaps, and my rate of forward motion collapses. My relaxed grip on the oar handles gives way to white knuckles and aching forearms. To scan for traffic in front of the boat, I need to swivel my head around. With that in mind, I named my boat *Janus* after the Roman god of portals who has two faces staring in opposite directions. It would be ideal for rowers—and parents with toddlers—to have eyes in the back of our head!

Just over eight years ago, one of my sculling buddies and I were having coffee after our last row of the season, lamenting the looming winter and imminent transition to indoor exercise. On a whim we decided to sign up for the next Cayuga Lake Triathlon, held every summer just three miles from my house. Since neither of us could swim well enough for competition, we started taking lessons in January, and by August both of us were able to negotiate successfully the three stages of the triathlon. It has since become an annual challenge, though for the past two years I have been part of a relay team. The switch from biking to jogging was always torture for me, so now I do only the swim leg, while the two guys on my team take care of the rest.

The thought of giving up on the triathlon entirely is hard. I think of my father, who started running the Boston Marathon when he turned fifty, and I remember cheering him on, especially the year he ran after having his chest split open for a heart valve replacement. When he quit running, I encouraged him to spend a week with me at a summer rowing camp. He embraced the sport as enthusiastically as my son and I had. Paul's two oldest children, Noelle and Andrew, have also taken up rowing, coping well with the intense training regimen required of them at college. And their younger brother, Declan, is an outstanding high school lacrosse player. I admire each of them for their commitment and determination to work through the inevitable pain.

Witnessing their dedication motivates me, and once again I have registered our relay team for the triathlon. I try to keep the top spinning, with the hope that it will wind down slowly and gracefully. I should come to terms with my denial, but denial or not, I refuse to let aging interfere with my natural tendency toward motion. As long as I am physically able, I vow to swim, bike, and run—okay, maybe walk—toward the ultimate finish line.

ILLUSTRATION 55

Book Marks **card for** ***The Amateurs.***

ILLUSTRATION 56

**Opposite, rounding the bend by Taughannock Falls
on the last leg of the Cayuga Lake Triathlon, August 2015.**

McCULLOUGH, DAVID
AUTHOR
THE WRIGHT BROTHERS
TITLE

DATE DUE	BORROWER'S NAME
2015	

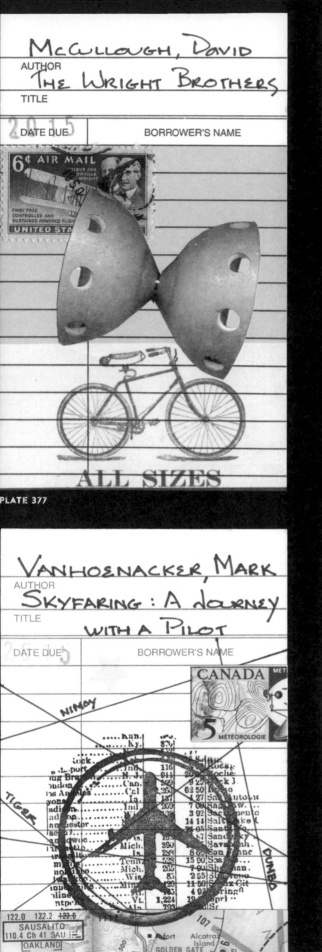

PLATE 377

McCANN, COLUM
AUTHOR
TransAtlantic
TITLE

DATE DUE	FUEL	REQUIRED (GALLONS)	TANK NO.
2013			

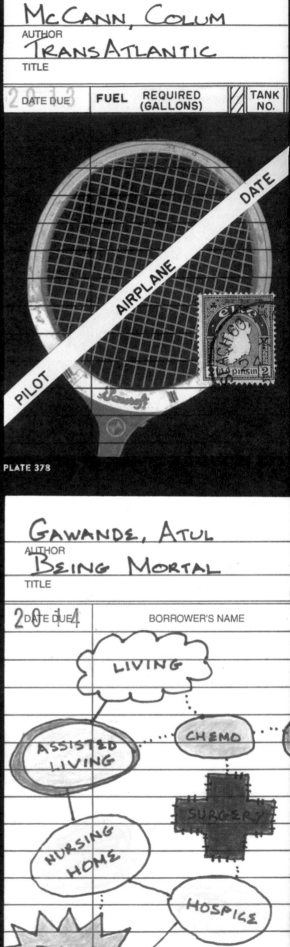

PLATE 378

VANHOENACKER, MARK
AUTHOR
SKYFARING : A Journey
WITH A PILOT
TITLE

DATE DUE	BORROWER'S NAME

PLATE 379

GAWANDE, ATUL
AUTHOR
BEING MORTAL
TITLE

DATE DUE	BORROWER'S NAME
2014	

PLATE 380

BROWN, DANIEL JAMES
AUTHOR
THE BOYS IN THE BOAT
TITLE

DATE DUE	BORROWER'S NAME

20 13

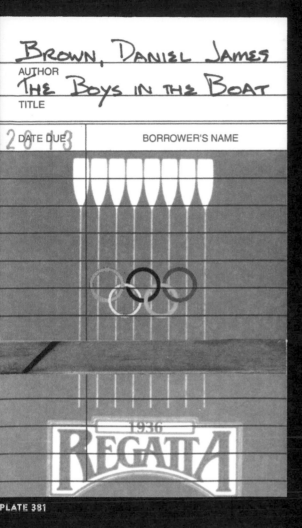

PLATE 381

HILLENBRAND, LAURA
AUTHOR
UNBROKEN
TITLE

DATE DUE	BORROWER

2010

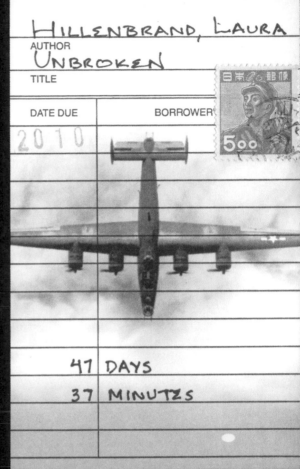

47 DAYS
37 MINUTES

PLATE 382

KALANITHI, PAUL
AUTHOR
WHEN BREATH BECOMES
TITLE AIR

DATE DUE	BORROWER'S NAME

20 16

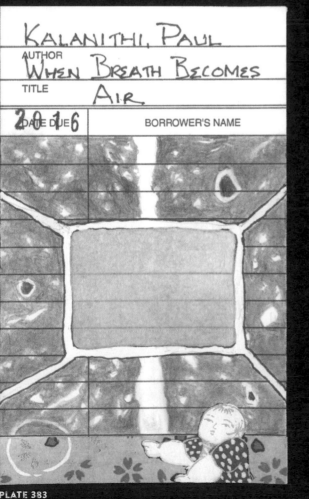

PLATE 383

MURAKAMI, HARUKI
AUTHOR
WHAT I TALK ABOUT WHEN
TITLE I TALK ABOUT RUNNING

DATE DUE	BORROWER'S NAME

2008

PAIN IS INEVITABLE —
SUFFERING IS OPTIONAL

PLATE 384

ROVELLI, CARLO
AUTHOR
SETTE BREVI LEZIONI
TITLE
DI FISICA

DATE DUE 4	BORROWER'S NAME

PLATE 385

BRYSON, BILL
AUTHOR
ONE SUMMER:
TITLE
AMERICA 1927

DATE DUE	BORROWER'S NAME

NYSE

ROXY

CAL

NY

UNITED STATES POSTAGE
LINDBERGH AIR MAIL
NEW YORK · PARIS
10 CENTS 10

GREAT MISSISSIPPI FLOOD

PLATE 386

KAUFMAN, M & VAN VLIET, C.
AUTHOR
AUNT SALLIE'S LAMENT
TITLE

DATE DUE 3	BORROWER'S NAME

PLATE 387

JOHNSON, KIRK WALLACE
AUTHOR
THE FEATHER THIEF
TITLE

DATE DUE 8	BORROWER'S NAME

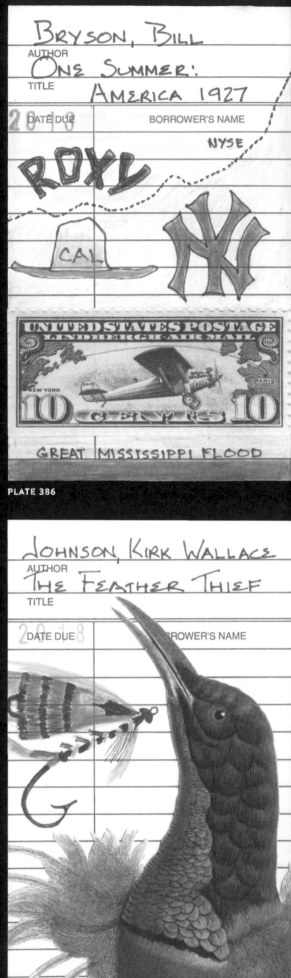

PLATE 388

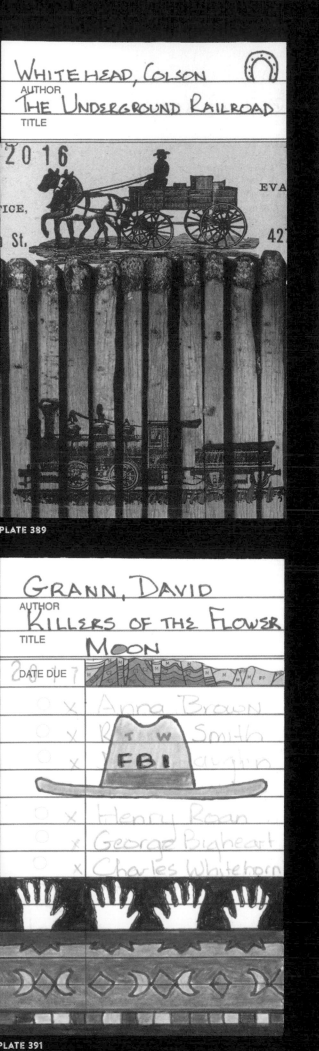

WHITEHEAD, COLSON
AUTHOR
THE UNDERGROUND RAILROAD
TITLE

2016

PLATE 389

GRANN, DAVID
AUTHOR
KILLERS OF THE FLOWER
TITLE
MOON

DATE DUE

× Anna Brown
× Smith
× FBI
× Henry Roan
× George Bigheart
× Charles Whitehorn

PLATE 391

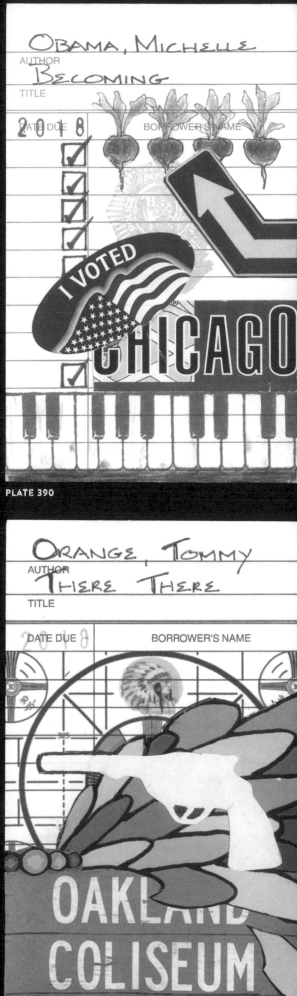

OBAMA, MICHELLE
AUTHOR
BECOMING
TITLE

DATE DUE BORROWER'S NAME

2018

I VOTED

CHICAGO

PLATE 390

ORANGE, TOMMY
AUTHOR
THERE THERE
TITLE

DATE DUE BORROWER'S NAME

2018

OAKLAND
COLISEUM

PLATE 392

MIRANDA, L-M & McCARTER, J.
AUTHOR
HAMILTON: THE REVOLUTION
TITLE

DATE DUE	BORROWER'S NAME

PLATE 393

DESAI, MIHIR A.
AUTHOR
THE WISDOM OF
FINANCE
TITLE

DATE DUE	BORROWER'S NAME

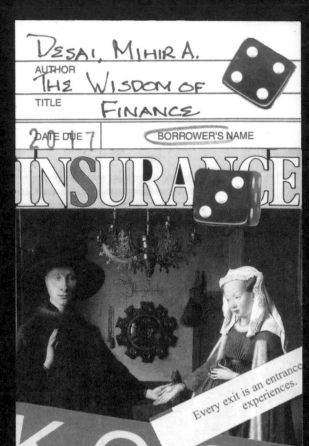

PLATE 394

WESTOVER, TARA
AUTHOR
EDUCATED
TITLE

DATE DUE	BORROWER'S NAME

PLATE 395

TOWLES, AMOR
AUTHOR
A GENTLEMAN IN MOSCOW
TITLE

DATE DUE	BORROWER'S NAME

PLATE 396

HAMID, MOHSIN
AUTHOR
EXIT WEST
TITLE

DATE DUE

PLATE 397

HALLIDAY, LISA
AUTHOR
Asymmetry
TITLE

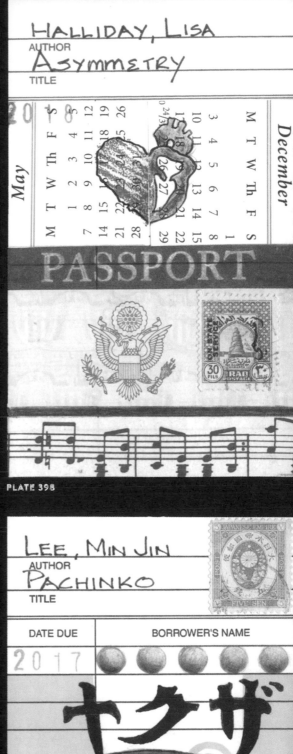

PASSPORT

PLATE 398

MONTGOMERY, SY
AUTHOR
THE SOUL OF AN OCTOPUS
TITLE

DATE DUE | BORROWER'S NAME

NEW ENGLAND AQUARIUM

PLATE 399

LEE, MIN JIN
AUTHOR
PACHINKO
TITLE

DATE DUE | BORROWER'S NAME

2 0 1 7

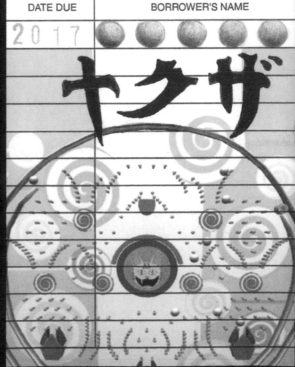

ヤクザ

PLATE 400

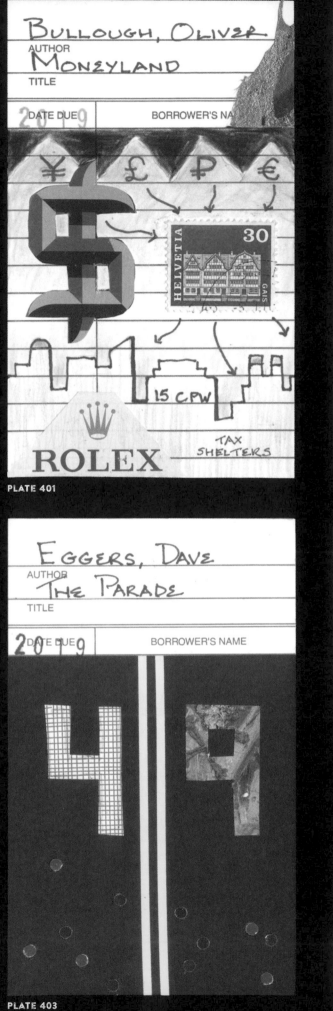

PLATE 401

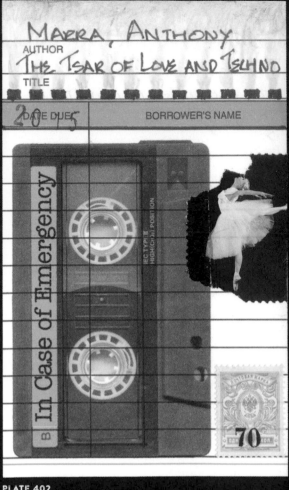

PLATE 402

PLATE 403

PLATE 404

AUTHOR ORLEAN, SUSAN

TITLE THE LIBRARY BOOK

DATE DUE 2008 1986	BORROWER'S NAME
	Harry Peak

Los Angeles

PLATE 405

AUTHOR BINDER, JULEE ED.

TITLE ULTIMATE VISUAL DICTIONARY

DATE DUE 1998	BORROWER'S NAME

PLATE 406

AUTHOR SEE, CAROLYN

TITLE MAKING A LITERARY LIFE

DATE DUE 2002	BORROWER'S NAME

1000 WORDS A DAY
5 DAYS A WEEK
UNDERWOOD

PLATE 407

AUTHOR NUNEZ, SIGRID

TITLE THE FRIEND

DATE DUE 2018

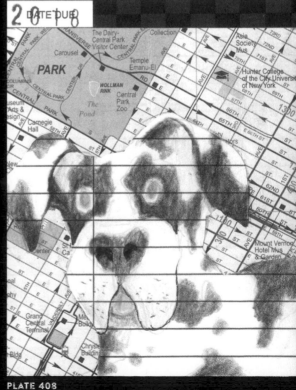

PLATE 408

All
about
Granny

By: Andrew
Cooke

| Collections and Recollections

While I sit here at home in my library, choosing the next words to type, the books around me catch my attention and interrupt my train of thought. On the shelf above my computer rest William Strunk Jr. and E. B. White's *The Elements of Style*, the guide for critical questions like whether to use a colon or semicolon, and John McPhee's *Draft No. 4*, in which he indicates that colons and semicolons will be the least of my problems as an author. Both were ever-present chaperones that aided me in writing the chapters for this book. My gaze travels across the other shelves, following "songlines" and "blue highways," as I recall paths I have taken in my life.

A book can be like an old tune. Similar to hearing a few bars of music, even a glimpse of a book has the potential to evoke a memory. When I glance at the gradations of green on the spine of *The Tsar of Love and Techno*, a collection of Anthony Marra's short stories, I think of my granddaughter Noelle. She read it when it was assigned to her in college, and on her recommendation, I bought a copy for myself. Shortly after I started the book, Noelle sent me a concept map one of her classmates had compiled, which served as a visual directory to the complicated relationships, recurrent themes, and polluted scenery populating the interlacing stories.

The cards in my *Book Marks* case, in their way, act like a concept map of my life. Browsing through these metaphorical bookmarks, I often feel like I am visiting my former selves, distinct but related. Unlike the collages of imaginary maps I have made, these cards lead me somewhere personal—back into my past and through a lifetime of reading, at least as far as I can reconstruct it. As the poet Joseph Brodsky wrote, "More than anything, memory resembles a library in alphabetical disorder." The cards, like the memories within the library of my mind, *are* in alphabetical disorder. (I doubt Dewey would approve.) But their chronological arrangement provides a structural framework in which my mind can wander at will between the divider tabs and through recollections of living with literature as my companion.

Sitting and looking at my bookshelves, also in alphabetical disarray, is similar to flipping through the cards. Occasionally I come across a book in my library that seems out of place. While certain titles can reinforce how we see ourselves, others reveal the tangential roads traveled in a lifetime, the many diversions and dead ends encountered along the way. One of the pleasures of rearranging the books on my shelves is laying my hands on these strays and outliers. Murder mysteries by Louise Penny may lie outside what I see as my more predictable path, but they are, nonetheless, part of the journey. What we choose to read tells something about who we are, be it a sexy thriller or an exposé of white-collar crime, art criticism or a graphic novel, Tolstoy or *Peanuts*.

Plate 402

Joseph Brodsky, *Less than One: Selected Essays* (New York: Farrar, Straus and Giroux, 1986).

ILLUSTRATION 57

Opposite, detail of my library showing *All about Granny Bee*, written and illustrated by my grandson Andrew Cooke. Limited edition of 1.

Two possessions in my library effectively frame my life, connecting me to both the past and the future. The first is the fifteenth-century book of hours handed down from my great-grandfather—a Presbyterian minister, hymnist, and book collector. The second is the singular copy of *All About Granny Bee*, written and illustrated by my grandson Andrew. The drawings inside Andrew's treasured gift are priceless, and while the gold initials inside the Flemish manuscript are masterfully painted, what intrigues me even more is the construction of the cover with silver edge-pins and clasps. Both of these volumes exemplify how artists and artisans over the centuries have applied their talents to the written word, in editions of all shapes, sizes, and materials, from illuminated manuscripts to comic books. While early bookbinders tooled richly ornamental covers at the behest of wealthy clients, publishers now commission illustrators to design paperbacks to catch the eye of browsers in bookstores as well as online. The innovative interplay of word and image is ever evolving, sometimes to the point of challenging the very definition of "book." This is especially true when an artist picks up a traditionally bound volume and manipulates it by cutting, tearing, folding, or otherwise modifying it, creating a one-of-a-kind artist's book.

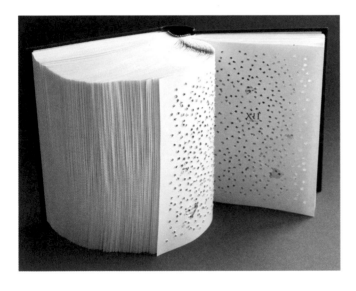

ILLUSTRATION 58

Double Blind, 2004, 9.5 x 14 x 4.5 inches. An artist's book made by altering a hardbound copy of *The Blind Assassin* by Margaret Atwood.

Midcareer I began to experiment with breaking the idea of a book out of its binding and made my first artist's book. Altering a book in any way felt like a desecration, so I started with a discarded volume I had picked up at a library sale—a hardbound copy of *The Blind Assassin* by Margaret Atwood. The title was appropriate for the mission I had in mind. I first created a template with giant Braille letters for the phrase "Can you read me?" chosen as a play on Atwood's title. Using it as a guide, I penciled the pattern onto the title page. Then, placing the bit of my electric drill on the dot of each cell, I forced it, smoking hot, through the entire volume, again and again. At the front of the book the pages are pierced with neat holes in inverted Braille that become increasingly ragged, then totally illegible, toward the back. The mangled book, now an artwork, stands permanently open like a fan. In the spirit of tit for tat, I later altered a copy of my previous book, which documents *Rock of Ages, Sands of Time*, by cutting rectangles of decreasing size through the succession of geological illustrations and renamed it *Quarry*.

Writing the autobiographical chapters for this book felt like taking a drill and boring through my life. Some memories were neat, others ragged. Unearthing them was sometimes difficult, forcing me to revisit long-buried sorrows. While I often look to the past for material to use in my artwork,

in so doing I generally reference a common history. This time, I had to face some personal facts that were not so easy to share. Deciding what to include and what to omit was complicated. I had to acknowledge the painful moments and unresolved issues before I could recapture the good times. The process reminded me of writing Dick's eulogy: I had to step slowly backward in time to resuscitate the man I had fallen in love with before the ravages of dementia took their toll on him.

Perhaps most difficult was recounting my first husband's struggles and his untimely death. As I revisited some of the more distressing events of our life together as a young family, I wondered if George and our marriage might have survived today, given changing attitudes toward mental illness. I also wonder how my childhood might have been different. But this is not a postmodern novel with three different endings. Instead, it is my story, presented as context for viewing these artworks.

These days, as I continue to read, I keep making new cards for the *Book Marks* file drawers. Recent additions are Amor Towles's *A Gentleman from Moscow* and Sy Montgomery's *The Soul of an Octopus*. In both cases the main characters are confined within tight quarters for most of their lives. Clever octopuses prowl the perimeter of the tanks at the New England Aquarium, while a Russian count, held under house arrest in a grand hotel, finds purpose within as decades of political upheaval unfold outside. I now find myself in a similar form of solitary confinement, like almost everyone in the world, as a result of a global pandemic. During these months of isolation, I have been selecting which cards to include in this book. In the process, I have thought often about the many authors represented here; I imagine most of them wrote in solitude over long months, even years. I also think about the infinite combinations of their words in the service of ideas as I arrange the cards for each page of plates, hoping to create new and surprising associations through proximity. I wonder what kind of exchange would transpire if the authors, whose books are squeezed next to one another on the page, found themselves in similarly cozy situations.

These authors and their books keep me company now as I take refuge in my library. On the bookshelves, the wide world in all its beauty and squalor is distilled at my fingertips, and, as of this moment, I can still easily access the library of my mind, with all its memories of joy and pain and, of course, books.

Plate 396

Plate 399

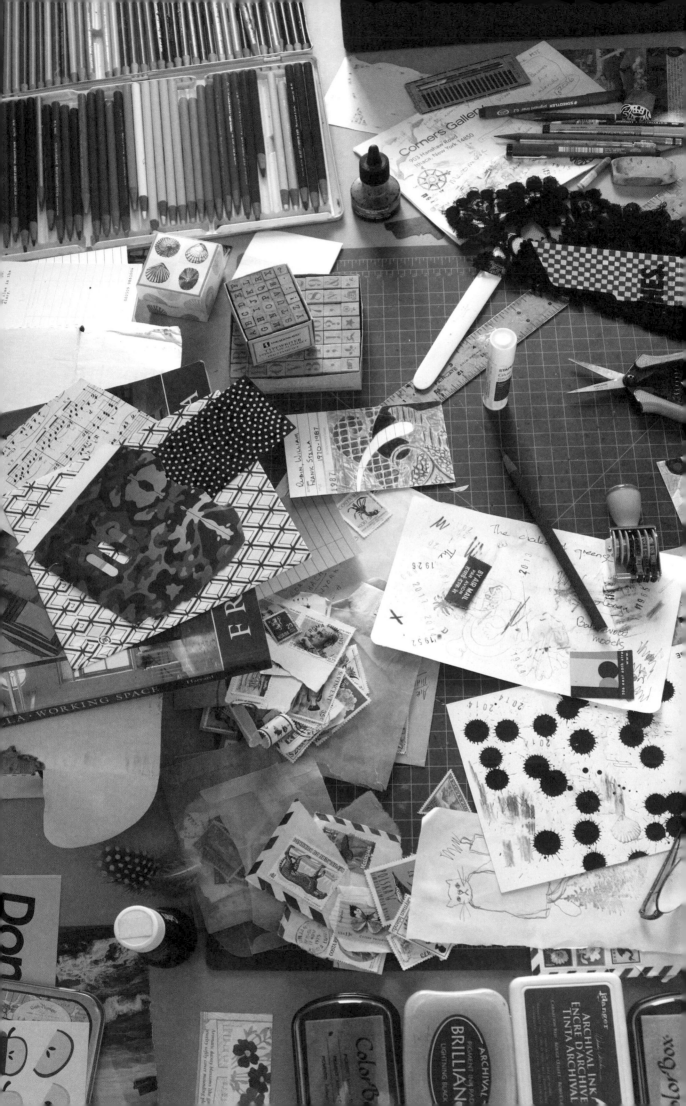

THE CARD-MAKING PROCESS

I keep the materials for making the *Book Marks* in my studio: a box of checkout cards from Vernon Library Supplies, rubber stamps and ink pads, colored pencils, Staedtler pens, folders full of paper scraps, and my childhood postage stamp collection. Over twelve years of designing these cards, I have also amassed ephemera that sometimes prove useful, including tickets to the 1893 world's fair—see the card for *Devil in the White City*—and a tiny pair of sunglasses with purple frames that is still waiting for a suitable scenario. While rummaging through the accumulated bits and pieces, I occasionally discover an item that prompts me to make a new card for a book I read years ago or to revise a card already filed in the library case.

Illustration 2

To make a card, I need to come up with one or more images that represent my interpretation of some facet of the book's contents. Then comes the challenge of fitting that imagery into the confining borders of the card. For some books, I am unable to come up with an image, leaving that book unrecorded in my library's card catalog. I was surprised by how difficult it was to make the artworks for children's literature, as it is hard to compete with the often-already-distinctive illustrations. For these, I relied heavily on rubber-stamping. Now and then a specific image so inhabits my memory, however, that I can't help but attempt to re-create it. For example, on the card for *The Travels of Babar* I drew the eyes painted on the elephant's rump to scare away the rhinoceros army, but I colored the tail orange—like a carrot nose. Some rubber stamps I borrowed from artist friends—and returned only with much regret! Given the limited selection of stamps available to me, though, some stamped images are repeated on multiple cards, such as the pig for *Charlotte's Web*, *Lord of the Flies*, and *MOO*. To distinguish whatever stamp is used more than once, I add attributes to connect the image to the specific book.

Illustration 10

Illustration 13

Plates 62, 232

Since wet mediums cause the card stock to curl, I limit myself to ink and colored pencil for drawing and often resort to digital imagery—occasionally of my own artwork, as seen in the cards for *The Log from the Sea of Cortez* and *The Yearling*. I use text sparingly. A few cards have handwritten quotes from passages relating to memory—the thread that binds this book together. And for other cards, language is essential to convey a particular detail that captured my attention. For example, I wrote the names of all the children in *Cheaper by the Dozen* in Morse code, as they were proficient in its usage.

Plate 162

Illustration 16

Plate 39

Generally, I don't alter the shape of a card except to make a strong statement. I partially burned the card for *Hiroshima* and fashioned a door that opens and closes for *The Diary of a Young Girl*. I cut and folded the card for *Aunt Sallie's Lament*, whose pages are reminiscent of quilt blocks, in an attempt to echo the unique asymmetrical creation of designer Claire Van Vliet and poet Margaret Kaufman. Despite my modifications, these cards fit comfortably into my *Book Marks* library case, except for one—my crumpled interpretation of *Unsafe at Any Speed*. Accidents do happen!

Plate 56

Plate 55

Plate 387

Illustration 4

Illustration 24

ACKNOWLEDGMENTS

It took a village to bring this book to completion.

First and foremost, it would not exist at all without the many authors whose works my cards represent. After the arduous process of putting my own thoughts on paper, I appreciate their literary endeavors even more. My apologies if I misrepresented any of their books through my personal interpretation or the whims and lapses of my memory.

I deeply appreciate the incisive guidance of Beth Daugherty, the structural engineer of this project. She examined every word and rearranged nearly every paragraph of the manuscript. In the course of our lengthy telephone conversations, she patiently prodded me to "work my magic" when I faltered and gave me a pep talk when I melted down. It can't be easy to cope with a stubborn author. *Book Marks* is the product of her vision, organization, and dedication to bringing it to fruition.

Kathy Hart designed the book with great sensitivity to harmonizing text and imagery. Although I was hesitant to include personal photographs and memorabilia in the chapters, her engaging layouts persuaded me otherwise. Leslie Kazanjian made uncountable improvements to the text, beginning with the first sentence of the prologue. Wendy Kenney carried out the heroic job of indexing and vetting all the bibliographic information for the 400-plus cards and even added interesting details. And Eric Chu and Steve Bloom of Pimlico Book Company made the book a physical reality that surpassed all my expectations.

I want to thank those who lent me their rubber stamps, in some cases for years: Ashley Miller, Elizabeth McMahon, and Laura Cooke. Yvonne Fogarty suggested the apt quotation for the epigraph. Nick Whitmer shared his expertise on library functions and history; I only wish I could have included all the interesting information he sent my way. Librarians Susan Currie, Janet Steiner, Judy Barkee, Annette Birdsall, and Lis Chabot all lent support to the project. Warren Allmon and Chelsea Steffes arranged access to the Museum of the Earth for a photography shoot during the pandemic. Terry Plater, John Guckenheimer, and David Larrabee addressed questions in their areas of expertise that arose in the course of my writing the book.

I would like to thank the following readers whose comments helped shape the book: Judith Andrade, Paula Bennett, Janet Berlo, Lisa Bernhard, David Blake, Jon Brown, George Cooke, Paul Cooke, Gay Daly, Evelyn Dean-Olmsted, Baldomero Fernandez, Betsy Gillen, Johanna Heinemann-Haas, Michael Kathrens, Joanie Mackie, Lorraine McCue, Joyce Morgenroth, Josh Olmsted, Carolyn Richard, Connie Richard, Robert Richard, Ruth Rosenblatt, Laurie Rubin, Viva Stowell, Rebecca Thackrey, and David Nelson Wren. Special thanks go to Frances Cooke, Janet Daugherty, Peggy Haine,

and Ethel Rompilla, who each made significant contributions to improving the text and helped me avoid blunders with their insightful suggestions and tireless review of various versions of the manuscript. I particularly want to extend my profound gratitude to Amy McCune, who read all the drafts, suggested a great tweak to the title of the book, and listened to my moans and groans over deadlines and "final" edits that took forever to finalize.

The encouragement and support of many friends, some of whom appear in the stories I recount here, have sustained me over the years: Meredith Kusch, Joan and Edward Ormondroyd, Kevin and Elizabeth McMahon, David and Susan Means, the late Mary Ellen Rossiter, Nancy Ramage, Janice Frossard, Lynn Wiles, Ineke Dhondt, Gene Endres, Nancy Rosan, Margaretta Lovell, Susan Kemp, Joyce Hawley, Paulette Bierzychudek, Naomi Grossman, Ruth Sproul, Irene Silverman, Carol Skinner, Ethan Akin, Scott Sutcliffe, and Rodney Bent. (Forgive the alphabetical disorder.) Thank you also to the members of my reading group. They have provided camaraderie, spirited discussions, and countless interesting books to consider over the past thirty years.

I am grateful to the Center for Book Arts in New York City and the Everson Museum in Syracuse, New York, for displaying this collection of cards in its early stages. Carla Rae Johnson, an outstanding artist and artist's advocate, included the *Book Marks* file case and contents in the exhibit *Artists in the Archives*, which traveled to numerous libraries and institutions of learning. This inspired Sally Grubb at the Tompkins County Public Library in Ithaca, New York, to acquire an antique card-catalog with fifteen drawers. She encouraged patrons to create cards with pictures or comments about their favorite books and file them within it. Some even made unique booklets to fit within the dimensions of the drawers. The card catalog is now in the library's permanent collection, filled with hundreds of index cards celebrating its more than 150 years of history.

And finally my heartfelt love and respect go out to the members of my family, whose pursuits, comments, and contributions built this book. My sons, George and Paul Cooke, were somewhat dismayed at their mother's laying out laundry in public, but my writing the book led to many meaningful discussions about our lives together. My daughter-in-law Ruth read the manuscript with a critical eye and at the same time encouraged me by pointing out the parts she loved. My grandchildren—Frances, Noelle, Andrew, and Declan Cooke—gave me the enormous pleasure of seeing them grow into adulthood with gusto and grit, and in turn I leave them a little piece of their family history. I deeply appreciate the friendship of Dick's children: Jennifer McGuire helped me resolve a sticky issue in this book, and Bryan Root gave me leave to use his name in vain or otherwise. Despite the growing pains I shared with my siblings, I fondly recall building sprawling cities out of blocks and books with my brother and taking turns batting and fielding a baseball with my sister. Finally, I want to raise a toast to the absent family members without whom there would be no story to tell: George E. Cooke, Richard Root, my parents, Muzzy and Pop-Pop, Gammy, and Uncle Robin.

LIST OF BOOKS REPRESENTED BY CARDS

I hope this book—and art project—inspire further reading. With that in mind, I've included publication information for the books represented by my cards. This is not meant to be a proper bibliography but, rather, a guide. Editions represent the copy of the book I own (whether acquired new or used) or likely read or had read to me as a child. Many publishers' names have changed over time. Sometimes the name appears as it was at the time the edition was published and sometimes the current name is used throughout. I have attempted to provide original titles if first published in a language other than English, as well as original publication dates. Please forgive any errors or omissions.

FRONTISPIECE: *Kafka on the Shore* by Haruki Murakami. Translated from the Japanese by Philip Gabriel. Alfred A. Knopf, 2005. First published in 2002 as *Umibe no Kafuka*.

PROLOGUE: LIBRARY OF THE MIND

Illustration 1 *Proust Was a Neuroscientist* by Jonah Lehrer. Mariner Books, 2008. Illustrated edition, paperback.
Illustration 2 *The Devil in the White City: Murder, Magic, and Madness at the Fair That Changed America* by Erik Larson. Crown Publishers, 2003.
Illustration 3 *The Wind in the Willows* by Kenneth Grahame. Introduction by A. A. Milne. Illustrated by Arthur Rackham. Limited Editions Club, 1940. First published in 1908 by Charles Scribner's Sons, without illustrations other than a frontispiece by Graham Robertson.
Illustration 5 *The Sixth Extinction: An Unnatural History* by Elizabeth Kolbert. Picador, 2015. Trade paperback.

CHAPTER 1: FARM AND FABLES

Plate 1 *Walt Disney's Three Little Pigs* by Walt Disney Studios. Illustrated by Milt Banta and Al Dempster. Simon & Schuster, 1948.
Plate 2 *The Tale of Peter Rabbit* written and illustrated by Beatrix Potter. Frederick Warne & Co., 1902.
Plate 3 *Make Way for Ducklings* written and illustrated by Robert McCloskey. The Viking Press, 1941.
Plate 4 *The Gingerbread Man: A Story Retold* by Whitman staff. Illustrated by Sally Tate. Whitman Publishing Co., 1944. The popular American folktale first appeared in print in the May 1875 issue of *St. Nicholas Magazine*.
Plate 5 *Raggedy Ann Stories* written and illustrated by Johnny Gruelle. The P. F. Volland Company, 1918.
Plate 6 *Little Black Sambo* by Helen Bannerman. Little Golden Book, Simon & Schuster, 1948.
Plate 7 *Winnie-the-Pooh* by A. A. Milne. Illustrated by Ernest H. Shepard. E. P. Dutton, 1926.
Plate 8 *Madeline* written and illustrated by Ludwig Bemelmans. Simon & Schuster, 1939.
Plate 9 *My Father's Dragon* by Ruth Stiles Gannett. Illustrated by Ruth Chrisman Gannett. Random House, 1948.
Plate 10 *Pookie* written and illustrated by Ivy L. Wallace. Collins (predecessor to HarperCollins in the UK), 1946.
Plate 11 *Cinderella* retold by C. S. Evans. Illustrated by Arthur Rackham. William Heinemann Ltd., 1919. The first published European version of this ancient folk tale appeared in 1634 in a collection entitled *Pentamerone*, compiled by Giambattista Basile and written in Neapolitan dialect.
Plate 12 *Slovenly Peter, or Cheerful Stories and Funny Pictures for Good Little Folks: Illustrations Colored by Hand After the Original Style* written and illustrated by Heinrich Hoffmann. The John C. Winston Co., 1919. First published in 1845 in German as *Der Struwwelpeter*.
Plate 13 *Mary Poppins* by P. L. Travers. Illustrated by Mary Shepard. Reynal and Hitchcock, 1934.
Plate 14 *Peter Pan and Wendy* by James M. Barrie. Illustrated by Mabel Lucie Attwell. Charles Scribner's Sons, 1928. Originally written in 1904 by Barrie as a play, *Peter Pan, or The Boy Who Wouldn't Grow Up*. In 1911, Barrie adapted it as a novel entitled *Peter and Wendy*.
Plate 15 *Fun with Dick and Jane* by William S. Gray and May Hill Arbuthnot. Illustrated by Eleanor Campbell and Keith Ward. Scott, Foresman and Company, 1946. Characters and text developed by Zerna Sharp.
Plate 16 *The Story of Doctor Doolittle, Being the History of His Peculiar Life at Home and Astonishing Adventures in Foreign Parts* written and illustrated by Hugh Lofting. Frederick A. Stokes, 1920.
Plate 17 *Mrs. Piggle-Wiggle* by Betty MacDonald. Illustrated by Richard Bennett. J. B. Lippincott Company, 1947.

Plate 18 *Petunia* written and illustrated by Roger Duvoisin. Alfred A. Knopf, 1950.

Plate 19 *The Wonderful Wizard of Oz* by L. Frank Baum. Illustrated by W. W. Denslow. George M. Hill Co., 1900.

Plate 20 *The Jungle Books* by Rudyard Kipling. Foreword by Nelson Doubleday. Illustrations by Aldren Watson. Doubleday & Co., 1948. First published in 1894 and 1895 respectively by Macmillan & Co. in the UK, with illustrations by John Lockwood Kipling, Rudyard's father. Kipling wrote the story at Naulahka, his home in Vermont, U.S.A.

Plate 21 *Minn of the Mississippi* written and illustrated by Holling Clancy Holling. Houghton Mifflin Company, 1951.

Plate 22 *Pinocchio* by Carlo Collodi (Carlo Lorenzini). Illustrations by Fritz Kredel. Translated from the Italian by M. A. Murray. Grosset & Dunlap, 1946. The story was originally published as *Le avventure di Pinocchio* in 1883 by Felice Paggi, Florence, Italy, with illustrations by Enrico Mazzanti.

Plate 23 *The Little Prince* written and illustrated by Antoine de Saint-Exupéry. Translated from the French by Katherine Woods. Harcourt, Brace & World, 1943. As of 2017, *The Little Prince* had been translated into over three hundred languages, including Klingon and Esperanto, and was the world's most-translated book aside from religious texts. More than one million copies are sold every year.

Plate 24 *Stuart Little* by E. B. White. Illustrated by Garth Williams. Harper & Brothers, 1945.

Plate 25 *Little Lord Fauntleroy* by Frances Hodgson Burnett. Illustrated by Reginald Birch. Charles Scribner's Sons, 1886.

Plate 26 *The Secret Garden* by Frances Hodgson Burnett. Illustrated by Maria Louise Kirk. Frederick A. Stokes, 1911.

Plate 27 *A Little Princess: Being the Whole Story of Sara Crewe Now Told for the First Time* by Frances Hodgson Burnett. Illustrated by Ethel Franklin Betts. Charles Scribner's Sons, 1905.

Plate 28 *The Adventures of Tom Sawyer* by Mark Twain. Illustrated by Peter Hurd. The John C. Winston Company, 1931. First published in 1876 by the American Publishing Company.

Plate 29 *Lassie Come-Home* by Eric Knight. Illustrated by Phoebe Erickson. The John C. Winston Co., 1940. Originally appeared as a story in the December 17, 1938, issue of *The Saturday Evening Post.*

Plate 30 *King of the Wind* by Marguerite Henry. Illustrated by Wesley Dennis. Rand McNally, 1948.

Plate 31 *Horsemanship for Beginners: Riding, Jumping, and Schooling* by Jean Slaughter. Alfred A. Knopf, 1952.

Plate 32 *A Pony for Linda* written and illustrated by C. W. Anderson. The Macmillan Company, 1951.

Illustration 7 *The Story of Ferdinand* by Munro Leaf. Illustrated by Robert Lawson. The Viking Press, 1938. Paperback.

Illustration 10 *The Travels of Babar* written and illustrated by Jean de Brunhoff. Random House, 1961. First published in 1934 by Harrison Smith and Robert Haas.

Illustration 13 *Charlotte's Web* by E. B. White. Illustrated by Garth Williams. Harper & Brothers, 1952.

CHAPTER 2: DISLOCATIONS AND DAYDREAMS

Plate 33 *Hans Brinker; or, The Silver Skates: A Story of Life in Holland* by Mary Mapes Dodge. Illustrated by Louis Rhead. Harper & Brothers, 1924. First published in 1865 by James O'Kane, New York, with illustrations by Thomas Nast and F. O. C. Darley.

Plate 34 *Otto of the Silver Hand* written and illustrated by Howard Pyle. Charles Scribner's Sons, 1926. First published in 1888 by Charles Scribner's Sons.

Plate 35 *An Introduction to Nature: Birds, Wild Flowers, Trees* by John Kieran. Illustrated by Don Eckelberry, Tabea Hoffman, and Michael H. Bevans. Doubleday & Co., 1955.

Plate 36 *The Children of Odin* by Padraic Colum. Illustrated by Willy Pogany. The Macmillan Company, 1920.

Plate 37 *Mutiny on the Bounty* by Charles Nordhoff and James Hall. Little, Brown and Company, 1932.

Plate 38 *Men Against the Sea* by Charles Nordhoff and James Hall. Little, Brown and Company, 1934.

Plate 39 *Cheaper by the Dozen* by Frank Gilbreth Jr. and Ernestine Gilbreth Carey. Illustrated by Donald McKay. Thomas Y. Crowell Company, 1948.

Plate 40 *Treasure Island* by Robert Louis Stevenson. Illustrated by N. C. Wyeth. Charles Scribner's Sons, 1919. Serialized between 1881 and 1882 in *Young Folks* magazine as *Treasure Island or the mutiny of the* Hispaniola, written under the pseudonym of Captain George North. First published in book form in 1883 by Cassell and Company, London.

Plate 41 *A Night to Remember: The Classic Account of the Final Hours of the* Titanic by Walter Lord. Henry Holt and Company, 1955.

Plate 42 *The Adventures of Huckleberry Finn (Tom Sawyer's Comrade)* by Mark Twain. Harper & Brothers, 1912. First published in 1885 by Charles L. Webster and Company.

Plate 43 *Around the World in Eighty Days* by Jules Verne. James R. Osgood and Company, 1873.

Plate 44 *The Three Musketeers* by Alexandre Dumas. Translated from the French by Jacques Le Clercq. Modern Library, 1950. Originally serialized from March to July, 1844, in *Le Siècle* as *Les Trois Mousquetaires*.

Plate 45 *Annapurna: First 8000-Metre Peak (26,493 Feet)* by Maurice Herzog. Translated from the French by Nea Marin and Janet Adam Smith. Jonathan Cape, 1952. First published in 1951 by Arthaud as *Annapurna premier 8,000*.

Plate 46 *A Journey into the Interior of the Earth* by Jules Verne. Ward, Lock and Co., London, c. 1881. Translated from the French by Frederick Amadeus Malleson. Serialized in 1870 in *Boys Journal* (London) as *Journey to the Centre of the Earth*. First published in 1864 as *Voyage au centre de la Terre*.

Plate 47 *Kon-Tiki: Across the Pacific by Raft* by Thor Heyerdahl. Translated from the Norwegian by F. H. Lyon. Rand McNally, 1950. First published in 1948 by Gyldendal Norsk Forlag as *Kon-Tiki ekspedisjonen*.

Plate 48 *Brave New World* by Aldous Huxley. Harper & Brothers, 1932.

Plate 49 *Little Women, or Meg, Jo, Beth and Amy* by Louisa May Alcott. Illustrated by Clara M. Burd. The John C. Winston Co., 1926. Originally published as two volumes in 1868 and 1869 by Roberts Brothers in Boston.

Plate 50 *The Red Badge of Courage: An Episode of the American Civil War* by Stephen Crane. D. Appleton and Company, 1895.

Plate 51 *1984* by George Orwell. Secker & Warburg, 1949.

Plate 52 *Animal Farm* by George Orwell. Harcourt, Brace & Co., 1946.

Plate 53 *To Kill a Mockingbird* by Harper Lee. J. B. Lippincott Company, 1960.

Plate 54 *Gone with the Wind* by Margaret Mitchell. The Macmillan Company, 1936. The author's tentative title for the book was *Tomorrow is Another Day*.

Plate 55 *The Diary of a Young Girl* by Anne Frank. Introduction by Eleanor Roosevelt. Translated from the Dutch by B. M. Mooyaart-Doubleday. Doubleday & Co., 1952. First published in 1947 as *Het Achterhuis*. Retrieved from a pile of rejected manuscripts, *The Diary of a Young Girl* has been translated into over 70 languages.

Plate 56 *Hiroshima* by John Hersey. Alfred A. Knopf, 1946.

Plate 57 *Aeneis (The Aeneid)*, from *Opera* by Virgil (P. Vergili Maronis). Oxonii e typographeo clarendoniano, 1963. Latin edition.

Plate 58 *The Picture of Dorian Gray* by Oscar Wilde. Horace Liveright, 1930. Originally appeared in the July 1890 issue of *Lippincott's Monthly Magazine*. First published in 1891 in book form by Ward Lock and Bowden, London.

Plate 59 *Jane Eyre* by Charlotte Brontë. Downey and Co., London, 1898. First published in 1847 by Smith, Elder & Co., London.

Plate 60 *Gulliver's Travels* by Jonathan Swift. Illustrated by Aldren Watson. Grosset & Dunlap, 1947. First published in 1726 by Benjamin Motte, London, as *Travels into Several Remote Nations of the World, in Four Parts. By Lemuel Gulliver, first a surgeon, and then a captain of several ships.*

Plate 61 *Spoon River Anthology* by Edgar Lee Masters. The Macmillan Company, 1915.

Plate 62 *Lord of the Flies* by William Golding. Faber and Faber, 1954.

Plate 63 *The Nun's Story* by Kathryn Hulme. Little, Brown and Company, 1956.

Plate 64 *Ethan Frome* by Edith Wharton. Charles Scribner's Sons, 1911.

Plate 65 *The Beautiful and the Damned* by F. Scott Fitzgerald. Charles Scribner's Sons, 1922.

Plate 66 *The Prime of Miss Jean Brodie* by Muriel Spark. Macmillan & Co., London, 1961.

Plate 67 *Macbeth* by William Shakespeare. Penguin Classics, 1956. Originally published in the First Folio, entitled *Mr. William Shakespeare's Comedies, Histories, & Tragedies*, 1623.

Plate 68 *Of Human Bondage* by W. Somerset Maugham. Modern Library, 1915. First published by George H. Doran Company in 1915.

Plate 69 *The Scarlet Letter* by Nathaniel Hawthorne. Modern Library, 1950. First published in 1850 by Ticknor, Reed and Fields, Boston.

Plate 70 *Of Mice and Men* by John Steinbeck. Covici-Friede, 1937.

Plate 71 *The Adventures of Oliver Twist* by Charles Dickens. Chapman and Hall, 1873. Originally serialized in *Bentley's Miscellany* between 1837 and 1839. In 1838, before the serialization ended, the story was published as a three-volume book, *The Adventures of Oliver Twist, or The Parish Boy's Progress*.

Plate 72 *Daisy Miller* by Henry James. Harper & Brothers, 1879.

Plate 73 *Franny and Zooey* by J. D. Salinger. Little, Brown and Company, 1961. The short story "Franny" and the novella *Zooey* were published in *The New Yorker* in 1955 and 1957, respectively, followed by the 1961 publication of the book.

Plate 74 *Lady Chatterley's Lover* by D. H. Lawrence. Grove Press, 1959.

Plate 75 *Peyton Place* by Grace Metalious. Julian Messner, Inc., 1956.

Plate 76 *An American Tragedy* by Theodore Dreiser. Boni & Liveright, 1925.

Plate 77 *Οδυσσεια* (*The Odyssey of Homer*) edited by W. B. Stanford. The Macmillan Company, 1965. Greek edition.

Plate 78 *Selections from the Greek Elegiac, Iambic and Lyric Poets* edited by J. A. Moore. Harvard University Press, 1965. Greek edition. First published in 1947.

Plate 79 *Μήδεια (Medea)* by Euripides. Edited with introduction and commentary by D. L. Page. Oxford at the Clarendon Press, 1964. Greek edition. First published in 1938.

Plate 80 *The King Must Die* by Mary Renault. Pantheon Books, 1958.

Plate 81 *Walden Two* by B. F. Skinner. The Macmillan Company, 1948.

Plate 82 *Black Like Me* by John Howard Griffin. Houghton Mifflin Company, 1961.

Plate 83 *Dr. Zhivago* by Boris Pasternak. Pantheon Books, 1958.

Plate 84 *Anthem* by Ayn Rand. Cassell and Company, 1938.

Plate 85 *The Forsyte Saga* by John Galsworthy. William Heinemann Ltd., 1922. Consolidation of a series of three novels and two interludes first published between 1906 and 1921.

Plate 86 *A Town Like Alice* by Nevil Shute. William Heinemann Ltd., London, 1950.

Plate 87 *A Farewell to Arms* by Ernest Hemingway. Charles Scribner's Sons, 1929.

Plate 88 *Lucky Jim* by Kingsley Amis. Doubleday & Co., 1954.

Illustration 15 *The Sleeping Beauty* told by C. S. Evans. Illustrated by Arthur Rackham. William Heinemann Ltd., London, 1920.

Illustration 16 *The Yearling* by Marjorie Kinnan Rawlings. Illustrated by N. C. Wyeth. Charles Scribner's Sons, 1942. First published in 1938, it was the best-selling novel in America that year.

Illustration 19 *A Tale of Two Cities* by Charles Dickens. Illustrated by Phiz (Hablot Knight Browne). Chapman and Hall, London, 1875. Originally serialized in Dickens's literary periodical *All the Year Round*, the story was first published in book form by Chapman and Hall in 1859.

CHAPTER 3: BEGINNINGS AND ENDINGS

Plate 89 *Webster's Seventh New Collegiate Dictionary*. G. & C. Merriam Company, 1963.

Plate 90 *Rabbit, Run* by John Updike. Alfred A. Knopf, 1960.

Plate 91 *Joy of Cooking* by Irma S. Rombauer and Marion Rombauer Becker. Illustrated by Ginnie Hofmann. The Bobbs-Merrill Company, 1963. Originally self-published and printed for Rombauer by A. C. Clayton in 1931, the cookbook was first published by the Bobbs-Merrill Company in 1936.

Plate 92 *The Heart is a Lonely Hunter* by Carson McCullers. Houghton Mifflin Company, 1940.

Plate 93 *Gift from the Sea* by Anne Morrow Lindbergh. Pantheon Books, 1955.

Plate 94 *Baby and Child Care* by Benjamin Spock, M.D. Pocket Books, 1957. Mass-market paperback. First published in 1946 as *The Common Sense Book of Baby and Child Care* by Duell, Sloan and Pearce.

Plate 95 *A Tree Grows in Brooklyn* by Betty Smith. Harper & Brothers, 1943.

Plate 96 *Infant and Child in the Culture of Today: The Guidance of Development in Home and Nursery School* by Arnold Gesell and Frances L. Ilg. Harper & Brothers, 1943.

Plate 97 *The Very Hungry Caterpillar* written and illustrated by Eric Carle. World Publishing, 1969.

Plate 98 *The Little Engine That Could: Retold by Watty Piper from* The Pony Engine *by Mabel C. Bragg* by Watty Piper (Arnold Munk). Illustrated by Lois L. Lenski. The Platt & Munk Co., 1930.

Plate 99 *The Adventures of Tintin: Explorers on the Moon* written and illustrated by Hergé. Translated from the French by Danièle Gorlin. Golden Press, 1960. Originally serialized in Belgium's *Tintin* magazine between 1952 and 1953. First published in book form by Casterman, Brussels, in 1954.

Plate 100 *Ant and Bee: An Alphabetical Story for Tiny Tots* by Angela Banner. Illustrated by Bryan Ward. Edmund Ward Ltd., London, 1950.

Plate 101 *The Five Chinese Brothers* by Claire Huchet Bishop. Illustrated by Kurt Wiese. Coward-McCann, Inc., 1938.

Plate 102 *The Ashley Book of Knots: Every Practical Knot—What It Looks Like, Who Uses It, Where It Comes From, and How to Tie It* by Clifford W. Ashley. Doubleday, Doran & Co., 1944.

Plate 103 *Curious George* written and illustrated by H. A. and Margret (uncredited) Rey. Houghton Mifflin Company, 1958. First published in 1941.

Plate 104 *Where the Wild Things Are* written and illustrated by Maurice Sendak. Harper & Row, 1963.

Plate 105 *Desert Solitaire: A Season in the Wilderness* by Edward Abbey. McGraw-Hill, 1968.

Plate 106 *Silent Spring* by Rachel Carson. Houghton Mifflin Company, 1962.

Plate 107 *The Population Bomb* by Paul R. and Anne (uncredited) Ehrlich. Sierra Club-Ballantine Books, 1968. Mass-market paperback original.

Plate 108 *The Greening of America* by Charles A. Reich. Random House, 1970.

Plate 109 *Candy* by Terry Southern and Mason Hoffenberg. G. P. Putnam's Sons, 1964.

Plate 110 *Siddhartha* by Hermann Hesse. Translated from the German by Hilda Rosner. New Directions, 1951. First published in 1922 by S. Fischer, Berlin.

Plate 111 *The Dot and the Line: A Romance in Lower Mathematics* by Norton Juster. Random House, 1963.

Plate 112 *The Electric Kool-Aid Acid Test* by Tom Wolfe. Farrar, Straus and Giroux, 1968.

Plate 113 *The Student Pilot's Flight Manual: From First Flight to Pilot Certificate* by William K. Kershner. Iowa State University Press, 1968.

Plate 114 *Stick and Rudder: An Explanation of the Art of Flying* by Wolfgang Langewiesche. McGraw-Hill, 1944.

Plate 115 *Fear of Flying* by Erica Jong. Holt, Rinehart and Winston, 1973.

Plate 116 *Jonathan Livingston Seagull* by Richard Bach. The Macmillan Company, 1970.

Plate 117 *The Whole Earth Catalog* by Stewart Brand. Portola Institute, 1970. Large-format softcover original.

Plate 118 *Fire in the Lake: The Vietnamese and the Americans in Vietnam* by Frances Fitzgerald. Little, Brown and Company, 1972.

Plate 119 *The Autobiography of Malcolm X* by Malcolm X with the assistance of Alex Haley. Grove Press, 1965.

Plate 120 *Soul on Ice* by Eldridge Cleaver. Ramparts Press Inc./McGraw-Hill, 1968.

Plate 121 *The Cat in the Hat* written and illustrated by Dr. Seuss (Theodor Geisel). Random House, 1957.

Plate 122 *Tree in the Trail* written and illustrated by Holling Clancy Holling. Houghton Mifflin Company, 1942.

Plate 123 *What Do I Do Monday?* by John Caldwell Holt. E. P. Dutton, 1970.

Plate 124 *The Sneetches and Other Stories* written and illustrated by Dr. Seuss (Theodor Geisel). Random House, 1961.

Plate 125 *Middlemarch, A Study of Provincial Life* by George Eliot (Mary Ann Evans). Houghton Mifflin Company, 1956. First published in eight parts between 1871 and 1872 by William Blackwood and Sons, Edinburgh.

Plate 126 *The Great Gatsby* by F. Scott Fitzgerald. Charles Scribner's Sons, 1925.

Plate 127 *Summerhill: A Radical Approach to Child Rearing* by A. S. Neill. Foreword by Erich Fromm. Hart Publishing Co., 1960.

Plate 128 *Mrs. Dalloway* by Virginia Woolf. Harcourt, Brace & Co., 1925.

Plate 129 *People's Park* edited by Alan Copeland and Nikki Arai. Ballantine Books, 1969. Trade paperback original.

Plate 130 *Slouching Towards Bethlehem* by Joan Didion. Farrar, Straus and Giroux, 1968.

Plate 131 *The Teachings of Don Juan: A Yaqui Way of Knowledge* by Carlos Castaneda. University of California Press, 1968.

Plate 132 *The Milagro Beanfield War* by John Nichols. Holt, Rinehart and Winston, 1974.

Plate 133 *Memoirs of an Ex-Prom Queen* by Alix Kates Shulman. Alfred A. Knopf, 1972.

Plate 134 *The Feminine Mystique* by Betty Friedan. W. W. Norton and Company, 1963.

Plate 135 *One Flew Over the Cuckoo's Nest* by Ken Kesey. The Viking Press, 1962.

Plate 136 *Heart of Darkness* by Joseph Conrad. W. W. Norton and Company, 1963. Trade paperback. Serialized in three parts in *Blackwood's Magazine* in 1899. First published in book form by William Blackwood and Sons, Edinburgh, in 1902.

Plate 137 *The Age of the Avant-Garde: An Art Chronicle of 1956–1972* by Hilton Kramer. Farrar, Straus and Giroux, 1973.

Plate 138 *The Genesis of Modernism: Seurat, Gauguin, van Gogh and French Symbolism in the 1880s* by Sven Loevgren. Indiana University Press, 1971.

Plate 139 *Concerning the Spiritual in Art and Painting in Particular, 1912* by Wassily Kandinsky. Editorial note by Robert Motherwell. Wittenborn Art Books, 1970. Reprint edition. Paperback. First published in 1911 as Über *das Geistige in der Kunst*.

Plate 140 *Art and Culture: Critical Essays* by Clement Greenberg. Beacon Press, 1965. Trade paperback.

Plate 141 *Life with Picasso* by Françoise Gilot and Carlton Lake. McGraw-Hill, 1964.

Plate 142 *Archy and Mehitabel* by Don Marquis. Illustrated by George Herriman. Doubleday, Doran & Co., 1931. First published in 1927. The cockroach (archy) and alley cat (mehitabel), characters created in 1916, appeared often in Marquis's column for the New York City *Evening Sun*.

Plate 143 *The Phantom Tollbooth* by Norton Juster. Illustrated by Jules Feiffer. Epstein & Carroll, 1961.

Plate 144 *Charlie and the Chocolate Factory* by Roald Dahl. Illustrated by Joseph Schindelman. Alfred A. Knopf, 1964.

Plate 145 *Speedboat* by Renata Adler. Random House, 1976.

Plate 146 *Fahrenheit 451* by Ray Bradbury. Ballantine Books, 1953.

Plate 147 *The Bluest Eye* by Toni Morrison. Holt, Rinehart and Winston, 1970.

Plate 148 *Roots: The Saga of an American Family* by Alex Haley. Doubleday & Co., 1976.

Plate 149 *Zen and the Art of Motorcycle Maintenance: An Inquiry into Values* by Robert Pirsig. William Morrow & Co., 1974.

Plate 150 *Exercises in Style* by Raymond Queneau. Translated from the French by Barbara Wright. New Directions Paperback, 1981. First published in 1947 by Éditions Gallimard, Paris, as *Exercises de style*.

Plate 151 *The Illustrated Man* by Ray Bradbury. Doubleday & Co., 1951.

Plate 152 *The Origin of Consciousness in the Breakdown of the Bicameral Mind* by Julian Jaynes. Houghton Mifflin Company, 1976.

Illustration 23 *The Fannie Farmer Cookbook* edited by Wilma Lord Perkins (editor for 45 years of the popular cookbook written by her husband's aunt). Illustrated by Alison Mason Kingsbury. Little, Brown and Company, 1965. Originally published in 1896 as *The Boston Cooking-School Cook Book* by Fannie Merritt Farmer.

Illustration 24 *Unsafe at Any Speed: The Designed-In Dangers of the American Automobile* by Ralph Nader. Grossman Publishers, 1965.

Illustration 29 *Dawns + Dusks: Taped Conversations with Diana MacKown* by Louise Nevelson and Diana MacKown. Charles Scribner's Sons, 1976.

CHAPTER 4: ROMANCE AND HAPPENSTANCE

Plate 153 *Passages: Predictable Crises of Adult Life* by Gail Sheehy. E. P. Dutton, 1976.

Plate 154 *Moosewood Cookbook* written and illustrated by Mollie Katzen. Ten Speed Press, 1977.

Plate 155 *Saul Steinberg* by Harold Rosenberg. Alfred A. Knopf, 1978.

Plate 156 *Richard Diebenkorn: Paintings and Drawings, 1943–1976* with essays by Robert T. Buck Jr. et al. Catalog, Albright-Knox Art Gallery, 1976. Exhibition catalog.

Plate 157 *Outermost House: A Year of Life on the Great Beach of Cape Cod* by Henry Beston. Illustrated with photographs by William A. Bradford and others. Doubleday, Doran & Co., 1928.

Plate 158 *A River Runs Through It and Other Stories* by Norman Maclean. The University of Chicago Press, 1976.

Plate 159 *The Path Between the Seas: The Creation of the Panama Canal, 1870–1914* by David McCullough. Simon & Schuster, 1977.

Plate 160 *Under the Volcano* by Malcolm Lowry. Reynal & Hitchcock, 1947.

Plate 161 *PADI Dive Manual* by Dennis Graver. PADI International, 1978.

Plate 162 *The Log from the Sea of Cortez: The Narrative Portion of the Book* Sea of Cortez, *by John Steinbeck and E. F. Ricketts, 1941, Here Reissued with a Profile "About Ed Ricketts"* by John Steinbeck. The Viking Press, 1951.

Plate 163 *Beautiful Swimmers: Watermen, Crabs and the Chesapeake Bay* by William W. Warner. Illustrated by Consuelo Hanks. Atlantic Monthly Press, 1976.

Plate 164 *A Naturalist on a Tropical Farm* by Alexander Skutch. Illustrated by Dana Gardner. University of California Press, 1980.

Plate 165 *Surely You're Joking, Mr. Feynman! Adventures of a Curious Character* by Richard Feynman. W. W. Norton and Company, 1985.

Plate 166 *The Hitchhiker's Guide to the Galaxy* by Douglas Adams. Pocket Books, 1979. Paperback. Originally a radio broadcast that aired on the BBC in 1978.

Plate 167 *West with the Night* by Beryl Markham. North Point Press, 1983.

Plate 168 *A Feeling for the Organism: The Life and Work of Barbara McClintock* by Evelyn Fox Keller. W. H. Freeman and Company, 1983.

Plate 169 *Heaven's Command: An Imperial Progress* by Jan Morris (formerly James Morris). Penguin Books, 1982. The second title in the *Pax Britannica Trilogy*, first published in 1978 by Faber and Faber, London.

Plate 170 *Eminent Victorians: Cardinal Manning, Florence Nightingale, Dr. Arnold, General Gordon* by Lytton Strachey. Penguin Books, 1948. Originally published by Chatto & Windus, London, 1918.

Plate 171 *Rebecca* by Daphne du Maurier. Victor Gollancz, London, 1938.

Plate 172 *The French Lieutenant's Woman* by John Fowles. Little, Brown and Company, 1969.

Plate 173 *Blue Highways: A Journey into America* by William Least Heat-Moon. Atlantic Monthly Press, 1983.

Plate 174 *A Room with a View* by E. M. Forster. G. P. Putnam's Sons, 1911. First published in 1908 by Edward Arnold, London.

Plate 175 *Anna Karenina* by Leo Tolstoy. Translated from the Russian by Constance Garnett. Random House, 1939. Serialized in the *Russian Messenger* between 1875 and 1877, the story was first published in book form in 1878 as three volumes in Russia. First published in English in 1886 by Thomas Y. Crowell, New York.

Plate 176 *Love in the Time of Cholera* by Gabriel García Márquez. Translated from the Spanish by Edith Grossman. Alfred A. Knopf, 1988. First published in 1985 in Spanish as *El amor en los tiempos del cólera*.

Plate 177 *Life and Death in Shanghai* by Nien Cheng (Yao Nien-Yuan). Grove Press, 1987.

Plate 178 *The Bone People* by Keri Hulme. Penguin Books, 1986. Trade paperback.

Plate 179 *Love Medicine* by Louise Erdrich. Holt, Rinehart and Winston, 1984.

Plate 180 *The Songlines* by Bruce Chatwin. The Viking Press, 1987.

Plate 181 *Like Water for Chocolate: A Novel in Monthly Installments, with Recipes, Romances, and Home Remedies* by Laura Esquivel. Translated from the Spanish by Carol and Thomas Christensen. Doubleday, 1992. First published in 1989 in Mexico as *Como agua para chocolate: novela de entregas mensuales con recetas, amores, y remedios caseros.*

Plate 182 *The Name of the Rose* by Umberto Eco. Translated from the Italian by William Weaver. Harcourt Brace Jovanovich, 1983. First published in 1980 by Bompiani as *Il nome della rosa.*

Plate 183 *Lonesome Dove* by Larry McMurtry. Simon & Schuster, 1985.

Plate 184 *Midaq Alley* by Naguib Mahfouz. Translated from the Arabic by Trevor Le Gassick. Anchor Books, 1975. Trade paperback. First published in 1947 as *Zuqāq al-Midaq.* First English edition released in 1966.

Plate 185 *House* by Tracy Kidder. Houghton Mifflin Company, 1985.

Plate 186 *Home Cooking: A Writer in the Kitchen* by Laurie Colwin. Illustrated by Anna Shapiro. Alfred A. Knopf, 1988.

Plate 187 *Manual of Woody Landscape Plants: Their Identification, Ornamental Characters, Culture, Propagation and Uses* by Michael A. Dirr. Illustrated by Bonnie Dirr et al. Stipes Publishing Co., 1990. First published in 1975.

Plate 188 *Van Gogh in Arles* by Ronald Pickvance. Metropolitan Museum of Art/Harry N. Abrams, 1984. Exhibition catalog.

Plate 189 *Crossing to Safety* by Wallace Stegner. Random House, 1987.

Plate 190 *A Natural History of the Senses* by Diane Ackerman. Random House, 1990.

Plate 191 *Newcomb's Wildflower Guide: An Ingenious New Key System for Quick, Positive Field Identification of the Wildflowers, Flowering Shrubs and Vines of Northeastern and North Central North America* by Lawrence Newcomb. Illustrated by Gordon Morrison. Little, Brown and Company, 1977.

Plate 192 *An Artist of the Floating World* by Kazuo Ishiguro. Faber and Faber, 1986.

Plate 193 *A Lesson Before Dying* by Ernest J. Gaines. Alfred A. Knopf, 1993.

Plate 194 *Night Studio: A Memoir of Philip Guston* by Musa Mayer. Da Capo Press, 1997. Trade paperback. First published in 1988 by Alfred A. Knopf.

Plate 195 *The Secrets of a Fire King: Stories* by Kim Edwards. W. W. Norton and Company, 1997.

Plate 196 *The Embarrassment of Riches: An Interpretation of Dutch Culture in the Golden Age* by Simon Schama. Alfred A. Knopf, 1987.

Plate 197 *All the Pretty Horses* by Cormac McCarthy. Alfred A. Knopf, 1992.

Plate 198 *Cat's Eye* by Margaret Atwood. Doubleday, 1989.

Plate 199 *The Shipping News* by E. Annie Proulx. Scribner, 1993.

Plate 200 *Young Men and Fire: A True Story of the Mann Gulch Fire* by Norman Maclean. The University of Chicago Press, 1992.

Plate 201 *Gameboards of North America* by Bruce and Doranna Wendel. Photographs by Schecter Lee. E. P. Dutton in association with the Museum of American Folk Art, 1986. Exhibition catalog.

Plate 202 *Bread and Jam for Frances* by Russell Hoban. Illustrated by Lillian Hoban. Harper & Row, 1964.

Plate 203 *The Daily Practice of Painting: Writings and Interviews, 1962–1993* by Gerhard Richter. Edited by Hans-Ulrich Obrist. Translated from the German by David Britt. The MIT Press in association with the Anthony d'Offay Gallery, 1995. Trade paperback original.

Plate 204 *Second Nature: A Gardener's Education* by Michael Pollan. Atlantic Monthly Press, 1991.

Plate 205 *The No. 1 Ladies' Detective Agency* by Alexander McCall Smith. Polygon Books, Edinburgh, 1998.

Plate 206 *Sasol Birds of Southern Africa* by Ian Sinclair, Phil Hockey, and Warwick Tarboton. Struik Publishers, South Africa, 1993. Paperback original.

Plate 207 *Memoirs of a Geisha* by Arthur Golden. Alfred A. Knopf, 1997.

Plate 208 *The Birthday Boys* by Beryl Bainbridge. Carroll & Graf Publishers, 1991.

Plate 209 *Den of Thieves* by James B. Stewart. Simon & Schuster, 1991.

Plate 210 *Travels with Lizbeth: Three Years on the Road and on the Streets* by Lars Eighner. Ballantine Books, 1994. Trade paperback.

Plate 211 *The Things They Carried* by Tim O'Brien. Houghton Mifflin Company, 1990.

Plate 212 *Angels in America: A Gay Fantasia on National Themes* by Tony Kushner. Theatre Communications Group, 1991. The play premiered in 1991 and opened on Broadway in 1993.

Plate 213 *The Tortilla Curtain* by T. Coraghessan Boyle. The Viking Press, 1995.

Plate 214 *Animal Dreams* by Barbara Kingsolver. HarperCollins, 1990.

Plate 215 *A Fine Disregard: What Makes Modern Art Modern* by Kirk Varnedoe. Harry N. Abrams, 1994.

Plate 216 *Art* by Yasmina Reza. Translated from the French by Christopher Hampton. Dramatists Play Service, 1998. A French-language play that premiered in 1994 at Comédie des Champs-Élysées in Paris. The play subsequently ran in London in 1996 and on Broadway in 1998.

Plate 217 *The Beak of the Finch: A Story of Evolution in Our Time* by Jonathan Weiner. Vintage Books, 1995. Trade paperback.

Plate 218 *Dinosaurs of the Flaming Cliffs: The Thrilling Account of One of the Largest Dinosaur Expeditions of the 20th Century by the Expedition Leader* by Michael Novacek. Illustrated by Ed Heck. Anchor Books, 1996.

Plate 219 *The Explorer's Garden: Rare and Unusual Perennials* by Daniel J. Hinkley. Timber Press, 1999.

Plate 220 *Towards a New Museum* by Victoria Newhouse. The Monacelli Press, 1998. Trade paperback original.

Plate 221 *The Song of the Dodo: Island Biogeography in an Age of Extinctions* by David Quammen. Scribner, 1996.

Plate 222 *Petrified Wood: The World of Fossilized Wood, Cones, Ferns, and Cycads* by Frank J. Daniels. Edited by Brooks B. Britt and Richard D. Dayvault. Western Colorado Publishing Co., 1998.

Plate 223 *Roadside Geology of New York* by Bradford B. Van Diver. Mountain Press Publishing Company, 1985. Trade paperback original.

Plate 224 *Life: A Natural History of the First Four Billion Years of Life on Earth* by Richard Fortey. Alfred A. Knopf, 1998.

Illustration 34 *The Old Patagonian Express: By Train Through the Americas* by Paul Theroux. Houghton Mifflin Company, 1979.

Illustration 36 *A Proper Garden: On Perennials in the Border* by Elisabeth Sheldon. Illustrated by Constance Sheldon and George Sheldon. Stackpole Books, 1989.

Illustration 37 *Wonderful Life: The Burgess Shale and the Nature of History* by Stephen Jay Gould. W. W. Norton and Company, 1989.

Illustration 38 *Annals of the Former World* by John McPhee. Farrar, Straus and Giroux, 1998.

CHAPTER 5: TIME AND AGAIN

Plate 225 *Life of Pi* by Yann Martel. Harcourt, Inc., 2001.

Plate 226 *Bel Canto* by Ann Patchett. HarperCollins, 2001.

Plate 227 *House of Sand and Fog* by Andre Dubus III. W. W. Norton and Company, 1999.

Plate 228 *The Amazing Adventures of Kavalier and Clay* by Michael Chabon. Random House, 2000.

Plate 229 *Le Cosmicomiche* by Italo Calvino. Edizioni Mondadori, 1993. Italian edition. First published in 1965 by Giulio Einaudi. Published in English as *Cosmicomics*.

Plate 230 *The Journey Is the Destination: The Journals of Dan Eldon* edited by Kathleen M. Eldon. Chronicle Books, 1997.

Plate 231 *The Bonesetter's Daughter* by Amy Tan. Ballantine Books, 2001. Mass-market paperback.

Plate 232 *Moo* by Jane Smiley. Alfred A. Knopf, 1995.

Plate 233 *Notes from a Small Island* by Bill Bryson. Harper Perennial, 1995. Trade paperback.

Plate 234 *A Coast to Coast Walk* by A. Wainwright. Michael Joseph, London, 2001. First published in 1973.

Plate 235 *Atonement* by Ian McEwan. Vintage Books, 2002. Trade paperback.

Plate 236 *A History of the World in 10 ½ Chapters* by Julian Barnes. Alfred A. Knopf, 1989.

Plate 237 *The English Patient* by Michael Ondaatje. Alfred A. Knopf, 1992.

Plate 238 *Italy Out of Hand: A Capricious Tour* by Barbara Hodgson. Chronicle Books, 2005.

Plate 239 *Gomorra: Viaggio nell'impero economico e nel sogno di dominio della camorra* by Roberto Saviano. Edizioni Mondadori, 2006. Italian edition. Trade paperback original. Published in English as *Gomorrah: A Personal Journey into the Violent International Empire of Naples' Organized Crime System*.

Plate 240 *Il giardino dei Finzi-Contini* by Giorgio Bassani. Edizioni Mondadori, 2009. Italian edition. First published in 1962 by Giulio Einaudi. Published in English as *The Garden of the Finzi-Continis*.

Plate 241 *Cry, the Beloved Country: A Story of Comfort in Desolation* by Alan Paton. Charles Scribner's Sons, 1948.

Plate 242 *Don't Let's Go to the Dogs Tonight: An African Childhood* by Alexandra Fuller. Random House, 2001.

Plate 243 *The Curious Incident of the Dog in the Night-Time* by Mark Haddon. Vintage Books, 2003. Trade paperback.

Plate 244 *The Pickup* by Nadine Gordimer. Farrar, Straus and Giroux, 2001.

Plate 245 *The Cave* by José Saramago. Translated from the Portuguese by Margaret Jull Costa. Harcourt, Inc., 2002. First published in 2000 by Caminho, Portugal, as *A Caverna*.

Plate 246 *A Year in Provence* by Peter Mayle. Illustrated by Judith Clancy. Vintage Books, 1990. Trade paperback.

Plate 247 *The Botany of Desire: A Plant's-Eye View of the World* by Michael Pollan. Random House, 2001.

Plate 248 *Julie of the Wolves* by Jean Craighead George. Read by Christina Moore. Recorded Books, 1996. Audiobook. Story first published in 1972 by Harper & Row, with illustrations by John Schoenherr.

Plate 249 *Nickel and Dimed: On (Not) Getting By in America* by Barbara Ehrenreich. Metropolitan Books, 2001.

Plate 250 *Water for Elephants* by Sara Gruen. Algonquin Books, 2006.

Plate 251 *Kitchen Confidential: Adventures in the Culinary Underbelly* by Anthony Bourdain. Bloomsbury USA, 2000.

Plate 252 *Cod: A Biography of the Fish That Changed the World* by Mark Kurlansky. Walker and Co., 1997.

Plate 253 *When the Emperor Was Divine* by Julie Otsuka. Alfred A. Knopf, 2002.

Plate 254 *Do Androids Dream of Electric Sheep?* by Philip K. Dick. Signet, 1969. Mass-market paperback.

Plate 255 *Extremely Loud and Incredibly Close* by Jonathan Safran Foer. Houghton Mifflin Company, 2005.

Plate 256 *Never Let Me Go* by Kazuo Ishiguro. Faber and Faber, London, 2005.

Plate 257 *March* by Geraldine Brooks. The Viking Press, 2005.

Plate 258 *Smilla's Sense of Snow* by Peter Høeg. Translated from the Danish by Tina Nunnally. Farrar, Straus and Giroux, 1993. First published in 1992 as *Frøken Smillas fornemmelse for sne*.

Plate 259 *The Future of the Past* by Alexander Stille. Farrar, Straus and Giroux, 2002.

Plate 260 *Servants of the Map: Stories* by Andrea Barrett. W. W. Norton and Company, 2002.

Plate 261 *The Equation That Couldn't Be Solved: How Mathematical Genius Discovered the Language of Symmetry* by Mario Livio. Simon & Schuster, 2005.

Plate 262 *A Short History of Nearly Everything* by Bill Bryson. Broadway Books, 2003.

Plate 263 *Cloud Atlas* by David Mitchell. Random House, 2004. Trade paperback.

Plate 264 *Team of Rivals: The Political Genius of Abraham Lincoln* by Doris Kearns Goodwin. Simon & Schuster, 2012. Trade paperback. First published in 2005.

Plate 265 *Ex Libris: Confessions of a Common Reader* by Anne Fadiman. Farrar, Straus and Giroux, 1998.

Plate 266 *The Girl Who Played Go* by Shan Sa. Translated from the French by Adriana Hunter. Alfred A. Knopf, 2003. First published in 2001 by Éditions Grasset, Paris, as *La Joueuse de Go*.

Plate 267 *The Absolutely True Diary of a Part-Time Indian* by Sherman Alexie. Illustrated by Ellen Forney. Little, Brown Books for Young Readers, 2007. Trade paperback.

Plate 268 *Thinking in Pictures: And Other Reports from My Life with Autism* by Temple Grandin. Doubleday, 1995.

Plate 269 *The Zookeeper's Wife* by Diane Ackerman. W. W. Norton and Company, 2007.

Plate 270 *On Beauty* by Zadie Smith. Hamish Hamilton, London, 2005.

Plate 271 *36 Views of Mount Fuji: On Finding Myself in Japan* by Cathy N. Davidson. E. P. Dutton, 1993.

Plate 272 *Lost on Planet China: The Strange and True Story of One Man's Attempt to Understand the World's Most Mystifying Nation, or How He Became Comfortable Eating Live Squid* by J. Maarten Troost. Broadway Books, 2008.

Plate 273 *The Brief Wondrous Life of Oscar Wao* by Junot Díaz. Riverhead Books, 2007.

Plate 274 *The Accidental Billionaires: The Founding of Facebook, A Tale of Sex, Money, Genius and Betrayal* by Ben Mezrich. Doubleday, 2009.

Plate 275 *Cutting for Stone* by Abraham Verghese. Alfred A. Knopf, 2009.

Plate 276 *Tiny Sunbirds, Far Away* by Christie Watson. Other Press, 2011.

Plate 277 *The Story of Edgar Sawtelle* by David Wroblewski. Ecco, 2008.

Plate 278 *The Lacuna* by Barbara Kingsolver. HarperCollins, 2009.

Plate 279 *The Road* by Cormac McCarthy. Alfred A. Knopf, 2006.

Plate 280 *The Art of Racing in the Rain* by Garth Stein. HarperCollins, 2008.

Plate 281 *Reading Lolita in Tehran: A Memoir in Books* by Azar Nafisi. Random House, 2003.

Plate 282 *Lolita* by Vladimir Nabokov. Vintage International, 1989. Trade paperback. First published in 1955 by G. P. Putnam's Sons.

Plate 283 *Pride and Prejudice* by Jane Austen. The Macmillan Company, 1964. First published in 1813 by T. Egerton, London.

Plate 284 *The Help* by Kathryn Stockett. Amy Einhorn Books, 2009.

Plate 285 *Open City* by Teju Cole. Random House, 2011.

Plate 286 *The Marriage Plot* by Jeffrey Eugenides. Farrar, Straus and Giroux, 2011.

Plate 287 *Revolution* by Jennifer Donnelly. Delacorte Press, 2010.

Plate 288 *Freedom* by Jonathan Franzen. Farrar, Straus and Giroux, 2010.

Plate 289 *Zeitoun* by Dave Eggers. McSweeney's Books, 2009.

Plate 290 *The World Is Flat: A Brief History of the Twenty-First Century* by Thomas L. Friedman. Farrar, Straus and Giroux, 2005.

Plate 291 *State of Denial* by Bob Woodward. Simon & Schuster, 2006.

Plate 292 *The Nine: Inside the Secret World of the Supreme Court* by Jeffrey Toobin. Doubleday, 2007.

Plate 293 *Dreams from My Father: A Story of Race and Inheritance* by Barack Obama. Broadway Books, 2004. Trade paperback reprint. First published in 1995 by Times Books.

Plate 294 *The Big Short: Inside the Doomsday Machine* by Michael Lewis. W. W. Norton and Company, 2010.

Plate 295 *What is the What? The Autobiography of Valentino Achak Deng: A Novel* by Dave Eggers. McSweeney's Books, 2006.

Plate 296 *The World Without Us* by Alan Weisman. Thomas Dunne Books/St. Martin's Press, 2007.

Plate 297 *The Imperfectionists* by Tom Rachman. The Dial Press, 2010.

Plate 298 *Mr. Penumbra's 24-Hour Bookstore* by Robin Sloan. Farrar, Straus and Giroux, 2012.

Plate 299 *A Visit from the Goon Squad* by Jennifer Egan. Alfred A. Knopf, 2010.

Plate 300 *The Orphan Master's Son* by Adam Johnson. Random House, 2012.

Plate 301 *A Week in December* by Sebastian Faulks. Doubleday, 2010.

Plate 302 *Seven Days in the Art World* by Sarah Thornton. W. W. Norton and Company, 2008.

Plate 303 *Caleb's Crossing* by Geraldine Brooks. The Viking Press, 2011.

Plate 304 *The Cat's Table* by Michael Ondaatje. Jonathan Cape, London, 2011.

Plate 305 *Plainsong* by Kent Haruf. Alfred A. Knopf, 1999.

Plate 306 *Eventide* by Kent Haruf. Alfred A. Knopf, 2004.

Plate 307 *Life After Life* by Kate Atkinson. Little, Brown and Company, 2013.

Plate 308 *The Memory Keeper's Daughter* by Kim Edwards. The Viking Press, 2005.

Plate 309 *Old Filth* by Jane Gardam. Europa, 2006. Trade paperback.

Plate 310 *The Snow Leopard* by Peter Matthiessen. The Viking Press, 1978.

Plate 311 *State of Wonder* by Ann Patchett. HarperCollins, 2011.

Plate 312 *The End of Your Life Book Club* by Will Schwalbe. Alfred A. Knopf, 2012.

Illustration 40 *The Map That Changed the World: William Smith and the Birth of Modern Geology* by Simon Winchester. HarperCollins, 2001.

Illustration 44 *Notturno indiano* by Antonio Tabucchi. Sellerio editore, 1993. Italian edition. Published in English as *Indian Nocturne.*

Illustration 45 *In Search of Memory: The Emergence of a New Science of Mind* by Eric R. Kandel. W. W. Norton and Company, 2006.

Illustration 46 *A Sand County Almanac: And Sketches Here and There* by Aldo Leopold. Oxford University Press, 1987. First published in 1949.

6: DEPARTURES AND ARRIVALS

Plate 313 *Tuesdays with Morrie: An Old Man, a Young Man, and Life's Greatest Lesson* written and read by Mitch Albom. Brilliance Audio, 1997. Audiobook. Story first published in 1997 by Doubleday.

Plate 314 *The Shadow of the Wind* by Carlos Ruiz Zafón. Translated from the Spanish by Lucia Graves. The Penguin Press, 2004. First published in 2001 as *La sombra del viento.*

Plate 315 *On Looking: Eleven Walks with Expert Eyes* by Alexandra Horowitz. Scribner, 2013.

Plate 316 *Spain* by Anthony Ham et al. Lonely Planet Publications, 2011. Trade paperback. Eighth edition.

Plate 317 *The Immortal Life of Henrietta Lacks* by Rebecca Skloot. Crown Publishers, 2010.

Plate 318 *The Elegance of the Hedgehog* by Muriel Barbery. Translated from the French by Alison Anderson. Europa Editions, 2008. First published in 2006 by Gallimard as *L'Elégance du hérisson.*

Plate 319 *Rome: A Cultural, Visual, and Personal History* by Robert Hughes. Alfred A. Knopf, 2011.

Plate 320 *L'Amica geniale: Infanzia, adolescenza* by Elena Ferrante. Edizioni e/o, 2015. Italian edition. Published in English as *My Brilliant Friend.*

Plate 321 *My Name Is Red* by Orhan Pamuk. Translated from the Turkish by Erda M. Göknar. Vintage, 2001. Trade paperback. First published in 1998 by Ieti im Yayınları, Istanbul, as *Benim Adım Kırmızı.*

Plate 322 *Istanbul Passage* by Joseph Kanon. Washington Square Press, 2013. Trade paperback.

Plate 323 *Behind The Beautiful Forevers* by Katherine Boo. Random House, 2012.

Plate 324 *A Suitable Boy* by Vikram Seth. HarperCollins, 1993.

Plate 325 *Pocket Istanbul* by Virginia Maxwell. Lonely Planet Publications, 2015. Trade paperback.

Plate 326 *Mr. Wilson's Cabinet of Wonder: Pronged Ants, Horned Humans, Mice on Toast, and Other Marvels of Jurassic Technology* by Lawrence Weschler. Pantheon Books, 1995.

Plate 374 *On Bullshit* by Harry Frankfurt. Princeton University Press, 2005.
Plate 375 *Sostiene Pereira: una testimonianza* by Antonio Tabucchi. Feltrinelli, 1998.
 Italian edition. Published in English as *Pereira Maintains.*
Plate 376 *The Short and Tragic Life of Robert Peace: A Brilliant Young Man Who Left Newark for the Ivy League* by Jeff Hobbs. Scribner, 2014.

Illustration 48 *A Field Guide to the Birds, Giving Field Marks of All Species Found East of the Rockies* written and illustrated by Roger Tory Peterson. Houghton Mifflin Company, 1947. Second revised and enlarged edition.
Illustration 50 *The Museum of Innocence* by Orhan Pamuk. Translated from the Turkish by Maureen Freely. Alfred A. Knopf, 2009. First published in 2008 by İleti im Yayınları, Istanbul, as *Masumiyet Müzesi.*
Illustration 52 *The Quiet American* by Graham Greene. William Heinemann Ltd., London, 1955.
Illustration 55 *The Amateurs* by David Halberstam. William Morrow & Co., 1985.

EPILOGUE: COLLECTIONS AND RECOLLECTIONS

Plate 377 *The Wright Brothers* by David McCullough. Simon & Schuster, 2015.
Plate 378 *TransAtlantic* by Colum McCann. Random House, 2013.
Plate 379 *Skyfaring: A Journey with a Pilot* by Mark Vanhoenacker. Vintage Books, 2015. Paperback.
Plate 380 *Being Mortal: Medicine and What Matters in the End* by Atul Gawande. Metropolitan Books, 2014.
Plate 381 *The Boys in the Boat: Nine Americans and Their Epic Quest for Gold at the 1936 Berlin Olympics* by Daniel James Brown. The Viking Press, 2013.
Plate 382 *Unbroken: A World War II Story of Survival, Resilience, and Redemption* by Laura Hillenbrand. Random House, 2010.
Plate 383 *When Breath Becomes Air* by Paul Kalanithi. Foreword by Abraham Verghese. Random House, 2016.
Plate 384 *What I Talk About When I Talk About Running: A Memoir* by Haruki Murakami. Translated from the Japanese by Philip Gabriel. Alfred A. Knopf, 2008. First published in 2007 as *Hashiru Koto ni Tsuite Kataru Toki ni Boku no Kataru Koto.*
Plate 385 *Sette brevi lezioni di fisica* by Carlo Rovelli. Adelphi Edizioni, 2014. eBook. Published in English as *Seven Brief Lessons on Physics.*
Plate 386 *One Summer: America, 1927* by Bill Bryson. Doubleday, 2013.
Plate 387 *Aunt Sallie's Lament* by Margaret Kaufman. Designed by Claire Van Vliet. Chronicle Books, 1993. Softcover, trade edition. First published in 1988 by Janus Press (founded in San Diego in 1955 by Van Vliet).
Plate 388 *The Feather Thief: Beauty, Obsession, and the Natural History Heist of the Century* by Kirk Wallace Johnson. Viking Books, 2018.
Plate 389 *The Underground Railroad* by Colson Whitehead. Doubleday, 2016.
Plate 390 *Becoming* by Michelle Obama. Crown Publishers, 2018.
Plate 391 *Killers of the Flower Moon: The Osage Murders and the Birth of the FBI* by David Grann. Doubleday, 2017.
Plate 392 *There There* by Tommy Orange. Alfred A. Knopf, 2018.
Plate 393 *Hamilton: The Revolution: Being the Complete Libretto of the Broadway Musical with a True Account of Its Creation and Concise Remarks on Hip-Hop, the Power of Stories, and the New America* by Lin-Manuel Miranda and Jeremy McCarter. Grand Central Publishing, 2016.
Plate 394 *The Wisdom of Finance: Discovering Humanity in the World of Risk and Return* by Mihir A. Desai. Houghton Mifflin Harcourt, 2017.
Plate 395 *Educated: A Memoir* by Tara Westover. Random House, 2018.
Plate 396 *A Gentleman in Moscow* by Amor Towles. The Viking Press, 2016.
Plate 397 *Exit West* by Mohsin Hamid. Riverhead Books, 2017.
Plate 398 *Asymmetry* by Lisa Halliday. Simon & Schuster, 2018.
Plate 399 *The Soul of an Octopus: A Surprising Exploration into the Wonder of Consciousness* by Sy Montgomery. Atria Books, 2016. Trade paperback.
Plate 400 *Pachinko* by Min Jin Lee. Grand Central Publishing, 2017.
Plate 401 *Moneyland: The Inside Story of the Crooks and Kleptocrats Who Rule the World* by Oliver Bullough. St. Martin's Press, 2019.
Plate 402 *The Tsar of Love and Techno: Stories* by Anthony Marra. Hogarth, 2015.
Plate 403 *The Parade* by Dave Eggers. Alfred A. Knopf, 2019.
Plate 404 *The Overstory* by Richard Powers. W. W. Norton and Company, 2018.
Plate 405 *The Library Book* by Susan Orlean. Simon & Schuster, 2018.
Plate 406 *Ultimate Visual Dictionary.* DK Publishing, 1998. Trade paperback.
Plate 407 *Making a Literary Life: Advice for Writers and Other Dreamers* by Carolyn See. Ballantine Books, 2003. Trade paperback.
Plate 408 *The Friend* by Sigrid Nunez. Riverhead Books, 2018.

INDEX OF CARDS BY TITLE

INDEX OF CARDS BY AUTHOR

GENERAL INDEX

Includes all mentions within text, unless author or title is referenced in a *Book Marks* card; in those instances, please refer to the author and title indices. Stand-alone numbers refer to pages, "pl." to plates, and "ill." to illustrations (the number before "ill." refers to the page number on which the illustration appears).

Editor: Beth Daugherty
Cover and book design: Kathryn Hart
Copyediting: Leslie Kazanjian
Book references and indices: Wendy Kenney

Typeset in Gotham, Brandon Printed, and Special Elite
Printed on 140 gsm IKPP woodfree

First edition

Printed and bound in China by Pimlico Book International

ISBN: 978-1-7356001-0-9 (hardcover)

Library of Congress Control Number: 2020915911

Published by Bauer and Dean Publishers, Inc.
P.O. Box 98, Times Square Station
New York, NY 10108
www.baueranddean.com

Distribution by ACC Art Books (orders processed by National Book Network)
6 West 18th Street, Suite 4B
New York, NY 10011
Tel (212) 645-1111
ussales@accartbooks.com

For more information on the author:
www.barbarapagestudio.com

Unless noted below, all photographs owned by author:
Page 173, photograph courtesy of Elizabeth McMahon
Page 175, photograph by Ken Shelton

Front cover, cards by row, starting top, left to right:
Plates 192, 362, Illustration 16, Plates 327, 67, 171, 389, 97, 260, 126, 245, 311, 340, 283, 363, 388

Back cover, cards clockwise around text, starting top left:
Plates 113, 188, 360, 309, 262, 180, 214, 79, 282, 143, 359

Frontispiece: *Book Marks* card for *Kafka on the Shore*

Image opposite Contents:
Detail of bookshelves in author's library, with *Book Marks* library case at bottom

Image opposite Card-Making Process:
Worktable in author's studio